Contemporary Sculpture in Scotland

Andrew Patrizio

CRAFTSMAN HOUSE
G+B ARTS INTERNATIONAL

For Maureen and Ross

Distributed in Australia by Craftsman House,
Tower A, 112 Talavera Road,
North Ryde, Sydney, NSW 2113
in association with G+B Arts International:
Australia, Canada, China, France, Germany, India,
Japan, Luxembourg, Malaysia, The Netherlands,
Russia, Singapore, Switzerland

ISBN 90 5703 43 1X

Managing Editor: Marah Braye
Design: Kirsten Smith
Cover Design: Caroline de Fries
Colour Separations: Digital Pre-Press Imaging Pty Ltd, Sydney
Printer: Kyodo Printing Co., Singapore

Page 3: Jake Harvey, *Night Drum*, 1993, Carved limestone,
53 x 79 x 68 cm. Collection of Aberdeen Hospital. Photograph: Joe Rock.
Page 5 (from top): Kevin Henderson, *Propaganda Cradle* (detail), 1989, Wood, oil,
paint, 520 x 245 x 15 cm. Photograph: Catriona Grant; William Brotherston,
Coil (detail), 1994, Aluminium, 19 x 90 x 90 cm. Collection of the artist.
Photograph: AIC Photographic Services; George Wyllie, *The Paper Boat* (detail), 1989,
Installation in New York, 1990; Doug Cocker, *2 Tribes/40 Shades* (detail), 1994,
Wood, 150 x 335 x 12.7 cm. Collection of the artist. Photograph: Mike Davidson;
Dalziel + Scullion, *Television Cloth* (detail), 1994, Silk organza, ink, metal, unlimited
edition in two versions (14-inch and 21-inch television screens). Commissioned by
National Touring Exhibitions, London and Centre for Contemporary Arts, Glasgow.
Photograph: Dalziel + Scullion; Andy Goldsworthy, *Burnt Sticks* (detail), 1995,
Installation at San José Museum. Courtesy of Michael Hue-Williams Fine Art Ltd,
London. Photograph: Andy Goldsworthy.

Contents

The Artists

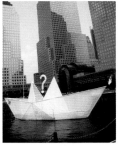

Acknowledgements

I would like to thank, first and foremost, the artists profiled in this book for their patience and support throughout the project. Thanks are also due to the many galleries, curators and administrators that supplied the photographs and information included here. In its initial stages, this book was very much part of a collaboration between myself and Bill Hare — his encouragement at all stages has been invaluable. For their help, I would also like to thank my publisher, Nevill Drury, and Sam Ainsley, John Gooch, Andrew Guest and Fiona Pearson. Finally, without the extended support of my wife, Maureen, this book would never have been published. Without the (sometimes welcome) intervention of my son, Ross, it might have been published a little earlier.

Preface

In 1996, the legendary Stone of Scone was unexpectedly moved by the authorities from its site beneath the Coronation Chair in London's Westminster Abbey and returned to Scotland. The Stone of Scone is a roughly hewn block of course-grained sandstone measuring 67 cm x 42 cm x 28 cm, and in appearance it is not unlike a Carl Andre sculpture.

Symbolically, however, the Stone of Scone is important in Scottish history and myth as the ceremonial 'throne' on which the ancient kings of Scotland were crowned. Scone, near today's city of Dundee, had been the Pictish capital since the eighth century AD, and when Edward I of England seized the Stone, around 1296 AD, he usurped the right of Scotland to be a nation under an independent king or queen. The Stone's mythic status was magnified in many other ways — it was believed to be either Jacob's Pillow from the Holy Land, St Columba's pillow from the holy island of Iona or the royal chair of Simon Brec, the ancient King of Spain. Compounding the sense of mystery surrounding the Stone is the generally held belief that Edward I never found the actual Stone but took with him a surrogate, leaving the true Stone hidden or lost to this day.

This peculiar history did not stop a Conservative government, in a last act of political expediency, from arranging for its return in 1996. For most of us brought up in Scotland it was inconceivable that the Stone might be voluntarily returned in our lifetimes, yet, true enough, the Stone was escorted (bagpipes and all) across the Border to its new home in Edinburgh Castle, with the then Secretary of State for Scotland by its side, smiling for the cameras. As a gesture to the Scottish voter, the move failed spectacularly: a year later, a general election was held and not a single Conservative candidate was returned to a place on the benches in Westminster.

I recount this story because the Stone of Scone occupies a place between landscape and sculpture; it is an object invested with so much symbolic power it could never be considered neutral and yet not carved enough to hint at a new form. This fact, and its recent return to its homeland, makes it a poetic and politically charged point of reference for the way in which contemporary sculpture in Scotland has been developing at the end of the twentieth century. I have chosen to write on some of the history of recent Scottish sculpture under the theme of archaeology and excavation, which I believe can sensitively and adequately contextualise the work of many different talents. Somewhat symbolically, the larger part of this book was written between the return of the Stone in spring 1996 and the national referendum held on September 11, 1997, in which three-quarters of the population voted for a devolved Scottish Parliament, previously lost to London in 1707, to be reinstated in the year 1999. While there are 'quiet revolutions' going on in Scottish politics, there has been something comparable in Scottish sculpture over the past ten or so years, which this book aims to chart through some of its most active and brilliant practitioners.

On the theme of revolution, when Ian Hamilton Finlay coined the aphorism, 'You cannot step into the same revolution twice' (his reworking of Greek philosopher Heraclitus's dictum, 'You cannot step into the same river twice'), he offered a potent reminder to anyone seeking to write a history of a contemporary topic. The fast flow of today's art current, in which Scottish sculptors have become particularly central over the past decade, means that our subject has already moved on, despite the emphatic physical presence of this book. Indeed, it would be a damning reflection on contemporary Scottish sculpture if it had not. The present is being buried each day under new layers, awaiting another process of excavation at some unknown point in the future.

Andrew Patrizio
LONDON AND EDINBURGH

7

Excavating Scottish Sculpture

'*We must reconcile ourselves to the stones,*
Not the stones to us.'

Hugh MacDiarmid,
On a Raised Beach, 1934

National landscapes are shaped by the complementary effects of the landscape on the people and the people on the landscape. 'Without a geographical setting,' prehistorian Stuart Piggott writes, 'any study of human communities in past or present times must be a meaningless abstraction.' Certainly, understanding and appreciating the strengths of Scottish sculpture requires a sense of the extraordinarily varied physical context from which it emerges. This essay begins with a consideration of the natural landscape as a source for sculpture, a landscape that acts as a foil for the more artificial and urban spaces which form another crucial part of the Scottish scene. The natural and the urban are two territories where layers of history and meaning have accumulated over the years, layers which sculptors have excavated painstakingly and reinterpreted for their own creative reasons.

In prehistoric times, the forest of Caledonia was the natural condition of most of Scotland. Its decline over the centuries, particularly under the impact of farming and deforestation, transformed the terrain, despite the fact that scientifically managed new plantations have since sprouted up in neat ranks across the faces of numerous glens. The Scottish countryside became forever marked as a highly charged, political territory — and no sculptor can go so far as to pick up a piece of wood without this association being at least partially present. Far from being a place of romantic and purely aesthetic inspiration, natural landscape is contested land where competing interests (people/nature, English/Scots, landowners/tenants, incomers/locals) have played out their battles. Lewis Grassic Gibbons's novel trilogy, *A Scots Quair*, describes the history of his north-east locale, Kinraddie, as a complex region, and in the novel's brief prelude he makes reference to a range of momentous events played out on its soil, from the times of William Wallace and the English incursions to the influence of the Reformation of the Church of Scotland, land rights issues, and the emergence of socialism. Gibbons reminded us that we live in a land with a long memory — a land, as he says, which holds 'the sweat of two thousand years in it'.

For those who know Scotland, the presence of prehistoric standing stones, across both the rural landscape and, more sparingly, in urban areas, is a reminder of this fact. Turning again to the opening of *A Scots Quair*, we find that powerful feelings of superstition are aroused by prehistoric remains:

> ... *nearby the bit loch was a circle of stones from olden times, some were upright and some were flat and some leaned which way and that, and right in the middle three big ones clambered up out of the earth and stood askew with flat sonsy faces, they seemed to listen and wait. They were Druid stones and folk told that the Druids had been coarse devils of men in the times long syne, they'd climb up there and sing their foul heathen songs around the stones ... And Long Rob of the Mill would say what Scotland wanted was a return of the Druids, but that was just a speak of his, for they must have been awful ignorant folk, not canny.*

Given the unquestionable inspiration which landscape and humankind's relationship with the earth has provided for Scottish sculptors, it is not surprising that a considerable amount of work has been publicly sited, some of it poignantly close to the sites of ancient history.

Although Scotland's first dedicated open-air space was established privately in 1955 at Glenkiln, Dumfriesshire, full development of open sites did not occur until the late 1970s and 1980s with a series of initiatives, such as The Highland Sculpture Park established in 1978 by the Scottish Sculpture Trust (also founded in 1978) within a part of the Caledonian Forest that still remained. A similar enterprise at Glenshee followed soon afterwards, its purpose to attract, as well as art enthusiasts, the increasing quantity of sightseers, walkers and skiers who visited the Highlands and so bring together two very different faces of Scottish contemporary life. The first Scottish Sculpture Open took place in 1981 at Kildrummy Castle, in northerly Aberdeenshire, where it continues to thrive today. The Open is run by the Scottish Sculpture Workshop, an initiative established by sculptor Fred Bushe in 1979 in nearby Lumsden to encourage students, indigenous sculptors and international visitors to develop their work in this remote area of Scotland.

The last on the list of early outdoor parks dedicated to sculpture is the short-lived Cramond Sculpture Park, Edinburgh, set up in 1985, which

responded to the temporary, largely mixed-media work starting to emerge from the art schools in Scotland and to which we will return later.

Cramond, The Highland Sculpture Park and Glenshee are all long defunct and almost pale into insignificance in comparison with The Yorkshire Sculpture Park, successfully set up in Henry Moore's hometown of Wakefield. The reasons for the limited achievement of what were undoubtedly worthy projects lie well beyond mere considerations of financial backing, another hallmark of the fragile nature of investment in Scottish art. A more fundamental observation might be that the Scottish landscape is already political, already charged with emotion, myth and visual power accrued over centuries, indeed millennia. We need only consider what, to most people living in Scotland today, is the single historical moment which most exemplifies the politicised landscape of our country. This is the Highland Clearances of the eighteenth and nineteenth centuries, a time of true oppression, when rural communities were forcibly relocated by their political masters to the coast so that hillsides could be turned over to profitable sheep farming. (The high emotion has not entirely left the region to this day and, while the cruel measures meted out are a thing of the past, huge sections of Scottish land is still extensively bought up as investment by outside entrepreneurs.) Scotland's dramatic glens and desolate wilderness — places which contain vital chapters in our history and to which we will return shortly — make little accommodation for medium-sized modernist sculpture sited out of doors, in direct competition with nature. Grander alternatives have never happened in Scotland — partly for financial reasons and also because few Scottish sculptors have shared the sensibility of their land art counterparts in the United States to bear heavily on the landscape to create colossal outdoor sculpture. Perhaps also due to the relatively modest size of our cities, there has never really existed a creative tension, as exists in the United States, between the perception of an overcivilised city culture and an untamed hinterland.

widespread revolution in the main directions in Scottish sculpture which occurred in the 1990s, the materials most sculptors used were invariably resilient — stone, metal, wood, as well as bone and bark — whether they were assembled, carved or cast. On one hand, artists were paying homage to ancestral craft skills and, on the other, they were seeking to create objects which asserted their own relative permanence. These kinds of ancient objects projected a concrete form of mysteriousness which is a vital part of the modernist sculpture tradition.

The academic study of bygone material culture may be something of a science but, as archaeologists themselves increasingly acknowledge, their work depends on unreliable evidence which itself is ever more contaminated by the passage of time. Scottish sculptors by and large seem acutely attuned and sensitive to the concept of time passing, and the ancient objects they have been drawn to, such as Celtic crosses and earthenware pottery, offer ways of mediating between the present and the past. Time becomes almost a material, alongside wood, stone and other media, with which sculptors work. This aspect may be particularly prevalent in Scotland due to the physical proximity of the past, represented by ancient sites, indigenous museum objects and artworks easily available to the artists' view, and it is common to find repeated reference made by practitioners to inspirational visits to rural sites and around museum collections.

The approach particularly of the generation of artists who trained in the 1960s and 1970s in Scotland is characterised by a considered reliance on craft skill and on themes concerned with universality, time, myth and ritual. This can be seen as a genuinely Scottish response to modernist sculpture on the international stage, specifically from two different sources, Constantin Brancusi and David Smith, each of whom showed breathtakingly innovative ways of working in the interface between semi-abstraction and what used to be called 'primitivism'.

Moving from the 'contexts of archaeology' — the forests, the glens and the standing stones — to a consideration of how some of its objects have been an inspiration to sculptors, archaeological artefacts have a solid physical presence which states clearly their identification with particular ancient races and cultures in Scotland's past. Speaking in very broad terms, before the

In drawing on the national and durable associations which the materials of archaeology offer, sculptors have also looked to the functional purpose of many of these fragments left to us by previous cultures. Clearly useful objects, such as kitchen utensils, farm implements and boats, have been carved, beaten or moulded for daily life and have a visual quality that, paradoxically,

often derives from the lack of aesthetic attention paid to them in their making. They have also been made to last, to resist destruction over the passage of time; for those who originally made and used these objects, they spoke of the place of origin and a world concretely rooted in the here-and-now. This sense of geography and permanence clearly has an appeal for the Scottish sculptors who are sensitive to the visual and conceptual power of local artefacts. Visual artists are tackling a problem very familiar to fellow Scottish poets and writers of fiction — that is, how to create work that seems moulded in the minds of those who use actually use the language daily. For sculptors, this means forging a 'visual vernacular' in which objects rather than words seem familiar, as if they have been regularly used, adapted and exchanged.

The shapes of pots, jars, rings, coins, axe heads and ploughs have been 'excavated', so to speak, by numerous sculptors in Scotland, such as William Turnbull, Jake Harvey and William Brotherston. Their interest stems not only from a fascination with the form of such artefacts, nor only through their appearance of age, but denotes a mistrust of the formal abstraction of high modernism. These Scots sculptors, particularly of the middle to older generations, have for many years been stating their difference from abstraction by underlining distinctive, indigenous influences saturated in pregiven meaning.

The prehistoric monoliths described by Gibbons in *A Scots Quair* are relatively unformed in shape and are pagan in purpose. Another type of archaeological object acts as a precedent for contemporary sculpture, namely religious Celtic crosses whose elaborate and intricately layered surfaces are both beautiful and mysterious. Two lines of Norman MacCaig's poem, *Celtic Cross* — 'Only men's minds could ever have unmapped/ Into abstraction such a territory' — memorably captures their powerful reticence. The Celtic carvings MacCaig talks of, which are to be found in museums displays, in town squares and in the middle of roundabouts, lack any representational subject and offer an early Christian alternative sculptural source to our pagan standing stones.

Sculpture of this century has thrived on the illegibility of objects from the past. Visual mystery stands in for the mysterious in its widest sense. MacCaig's poem arises through a consideration of the relief carvings across an ancient stone cross — 'a stone made light/ By what is carved upon it' — and such crosses, slabs and shrines are invariably the only witnesses to the vanished societies that created them. American Robert Smithson's *Spiral Jetty* (1969–70) on the salt lakes of Utah relies for its impact on ancient serpent mounds of similar shape constructed by Native Americans. Whether making general or specific cultural reference to ancient peoples, sculptors across the western world have used a variety of means in making sculpture to acknowledge the more resilient fragments of past lives. Rooting their practice in something which at least gives a concrete appearance of authenticity, national identity and longevity is clearly part of the attraction.

Whilst on the theme of 'collective memory' in sculpture, reference should be made here to a visit made to Scotland in 1970 by the German artist, Joseph Beuys. This major twentieth-century artist found an inspiration in the Scottish landscape which anticipated on a number of levels the new spirit in Scottish sculpture that emerged in the 1990s. He made and filmed an art performance in the bleak and remote landscape of Rannoch Moor, a site near Glencoe renowned for its terrible clan conflict over the years. The film was later incorporated in performances called *Celtic (Kinloch Rannoch) Scottish Symphony* at Edinburgh College of Art. In this work, Beuys was openly responding in shamanistic fashion to the power of ancient Scotland, although he recalled it in the following bizarre way: 'All of that had been alive inside me for a long time: Scotland, Arthur and the Round Table, the Grail legend. The elements coalesced and emerged.' — so conflating all manner of Celtic, romantic and English myth. At the time, Beuys's work made little discernible impact on the Scottish art scene, although a quarter of a century later younger artists in Scotland, to whom we will return, have developed their own multidisciplinary activity, alternative uses of materials, and work in performance and music in relation to a reconstituted idea of 'sculpture' for which Beuys is clearly a major precedent.

We briefly remarked on the Highland Clearances of the past two centuries, but running concurrently over the later part of the eighteenth century was a very different kind of movement. A number of great Scottish artists and antiquarians, among them David Allen, Gavin Hamilton and William Hamilton, based themselves in Italy to devote significant time to study,

collect, catalogue and draw the newly excavated antique artefacts emerging from Rome and Naples. The neoclassical revival was sparked off by the unearthing of objects belonging to the urban cultures of ancient Greece and Rome. The revival was European-wide, yet the Scots, with their predisposition towards rigorous empirical study and deductions based on first principles, brought very special qualities to whatever their subject was, be it geology, philosophy, history or the visual arts. Here were artists and intellectuals searching for the real, unalloyed foundations of things, an archaeological truth where the objects, being from the past, could not avoid being eloquent of it. The reconstruction of antiquity in the eighteenth century is the kind of project which fascinates a contemporary artist such as Ian Hamilton Finlay, who explores the problems and moral implications of 'excavating' canonical ideas and setting them up as absolutes in today's world.

VII

It is impossible to write on Scottish sculpture, contemporary or historical, without some reference to its southern neighbour, England — a country, after all, that has been characterised by art historian Nicholas Pevsner as 'an unsculptural nation'. This passing observation may be significant for a better understanding of the best of Scottish sculpture. Perhaps Scots intuitively understood the sculptural limitations of their economically more powerful neighbour and felt encouraged, by default even, to turn to the historic and prehistoric artefacts that could be found on home soil. It is remarkable just how dominated the cities of Glasgow and Edinburgh are by Victorian statuary, with their colonial, representational tableaux commemorating battle scenes and great men. A deeply conservative figuration with all the trappings of empire dominated the academic and public spheres in nineteenth-century art, in Scotland as elsewhere in the United Kingdom. Even today, public sculpture is popularly understood as being of such a type, yet it is depressing evidence of the English stylistic canon and her political and cultural dominance over recent centuries, and of Scottish culture's passive acceptance of it.

Certainly, Scotland has vacillated between positions which on one side yield to dominating outside influences, as it did in the nineteenth century, and, alternatively, assert its regional identity. Our most successful Victorian sculptor, Sir John Steell, attempted to argue for the indigenous nature of Scottish

figurative sculpture by remarking, '... the truthful solidity and heart-moving poetry of the Scottish mind well accorded with the essential characteristics of sculpture'. Despite this, the Scottish art establishment and artists themselves have seemed less able to conceive of a notion of national sculpture which might be considered to exist under the 'flag' of a distinctive collective style.

Even as late as the 1950s to 1980s, the situation had not changed radically, although, north of the border, two undoubtedly formidable practitioners from England, Henry Moore and Antony Caro — each of whose semi-abstract anthropomorphism was founded on the gestural character of sculpture and its relation to the body — wielded considerable influence. Similarly, the opening in 1960 of the Scottish National Gallery of Modern Art (SNGMA) in Edinburgh saw three works sited publicly out of doors: two bronzes by Henry Moore and one by Emile Antoine Bourdelle (one of Auguste Rodin's contemporaries). Such works, which stayed in situ for decades outside SNGMA, represented something of a rejection of progressive indigenous work but also began to look increasingly inadequate in the face of the radical rethinking that was occurring in the collapsing field of sculpture in the 1960s and 1970s. Despite isolated international successes over the period, Scotland still had to wait a few more decades before wider recognition occurred.

VIII

One can hardly discuss Scotland and its culture without underlining the impact of industrialisation, a subject which relates both to our sculpture and to the theme of archaeology. After all, the 1950s saw the newly invented discipline of industrial archaeology, yet by that time artists (Eduardo Paolozzi in particular) were already turning over the remnants of Britain's industrial past for symbolic use. Eduardo Paolozzi has built a career on the theme of accumulation founded on the principles of surrealism and the gathering and juxtaposing of material artefacts and imagery from across the world. The assembled detritus of urban life and the accumulation and shaping of vast quantities of discarded industrial material are merely buried resources for such artists as Gareth Fisher, David Mach and Craig Wood. The connection in sculpture between excavating the objects of consumerism and the practice of archaeology is not unique to Scottish art, of course, and we can witness parallel methods in the rest of Europe and the United States — for

11

example, in the work of John Chamberlain, Arman, Tony Cragg and Bill Woodrow. Urban archaeology registers the crisis of city life and it is not surprising that artists have been among the first in using it to ask new questions about what the boundaries of sculpture might be.

Public life in general has become a complex new problem to be scrutinised in relation to our sense of community and use of communications technology. It is perhaps inevitable, then, that public sculpture inherits many of the problems associated with this wider context. On one aesthetic level, there was perceived to be a disparity between the radical claims of abstract modernist art, bred in the studio, and the agendas of those who sought to bring sculpture to new constituencies, invited or otherwise. One example of unsuccessful public sculpture was the 24.4-metre kinetic Neon Tower set up in 1974 in Edinburgh by Roger Dainton. The technology involved rarely worked and, after many years standing 'unplugged', it was eventually dismantled in the late 1980s.

Alongside many other nations in the 1980s, Scotland's reconsideration of public art grew sharply. Dundee's Duncan of Jordanstone College established a Public Art Department which attempted to teach students how they might approach traditional public audiences and commissioners (nurtured on the aforementioned Victorian diet of realism and commemoration) and bring the 'private' languages of modern art into the common public domain. Artists trained at the college in many kinds of public artforms, including such craft-based subjects as mosaic and glass. In general across Scotland, newly commissioned public sculpture is of very mixed quality, although post-war new town developments in Irvine, Livingston and Glenrothes did support extensive programmes of public work by such figures as Ian Hamilton Finlay, William Tucker, David Harding, Andrew Mylius and Mary Bourne.

This is modest stuff, in comparison with French cultural policy of the past fifteen years or so, with its massive investment across Paris and elsewhere into a rich funding and curatorial structure for the creation of truly contemporary new sculpture. Politically orientated support of art as a national policy can have its dangers, as demonstrated in 1988 when Ian Hamilton Finlay, profiled here, became embroiled in an acrimonious debate in France about his proposed sculpture commission to celebrate the bicentenary of the Declaration of the Rights of Man. The sculpture had not passed the planning stage before the nature of the actual artwork was relegated behind the playing out of internal political antagonisms in the lead-up to a French general election.

In relation to the alliance between politics and sculpture, that same year Finlay was only one of two artists (the other was Dhruva Mistry) whose participation in the temporary sculpture extravaganza which accompanied the Glasgow Garden Festival resulted in permanently sited works. The festival was one element in the city's long-term strategy for urban renewal fuelled by way of cultural initiatives, although one which was not followed up in any concerted way to support new public work. Two years later and as an extension of Glasgow's year as European City of Culture in 1990, the Scottish Sculpture Trust was invited by the Venice Biennale to organise an unprecedented, stand-alone Scottish representation, which it did, with sculpture installed by Kate Whiteford, Arthur Watson and David Mach.

These disparate moments were each beginning to contribute incrementally to an increasing energy to be found in Scottish sculpture, different in mood and direction to much of what had gone on before.

Scotland is by no means closed off to international developments, as the work of the most outward-looking Scottish sculptors shows and as the steady influx of, and cultural contribution from, Eastern Europeans, Italians and Asians testify. Nevertheless, the Scots' historic subjugation under a powerful neighbour in England has meant an undeniable suspicion of any artistic movement which claims authority from abroad and seeks to 'colonise' the Scottish scene. Looking briefly at examples of international insurgencies in sculpture on Scotland over recent years, we notice mixed fortunes. There are very few commissioned works of public sculpture by non-Scots; one exception is (Scottish-born) American George Rickey's large steel mobiles that grace the grounds of the University of Glasgow. A prime spectacular failure of the 'colonialist' approach in sculpture was evident in the 1987 Scottish Arts Council–backed The Edinburgh International: Reason and Emotion in Contemporary Art, intended originally to be a biannual event but never seen again. The only Scottish sculptor selected was Ian Hamilton Finlay. Highly significant practitioners of international standing, such as James Lee Byars,

Rebecca Horn, Tony Cragg and Michelangelo Pistoletto, showed work in the Royal Scottish Academy, which seemed strangely out of context — sculpture which spoke in another, transnational language — a sense underlined by a poor critical and public response.

Six years later, in the winter of 1993, Lux Europae, a major display across Edinburgh of publicly sited sculptures on the theme of light, took place. It featured such major international figures as Bill Culbert, Bernhard Prinz, Patrick Corillon and Mischa Kuball, as well as artists featured in this book (including Finlay, Louise Scullion, Matthew Dalziel and George Wyllie), but it could not escape a heavily scripted agenda, springing as it did from a major political conference being hosted in the Scottish capital. (Its catalogue foreword was written by the UK Prime Minister.) Despite its confined context, its director, Isabel Vasseur, returns us to our theme, by capturing the spirit of urban archaeology already contained in the ancient city of Edinburgh to which artists aspired to respond. It is a place 'where one age leans on another, and where the medieval has settled with the classical and dares any intervention to disturb'. The exhibition's theme of light also recalled the significance of the eighteenth-century Scottish Enlightenment, and demonstrated some illuminating awareness of context on the part of the organisers. Lux Europae was a formidable event, and amid this picture a good number of small independent organisations has sprung up in the past decade, seeking to address the reconfigured, more politically and contextually aware direction which work sited in public spaces is now following.

Despite the international impact of artists such as Turnbull, Paolozzi, Boyle Family and Mach from the 1950s to 1980s, it will be clear that state-sponsored support for indigenous sculpture has hardly been rock-solid. The Scottish Arts Council, founded in 1967, was one important means by which less commercially viable art (notably temporary installations and ambitious sculpture) could be supported. Apart from the provision allowed to the favoured few in the sculpture parks of the 1980s (as we have seen, far from a straightforward proposition), there was until recently a dearth of appropriate opportunities for artists to offer a contemporary response to medieval carving on cathedral exteriors or Victorian bronzes of great men. It was only a matter of three or four years after such debacles as The Edinburgh International before young sculptors, particularly in Glasgow, began to see authentic and realistic ways of connecting with the international scene and of making their own contribution. And, like their counterparts active across the western world's contemporary art gallery structure, they were as happy to make use of the airport and the fax machine as the studio and the welding torch.

The precise source of this explosion of new, worldly art is usually credited as springing from the Department of Environmental Art in Glasgow School of Art, which, after its earlier role in teaching murals and stained glass, was transformed in 1985 by David Harding, an experienced public artist, into a place where students were encouraged to explore open-ended issues of context in relation to art production and dissemination. The department encouraged students to work across traditionally separate disciplines and also built on the philosophical stance of the Artist Placement Group (founded in 1965 in England by John Latham and Barbara Stevini) which coined the phrase 'the context is half the work', a mantra drilled into all students passing through Harding's department. In encouraging new directions for three-dimensional work which intervened in social spaces beyond the art school, it was far ahead of the sculpture departments in any of the four Scottish art schools (although, of course, the impact of the new agenda has prompted others to keep pace).

Similarly, the head of Glasgow School of Art's Masters course, Sam Ainsley, was a focal point for women sculptors in particular to develop a visual language which opposed the canons of male-dominated public art, and one which emphasised the personal and political. It is an unavoidable fact that up to the 1980s Scottish sculpture has been grossly dominated by male practitioners. Lagging behind many other western countries, there seems to be a serious absence of senior women sculptors of standing. Numerous group exhibitions up to that time (and sometimes beyond) unashamedly selected only male participants. Much of this work, setting to one side its inherent worth as art, has an industrial and fastidious physicality, and one often finds in artists' statements a list of processes such as cutting, shaping, drilling, bending, joining and stacking. Its close relation to industry and craft skill is no accident, and much traditional, modernist Scottish sculpture has been founded on what might be seen as stereotypical male attributes of function, solid design and resilience. This has been succeeded by the rise in the past decade of a number of women sculptors, public artists and installation artists, such as Sybille von Halem, Valerie Pragnell, Claire Barclay, Kirsty McGhie (each of whom came through Environmental

Art at Glasgow), Annie Cattrell, Kerry Stewart and those profiled in the following pages.

Students graduating from Environmental Art and elsewhere became increasingly adept at getting their work out beyond the confines of Scotland in ways unprecedented in earlier generations. One important route was Transmission Gallery, set up in 1986 by artists (primarily figurative painters) working in Glasgow, which had a fast-changing, energetic committee, a commitment to new media, film, installation and sculpture, all allied to an unusually strong sense of camaraderie among members. It also expanded the idea of low-cost international collaboration and exchange, which encouraged international artists to show in Glasgow in return for a reciprocal invitation to exhibit abroad. The strategy, which provided ambitious artists with the possibility of greater recognition, was described by one of the artists who undoubtedly benefited, Douglas Gordon, in the following terms: 'In the mid/late 80s the issue of ART in relation to PLACE in relation to INTERNATIONAL art practice was an engaging focus for many young artists who wanted to shift his/her practice from a provincial forum to an international dialogue.' Compared with the cultural and social determinates that operated in the 1940s for talents such as Paolozzi and Turnbull, or in the 1960s with Mark Boyle, or in the 1970s with Thomas Lawson, who each had to move to Paris, London or New York to pursue their careers, in the age of fax machines, cheap international travel and lucrative short-term commissions and residencies abroad, it has been a strategic move of many younger artists to see a strength in occupying the 'periphery' as opposed to the 'centre' and remain in the city of their training in order to benefit from long-standing support networks close to home.

For those operating in less high-risk circuits and building on the success of the Scottish Sculpture Workshop in remote Aberdeenshire, graduating students across the central belt of Scotland rallied in the latter part of the 1980s to found sculpture workshops in Glasgow and Edinburgh in order to gain workshop and equipment facilities to pursue professional lives as sculptors and commissioned craftworkers. This initiative was very much part of the entrepreneurial spirit which characterised the 1980s in the face of economic depression across the United Kingdom. It paralleled too, in a modest form, the way that artists in London were searching for new spaces in which to show work, such as artist-run galleries, derelict warehouses and shopping centres. Such strategies can be seen in the context of artists reassessing the entire basis of their relation to society and, more pragmatically, being forced into finding new markets.

With the influx of prominent women artists and a reluctance by younger male artists to align with the heavyweight practices of their predecessors, sculpture in recent years is neither created always with permanence in mind nor made from permanent materials. It retains an aura of durability in different ways. Art critic and historian Murdo Macdonald has written of the emerging generation of artists as being interested by 'the hidden, the lost, the culturally fractured, the unexpectedly manifest, the peripheralised, the fragmented'. Such an inventory of concerns accords with our theme of archaeological exploration. For a good number of the younger artists who recently left college, psychology, trauma, extreme states of mind and the like have produced work which might collectively be termed a psychological art of the mind. For Douglas Gordon, for example, the unearthing may be of archival film footage languishing in medical institutions; for Christine Borland, skeletal remains illegally imported from Asia; for Tracy Mackenna, words found through free-association. While the younger generation would not automatically associate themselves with artists such as Paolozzi and Turnbull, it is a fact that both generations have offered sophisticated responses in their own terms to the taxonomy of museums, ethnographic displays and western notions of 'primitivism' and the bizarre.

The modus operandi of emerging sculptors and installation artists bears little relation to traditional sculptural practice, therefore the theme of excavation operates on a more psychological level and has become embedded as part of these artists' processes, and less as a source or explicit reference point. Partly, this can be seen as a rejection of material stability implied by 'objects' in their traditional sense, as artists have focused more on the non-rational, the shifting and unfixed interior landscape. The touchstone of memory is a key route to the mentally excavated and unexcavated.

Associated with memory, inevitably, is the notion of time, and it is not surprising that an increasing number of fine-art sculptors are working simultaneously in film and digital media, in the production of video installation and video art. The New York art critic Rosalind Krauss has expressed this theme pertinently in her observation: 'One of the striking aspects of modern sculpture is the way in which it manifests its makers' growing awareness that sculpture is a medium peculiarly located at the juncture between stillness

and motion, time arrested and time passing. From this tension, which defines the very condition of sculpture, comes its enormous expressive power.' Sculpture, of course, has always involved physically moving around an object, so the element of time is hardly new in itself. However, in exploring sculptural installation and fusing it with film, video and digital elements, many artists have taken on time as a subject in a much more explicit way, so it is not surprising to find the archaeological theme taking new forms in new media.

The work that has come out of this contemporary situation in Scotland has been characterised by Maria Lind, a Swedish curator, as 'lyrical conceptualism'; something of a development from 1970s conceptualist practice, visually austere certainly, although less inflected by a direct political agenda and more poetic and mysterious. Whilst it would be naive not to recognise that fashions change in art at a furious pace, the growing number of young Scottish artists who have been picked up enthusiastically by the international exhibition circuit serves to lay down a challenge to many even younger artists in Scotland: provincialism, in its worst sense, is now a matter of personal choice.

What, finally, is the appeal of time, archaeology and the past in general as sources of inspiration to very different Scottish sculptors? The great contemporary Greek sculptor Jannis Kounellis proclaimed: 'I don't want to delve in the past for archaeological pleasure … but because the past has a reality which conditions us deep down.' The metaphor of archaeology in Scottish sculpture is not archaeological truth, however rudimentary, but an artistic projection from the sculptor onto the objects she or he creates. As a metaphor, it operates always firmly in the present, never in the past alone.

The Artists

Christine Borland

Since the 1970s, artists have sought to question the authority of sculptural objects and their display by way of underlining the procedures and processes which go to make up a work of art or, indeed, are responsible for many of the artefacts that surround us. Christine Borland is one such artist, and in the various in-depth forms of enquiry which make up her body of work we have to consider not only the final artwork, presented as sculpture or installation, but the possible narratives behind the objects which determine their present appearance.

The kinds of creative processes in which Borland participates are not of the conventional kind in sculptural practice. She collaborates with members of what might be called 'closed' institutions, such as museums, police forensic departments, archives and research institutes, using skills made available to her through collaborators. It is a delicate, complex and usually rewarding way to 'negotiate', literally, the creation of a work of art.

In the work *Holding, Waiting* (1994), the objects displayed were pieces seized by police as part of criminal investigations, some obvious in the threat they pose (such as guns and knives), others curiously innocuous (talcum powder and a bottle of Malibu). Borland's installation was open to multiple interpretations, with viewers invited to extrapolate, in their own terms, the history of each article.

The violence behind these 'guilty objects' underlies many of Borland's installations but is paradoxically neutralised in the passive form of display she uses. *East of Eden* (1994), consisting of an AK47 rifle buried in the ground,

OPPOSITE: From Life (detail), October 1994
Bronze cast clay head reconstructed from skull, plinth, Portacabin. Installation at Tramway, Glasgow. Courtesy of the artist and Lisson Gallery, London. Photograph: Simon Starling

RIGHT: From Life (detail), October 1994
Osteologist identifying preliminary characteristics of skeleton. Installation at Tramway, Glasgow. Courtesy of the artist and Lisson Gallery, London. Photograph: David Allen

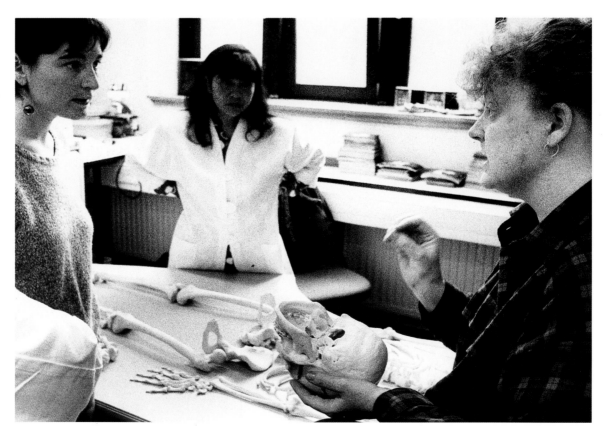

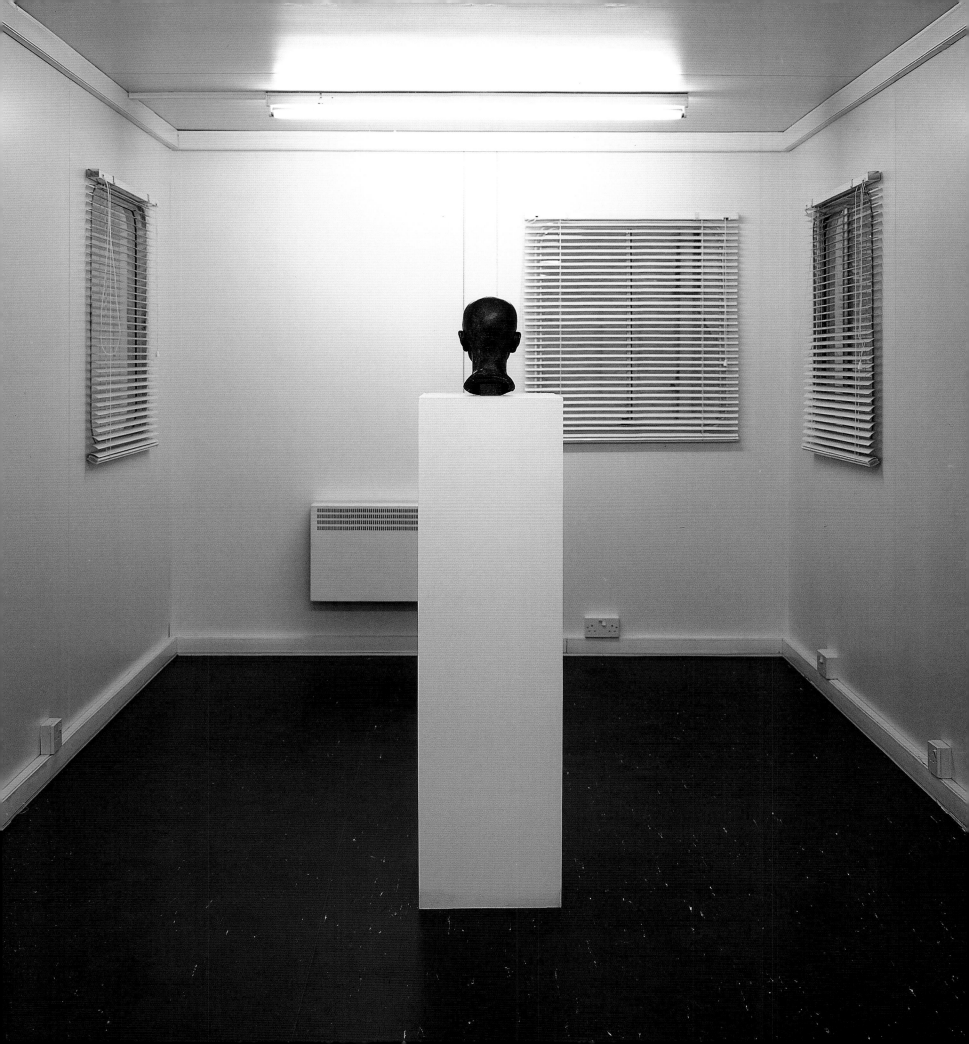

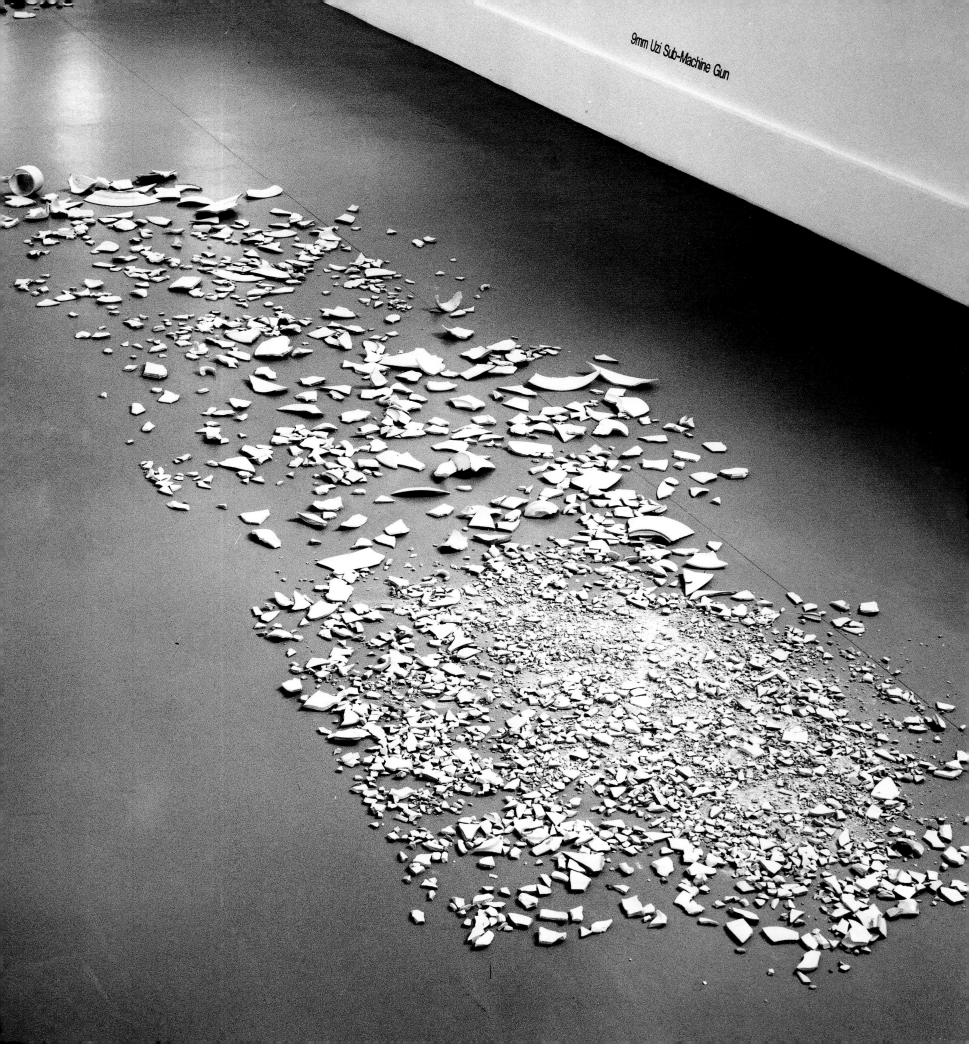

9mm Uzi Sub-Machine Gun

required no elaborate skills in its execution, yet it evoked powerful emotions in the way it appeared as a piece of criminal evidence or a dangerous weapon taken out of circulation or even a metaphor for human burial. The artist tests how little she can indicate as certain narrative but still allow the viewer to imagine possible (and often sinister) readings. In some ways, Borland might be said to develop the important sculptural notion of 'site' and 'non-site' proposed by the American land artist, Robert Smithson. Moving objects from their natural setting (the site) to a gallery (the non-site) creates a conceptual tension between how we expect objects to function in the outside world and how they appear to us when removed to a gallery.

Borland has focused on the motifs of the bullet hole and the shattered object as highly charged indications of violence. *Weakness, Disaster, Old Age and Other Misfortunes* (1992) included crockery that had been shot to pieces by five different guns. We are confronted with an untold story, full of hints of crime and violence, but the aggression of this type of work is partially confounded by the fact that the pieces are laid out as if for examination — they seem to belong more properly to a display of fragments unearthed during an archaeological dig than scattered in the aftermath of brute force.

Borland's interest in burial and identity have led her to make reference to the disciplines of archaeology and forensics as parallel activities to sculpture in which past histories are discovered and reconstructed. The complex installation, *From Life* (1994), involved working with a laboratory that specialises in reconstructive modelling. Its staff had the skills to work from a real human skull (and other parts of the same skeleton) to offer a portrait head which approximated the unknown subject. The description they proposed read, 'Female/Asian 25 Years Old/5ft 2in Tall/At least one advanced pregnancy'. Through the conventional scientific practices used by her collaborators, the artist makes a comment on the fragility of identity — it is difficult to retrace accurately the outer look of the living, let alone the detailed personal history that makes up a life. In a collaboration requiring great tact, she also raises the highly contentious moral issue of ownership and trade in human skeletons. As a concern, it parallels the problems of gun circulation, which feature in related work.

Borland is pursuing a way of making three-dimensional installations and sculpture that is painstaking in the degree of engagement with non-artists it encourages. It also allows the artist to contribute to an extensive history which already exists in art, one concerned with the grand themes of death, power and selfhood.

OPPOSITE: Weakness, Disaster, Old Age and Other Misfortunes (detail), 1992
Five groups of white crockery shot with different guns (detail shows '9 mm Uzi sub-machine gun'). Installation at Irish Museum of Modern Art, Dublin. Artwork since destroyed

Boyle Family

On the surface of it, the sculpture of the collective group, Boyle Family, appears supremely objective and fastidious. Yet from its origins in the 1960s, Boyle Family has shown passionate feelings towards the thought-provoking objects it makes.

Boyle Family is a thoroughly integrated group consisting of Mark Boyle, Joan Hills and their two children, Sebastian and Georgia. The mid-1960s saw Boyle and Hills as active participants in the interdisciplinary scene emerging in the United Kingdom, with their performances, earth sculptures and theatrical events. Increasingly, Boyle Family has come to occupy a unique position in contemporary art. The conscious distance they have established from any art movement might be explained by Hills's perceptive comment: 'The thing about movements is that they move — backwards.'

Boyle Family's philosophy explores the extremities of how artists might be objective recorders of the outer surface of the world, in all its variety and detail. They bury as many of the subjective selection processes, the biases and preconceptions we each hold concerning the nature of what surrounds us. It is a belief about the notion of 'realism' which John Ruskin elegantly expressed a century earlier: 'The more a painter accepts nature as he finds it, the more unexpected beauty he discovers in what he at first despises; but once let him arrogate the right of rejection, and he will gradually contract his circle of enjoyment, until what he supposed to be a nobleness of selection ends in narrowness of perception.' Boyle Family sets itself the task of how to choose a subject of art, not *what* to choose.

For decades, Boyle Family has worked on one of the most ambitious and moving artistic projects perhaps ever attempted, for which there seems to be no obvious end. This work, *Journey to the Surface of the Earth*, began in 1967 by randomly selecting one thousand sites on the face of the globe (these sites were determined by blindfolded strangers throwing darts onto a huge world map). Visits are then made to the place where the darts

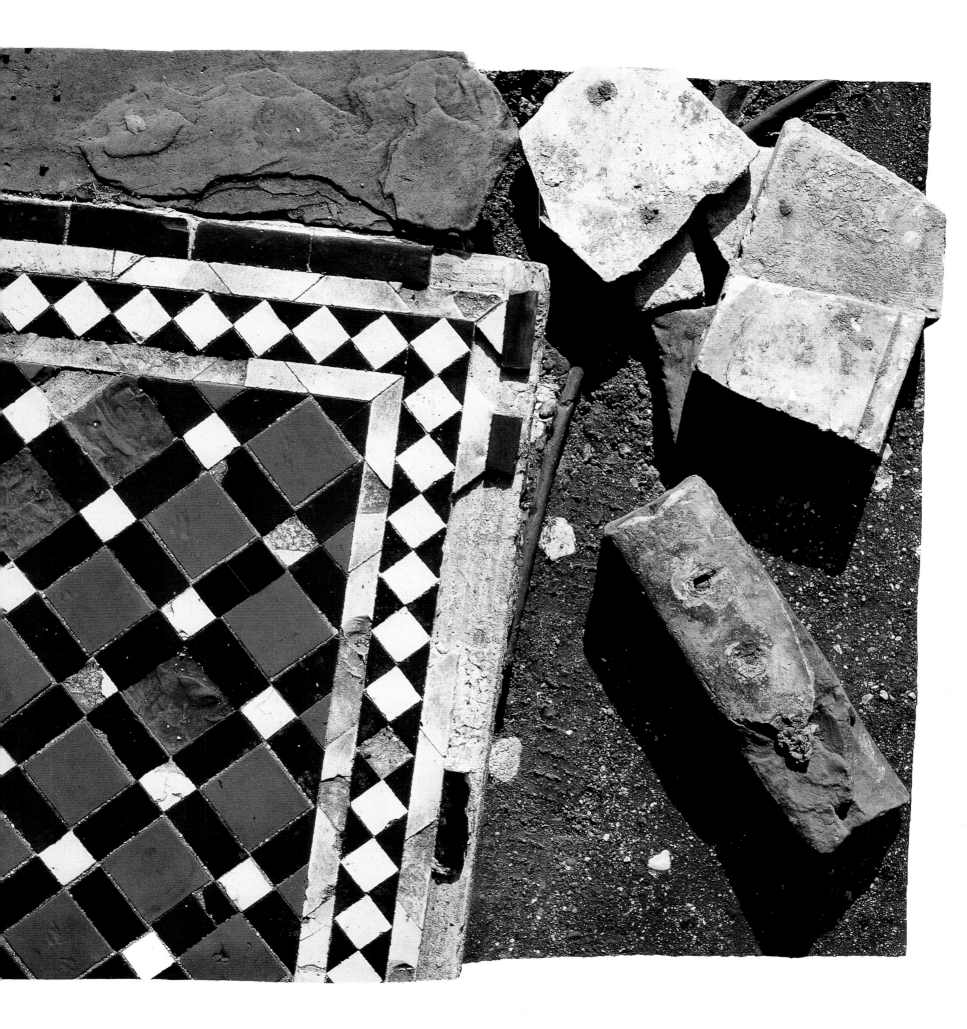

Boyle Family

OPPOSITE: Study from the
'White Cliff' series, 1988
Painted fibreglass,
335 x 183 cm

landed (precise locations are determined by throwing darts into larger scale maps). When on site, a right-angled piece of metal is thrown spinning to establish one corner of the area to be studied. These precise methods deliberately parallel those used in objective scientific research, such as geological field work.

The members of Boyle Family dig, collect specimens, take surface casts for reference, make record on film and in photographs, as well as note weather conditions, animate life found and evidence of human activity. These processes are close to those used in a carefully controlled archaeological dig, differing only in that they record the precise present rather than the past. The finished works, facsimile copies of the site, are rendered in painted fibreglass.

The family travelled more widely as their success grew internationally, and they have become increasingly innovative in finding technical solutions that allow them to depict difficult surfaces, such as dried mud, snow or shale rock faces. By 1997, and after intense activity, they had completed a mere 52 of the original thousand sites identified.

The fabrication of the relief sculpture seeks supreme accuracy in copying the details of the demarcated area, using resin, paint and often a degree of improvisation. The details of how surfaces are reproduced remain something of a family secret; technical considerations are not allowed to deflect from the philosophical and conceptual intentions behind their work. To underline the scientific aspirations, the sections were always reproduced to scale on six-foot squares, although by the mid-1980s works were occasionally made of either twice the height or length, and now the format is more varied.

In 1966, in a statement on what were to become the central artistic tenets of Boyle Family, Mark Boyle wrote: 'I have tried to cut out of my work any hint of originality, style, superimposed design, wit, elegance or significance. If any of these are to be discovered in the show then the credit belongs to the onlooker.' Certainly, we are free to interpret the relief surfaces as evocative of patterns of human change and fluctuation on the surface of the planet. In the very act of looking, natural subjects, such as tidal sand and eroding rock faces, alert us to the factor of time and the enduring presence of embedded objects. Boyle Family is seeking to do what many people might view as impossible: to record a world before art, and before prejudice.

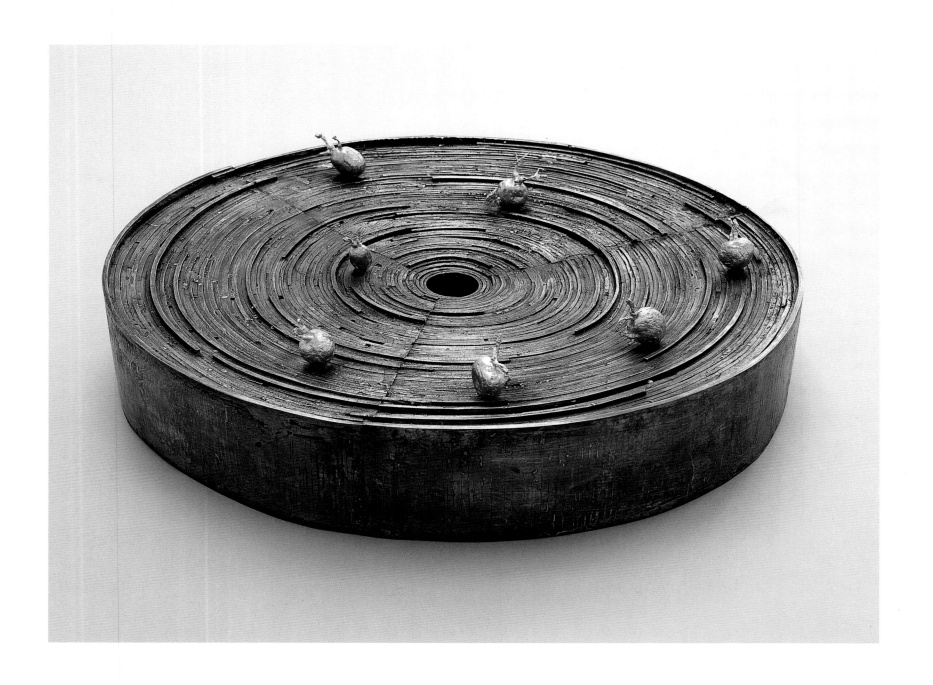

William Brotherston

William Brotherston is somewhat unusual among sculptors working in Scotland, in that he had a university education in history and fine art. While not being a theorist through his art practice in any academic sense, this training may help to explain his high degree of rigour and focus in sculpture. He distances himself from the reductive organising principles behind minimalist sculpture, a style which his work certainly suggests, and he can be better understood in his debt to modernist sculptors such as Constantin Brancusi and David Smith, for whom the mixture of craft traditions, poetry and sophistication were driving forces. Brotherston inflects his interest in mainstream western sculptural concerns with a more personal experience of Scotland and, while he has lived in and around Edinburgh, much of his work is a response to the interrelations between simple rural technology and the natural world.

OPPOSITE: Coil, 1994
Aluminium, 19 x 90 x 90 cm.
Collection of the artist.
Photograph: AIC Photographic Services

BELOW: Crown, 1984
Bronze, 36 x 66 cm.
Collection of the artist

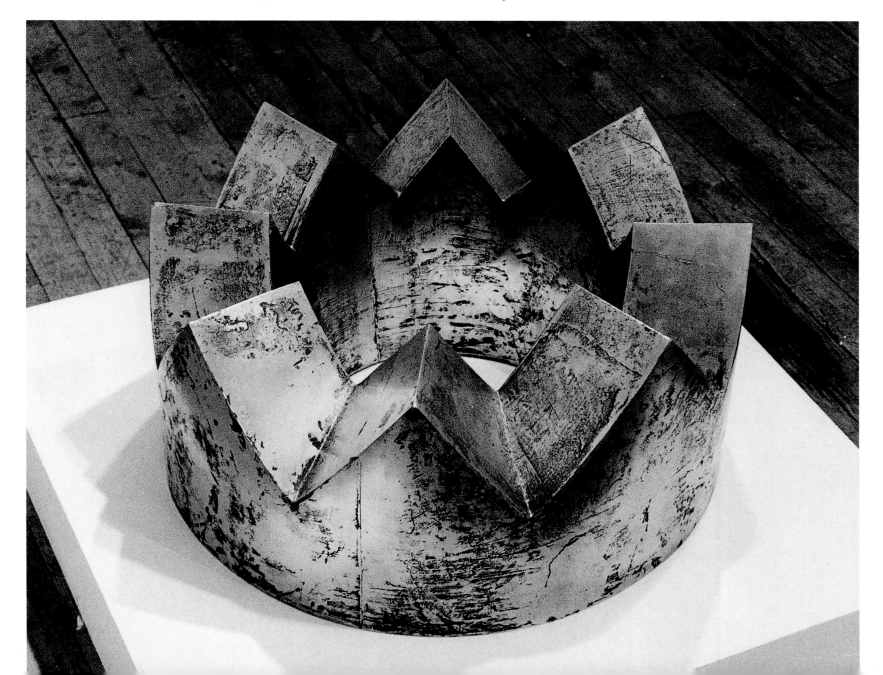

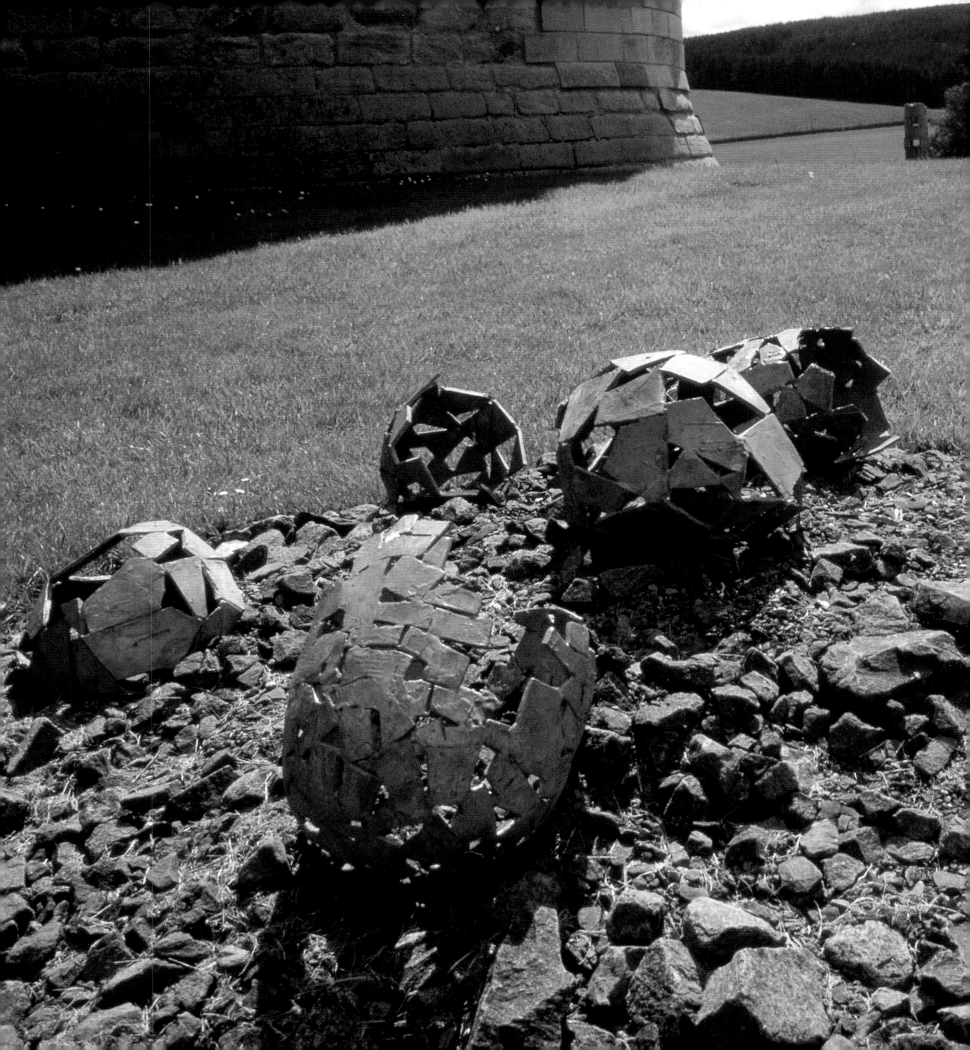

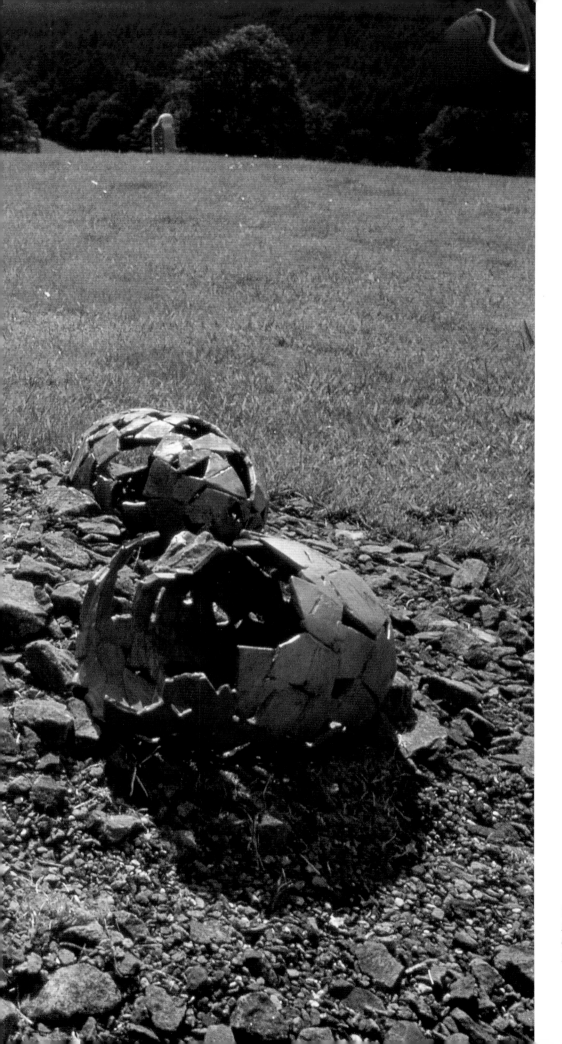

Five or Seven (?) Eggs from Ernhot, 1995
Bronze, ensemble approx. 180 cm diameter.
Collection of the artist.
Photograph: Gordon Reid

The technique he uses most often is casting geometric forms directly from wax to bronze, which he began in the mid-1970s. All his subsequent work involves processes of distillation from the forms of many objects found in the world, particularly those in landscape, plant life, body shapes, buildings, agricultural tools and geometric or mathematical models. He selects mainly from generalised, non-specific sorts of three-dimensional shapes which are then transformed in bronze in order to evoke as much character and personality as possible. The artist believes that the fewer direct references to the natural world he makes will allow for greater potential associations in the mind of the viewer.

The joining of geometrical structures such as cubes and triangles with more organic shapes found in the landscape often proposes a 'scene', such as a modest dwelling sited on a hillside, a clay vessel resting on the ground, or detritus floating above the waterline. Following from his interest in the relationship between the rural and human, he often suggests places where the humanly fashioned and the natural co-exist.

Compared with many contemporary sculptors, Brotherston usually works on a small scale and so monumental presence is implied rather than explicitly represented. He has found inspiration in medieval reliquaries, which has resulted in his own work sharing qualities of stillness and reverence with religious objects. Similarly, the artist responds to the ability to contain and distill universal forces which devotees perceive within holy icons. Reliquaries also purport to contain, rather than merely represent, a part of a holy subject, and for Brotherston this '… seemed to provide an analogy for what I thought a sculpture should be: that it contained within itself all its significance and this had been put there by the artist … a sculpture had a connection with the world of actuality, but was complete and independent of it.'

To create understated and allusive works independent of their inspiration, Brotherston asserts symmetry, repetition and variation in his work, whether derived from natural features (such as rings in a tree section) or geometrical models (such as cones, cubes and pyramids). Beneath this organising, however, the origins of the shapes he chooses are not so abstracted as to stop one sensing familiar forms (such as mountain ranges, rosebush thorns, the teeth of a saw, clock mechanisms).

Brotherston pays a great deal of attention to the surface of each work. Cast metal, in particular bronze, exposes many of the accidents which occur in its making. Early works in particular had surfaces burnished and polished so that the muted shine and reflections underlined the object's changing relationship with the space around it. More recently, the finish has been left deliberately in a rawer state, but nevertheless the varied detailing which is drawn out as the viewer walks around the work encourages one to be engrossed in the unfixed combinations of surface and form.

As a consequence, the works from the mid-1980s have increasingly emphasised or at least implied their own hollowness. The surfaces are to be read as the outer limit of a centrifugal force pushing outwards, and the resulting sculptures relate — both in their making and in their inspiration — to eggs, or to vessels thrown on a potter's wheel. In his most recent work, and for the first time in his oeuvre, the artist has started to place single objects in formal groupings, a development where once self-contained sculptural forms now interrelate.

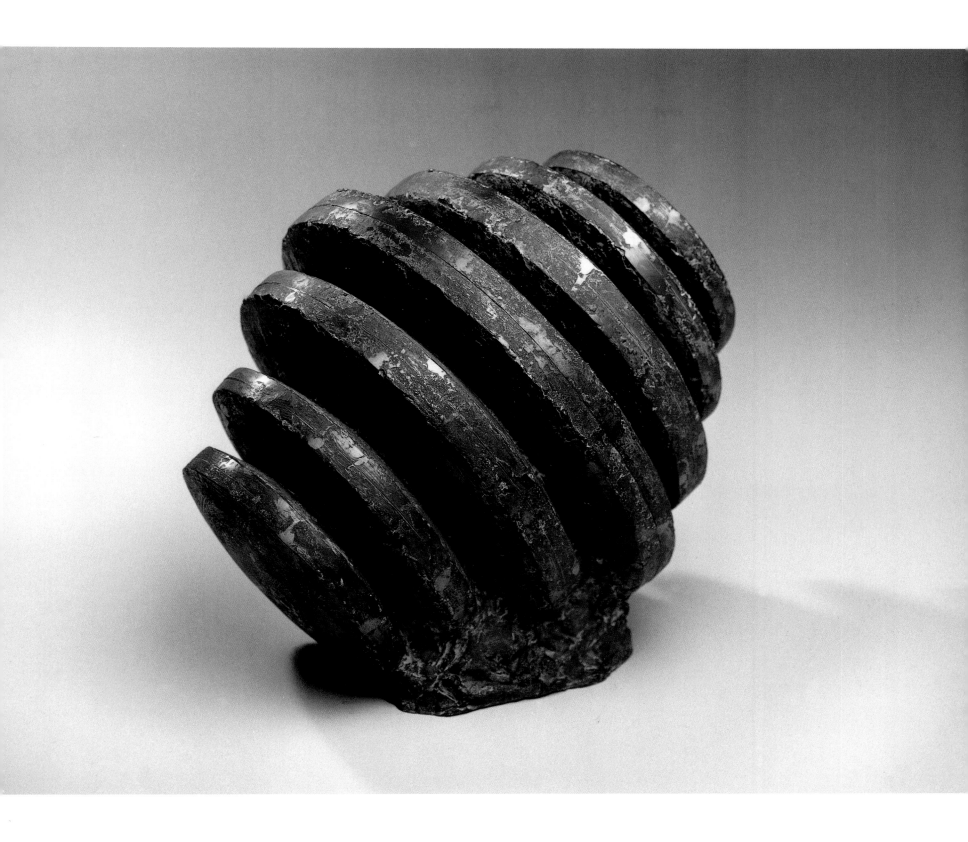

Reel, 1990
Bronze, 44 x 47 x 42 cm.
Collection of the artist.
Photograph: AIC Photographic Services

Jim Buckley

OPPOSITE: Connexion Mauve, 1996
*21 telephone kiosks, lights, coloured
filters. Installation at Lille, France*

BELOW: Ustka, 1994
Video still

Contemporary sculpture has been opened up, turned inside out and made to appear less monumental and visually static than that of earlier centuries. Twentieth-century sculpture invites the inquisitive eye in, asks the viewer to move around the sculpture to experience its changes and transformations in shape. For some, this is primarily an opportunity for formal invention — playing between positive and negative space. Yet, for recent practitioners, including Jim Buckley, enclosed and revealed spaces have political and psychological overtones which can help them to reveal in their work how our world is determined by the structures we build. Sculpture of this kind has become one way of showing the links between architecture and mental states.

Jim Buckley, born in 1957 in Cork, is by birth and training an Irish artist, although he has been based in Scotland for almost all his working life. Throughout the 1980s, his sculpture was indebted to the abstract inventiveness of such seminal artists as David Smith from the United States. However, in the course of using techniques of heavy engineering, Buckley's monumental constructivist pieces became steadily less formal, smaller and more fortress-like, such as *Barbican* (1990). They point towards areas of concern which have occupied him since.

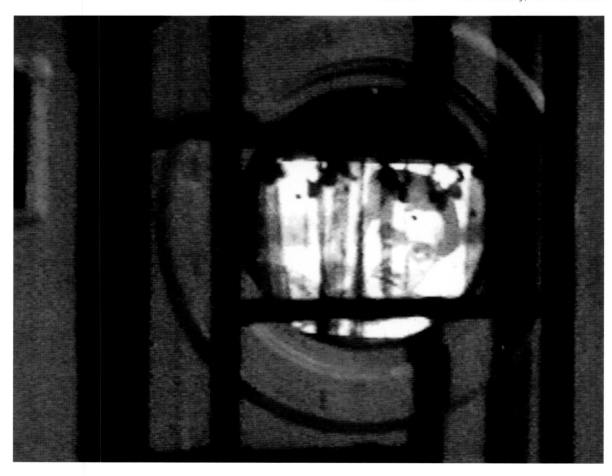

His 1991 exhibition, 'Illuminations', marked a watershed. He presented a series of small metal boxes, each with a fish-eye aperture through which the viewer peered after switching on an internal light. Inside each box, the viewer was confronted with a blocked-off, empty stage set and a corridor which dramatically appeared to stretch far into the distance. The effect produced a slightly different psychological mood from box to box. Each piece represented a familiar built structure; their identities were indicated by such titles as *Refuge*, *Ark* and *Asylum*.

Fashioned on the outside as defensive, armour-plated buildings, with aggressive

34

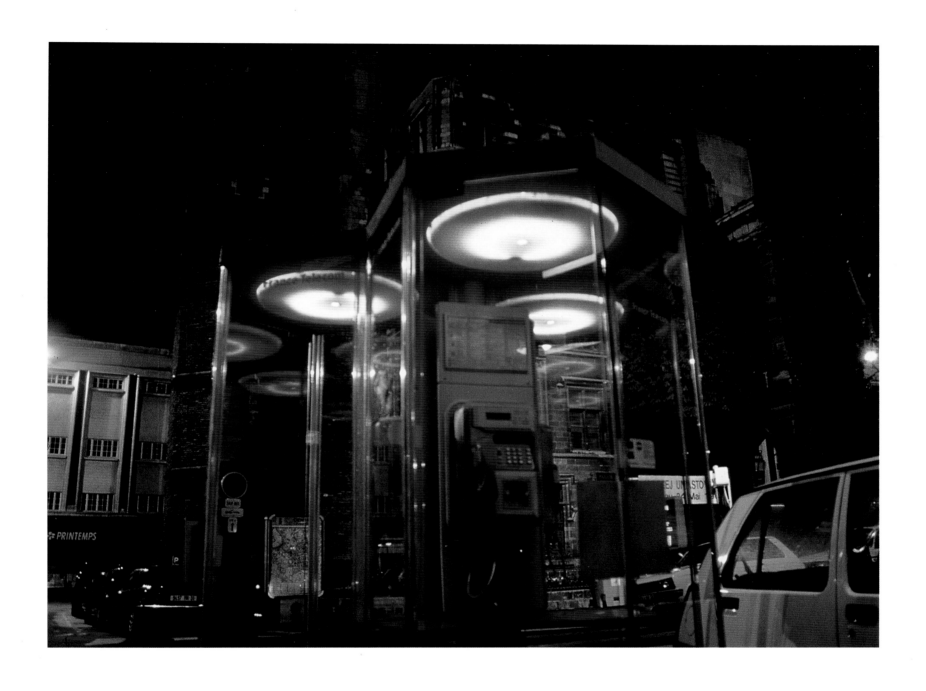

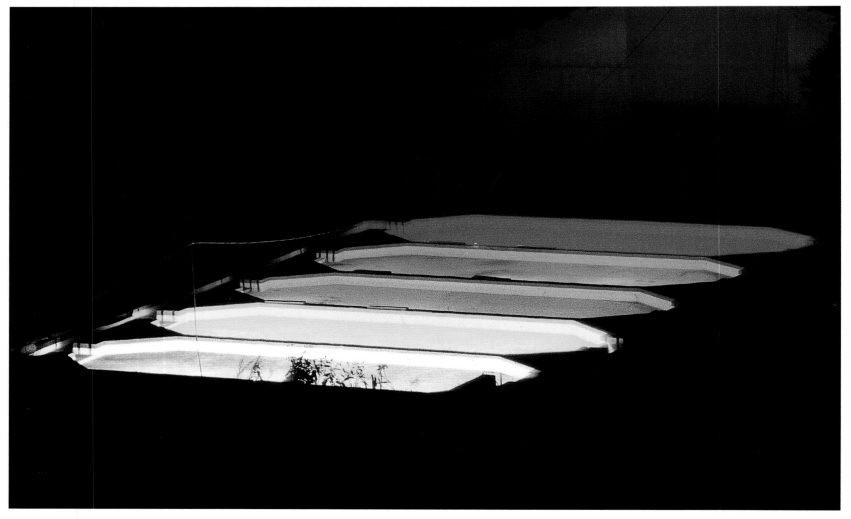

Flood, 1993
Concrete tanks, water, paint, lights,
each tank 250 x 700 x 100 cm.
Installation at Meiho, Japan

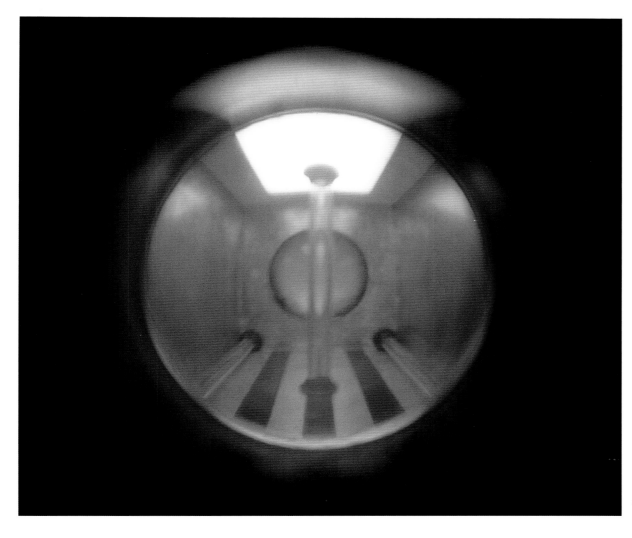

Interim (interior detail), 1994
Stainless steel, brass, glass,
plywood, paper, perspex,
22 x 22 x 33 cm

metal protrusions signalling their demand for privacy, these constructions warn off the temptation to approach. Yet the little eyehole provokes instinctive curiosity. The architectural types, carefully selected by the artist, are based on heavily regulated territories (such as hospitals, law courts, factories, cloisters, banks, catacombs, prisons) and are built up around ideas or objects (such as money, prisoners, disease, treasure). They contain things which are deemed worthy of protection or incarceration. One might go on to observe the sculptures' link to the Scottish landscape, populated as it is by numerous castellated keeps, dungeons and fortified historic buildings into which visitors peer as they try to reconstruct a sense of Scotland's dramatic past.

The artist's deep-seated interest in the connections between power, surveillance and architecture continues in related work, such as the installation, *J. H. von Wessenberg Gedachtniszimmer* (1991), where he sealed off sections of a former bishop's living quarters. The only view of the interior was through a distorted lenses. Such a technique — an ambitious development from his small boxes — introduces a theme of voyeurism by clearly paying homage to Marcel Duchamp's infamous last work, *Given* (1944–46), in which the spectator looks through two peepholes in the door

to see a bizarre tableau of a naked woman lying in a landscape.

Like many artists of his generation, Buckley has experimented with techniques little related to traditional sculpture, including light installation and video. The most ambitious of these is *Flood* (1993), in which the artist, working at the site of an abandoned fish farm, painted the interiors of five fish tanks white and then lit each one in turn white, yellow, blue, green or red. Filled with water, and viewed from Meiho's secluded and mountainous surroundings, the tanks echoed the shapes of fishes, and offered a comment, in the artist's words, on 'local people's concern about the degradation of their environment'. Buckley has shown himself able to deal with one of the great challenges of large-scale publicly sited installations, made even more difficult by being in an unfamiliar culture. The work, like much of his sculpture, set up a highly sympathetic and sophisticated interaction between the fabricated and natural worlds, which was discrete, subtle and, most importantly, temporary.

Recently, he has extended his interest in light, digital media and ambitious installation with such works as *Connexion Mauve* (1996), in which ordinary telephone kiosks were transformed into strongly lit markers that extended across the townscape of Lille in France.

Robert Callender

There have been numerous artists in the history of British art who have been drawn at some time to coastal subjects. As an island culture, there is much in the economic, military and cultural history of the United Kingdom that has led back in fundamental ways to the impact of the sea. This fact has been as much a point of departure for English artists, from Turner onwards, as it has for Scottish artists, such as William McTaggart and John Bellany. Although Robert Callender was born in England, Scotland has been his home since 1950, and he has found in its westerly coastline an inspiration which extends beyond the national landscape.

Callender began his career as a painter of monochromatic, stony beach scenes. These were executed with a high degree of finish and stylistic neutrality and owed a debt to the photorealist school of painting. This certainly represented an artistic reaction to the highly coloured post-fauvism which dominated much traditional Scottish landscape art until recently. Despite a change of medium in the 1980s, from painting to sculpture, Callender continued to develop his interest in the sea, prompted by the discovery of fascinating objects along the beaches of Scotland's west coast.

As the son of an engineer and boatbuilder on the river Thames, the artist has never lived far from either river or sea and he has drawn heavily on this quintessentially romantic subject. Before making his sculpture, the artist

OPPOSITE: Reconstruction, 1994
Recycled wood, 127 x 550 x 168 cm.
Photograph: Robert Callender

BELOW: Boiler, 1987
Cardboard, paper, paint,
244 cm diameter.
Photograph: Antonia Reeve

Coastal Collection, 1996–97
Cardboard, paper, marble dust,
paint, wood ash, 600 x 600 cm.
Studio installation, Fife.
Photograph: Robert Callender

beachcombs — a process Callender describes as both analytical, in that one has to concentrate closely on the ground at one's feet, and cleansing, in that it removes one's thoughts from city life. Since 1970, Callender has spent every summer in a modest stone cottage (termed a 'bothy' in Scotland) in West Sutherland, gathering material for inspiration. The dramatic northerly coastline provides not only driftwood used for cooking, heating and furniture-making, it offers a powerful focus for an imagined narrative based on the lives of those who first made boats and went out to sea to fish or travel. The particularly evocative Point of Stoer, where the bothy is located, is very rocky, a dangerous area for seafarers.

Callender's subjects are pieces of driftwood and the various fragments which come away from wrecked boats (metal plates, ropes and fixings). At first sight, his sculptures look like 'found objects', and might almost be interpreted as deriving from Marcel Duchamp's provocative relocation of various functional artefacts into the world of art. In fact, they are incredibly plausible-looking, three-dimensional facsimiles made from paper pulp, cardboard and balsa wood, then sealed in bitumen, pigmented and given a texture using peat, sawdust, paint and wood ash. Callender has developed craft skills to such a degree that he produces near-perfect copies, indistinguishable in their outer structure and surface from the originals. Hyper-realistic fabrications of sea debris, such as Callender's, have an engrossing power, but they avoid becoming mystically romantic, despite the subject, because of their obsessive resemblance to the originals. There is no intention of becoming nostalgic or misty-eyed about the past.

Increasingly, Callender's central theme has been the idea of recovery and archaeology — *Excavation*, a 1989 work, is a triptych relief sculpture based on the hull of a boat whose exposed ribs evoke the idea of a fossilised whale beached on prehistoric sand. In this way, washed-up bones become a metaphor for recovered memories. This direction in Callender's sculpture (which employs paper pulp in its making) is one that offers a clear message about recycling — echoed, of course, in the beachcombing which precedes the making of the works. Trees, which covered huge areas of ancient Scotland, are becoming an increasingly scarce resource, yet their wood has been relied on over the centuries by the now diminished boatbuilding industry. Callender is aware of the poetic paradox involved: in its reuse of materials and its interest in recycling, his sculpture simulates once functional but now destroyed wooden objects.

Callender makes an art of construction in the face of destruction. He mirrors the skills of the original boatbuilders, pays homage to an industry in crisis, yet manages throughout to remain firmly unsentimental.

OPPOSITE:
Beach Find, 1989
Cardboard, paper, paint, 176 x 82 cm
Beach Package, 1989
Cardboard, paper, paint, 155 x 74 cm.
Photograph: Antonia Reeve

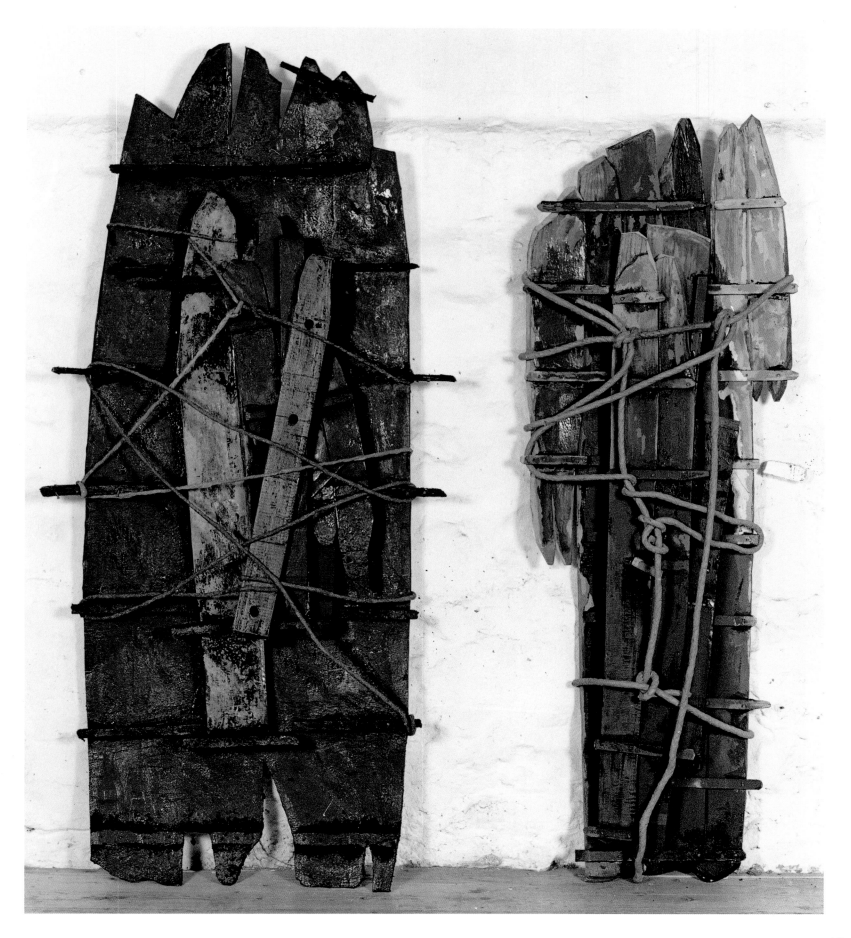

Doug Cocker

Doug Cocker is one of the few genuinely full-time sculptors working in Scotland. In 1990, he made the decision to leave his teaching job in Aberdeen, a brave, some might say foolhardy, decision for a Scottish sculptor to make, especially in the inhospitable economic climate of the 1990s. However, Cocker's choice was not made on impulse, it was made by an artist who, then in his mid-career, had built up a reputation based on impressive exhibitions, major commissions and, as evidenced by an outstanding body of work, a distinctive style.

In the best of Cocker's sculpture, there is strong intent and ability to stimulate a socio-political awareness in the spectator. He has written, 'As receivers of global bad news on a bewildering scale, we are forced to respond or hide. Engagement with the implications of this information has been an integral part of my work since the early 1980s.' As with his peers Tony Cragg and Bill Woodrow, Cocker's work is political in the broadest sense of the word. Such sculpture is not escapist, esoteric or purely aesthetic; it aims to draw attention to the underlying contradictions in late twentieth-century capitalist society. For example, in one of his most provocative works, *Beneath the Screaming Eagle* (1985), the ultimate symbol of material status and security (the house) is encircled from above by an encroaching barrier that throws a protective but ominous shadow on all below. Here, Cocker echoes the dire warning of such social commentators as Noam Chomsky that we put our trust in false gods to protect us from our worst nightmares only to find that they compound our sense of insecurity and heighten our fearful state, further imprisoning us.

RIGHT: Persian Whispers, 1989
Wood, bark, lead, 244 x 91.5 x 76 cm.
Private collection, Australia.
Photograph: Mike Davidson

PAGES 46–47: 2 Tribes/40 Shades, 1994
Wood, 150 x 335 x 12.7 cm.
Collection of the artist.
Photograph: Mike Davidson

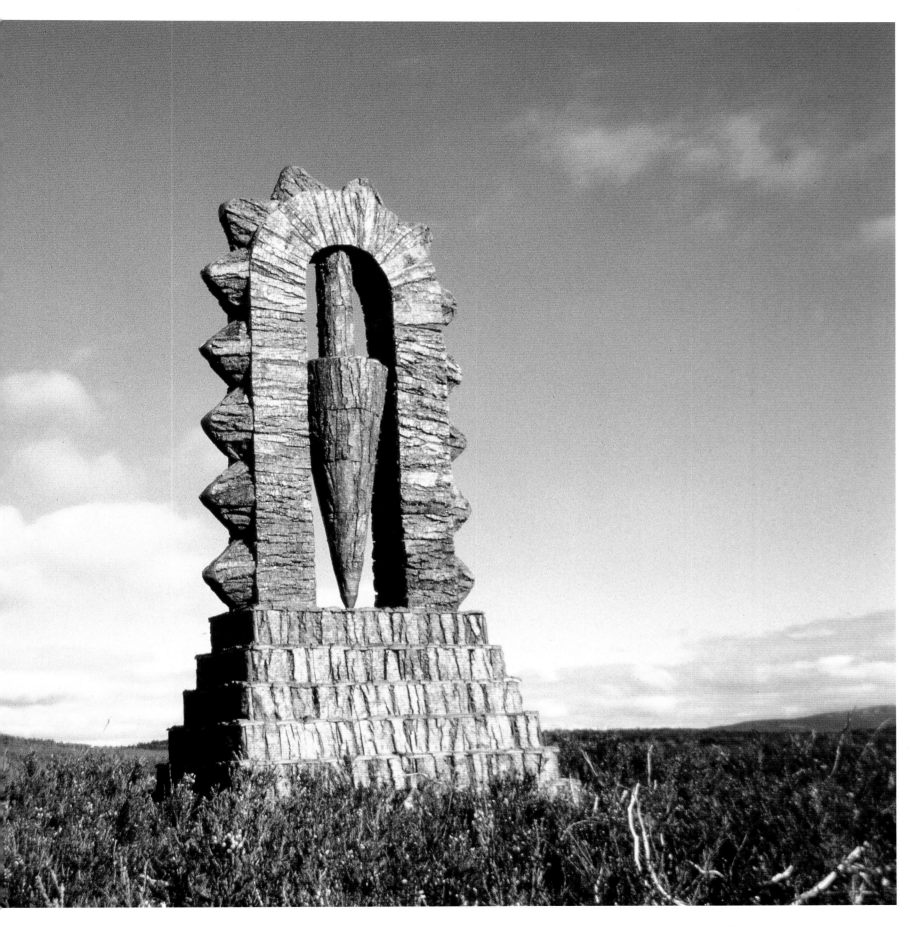

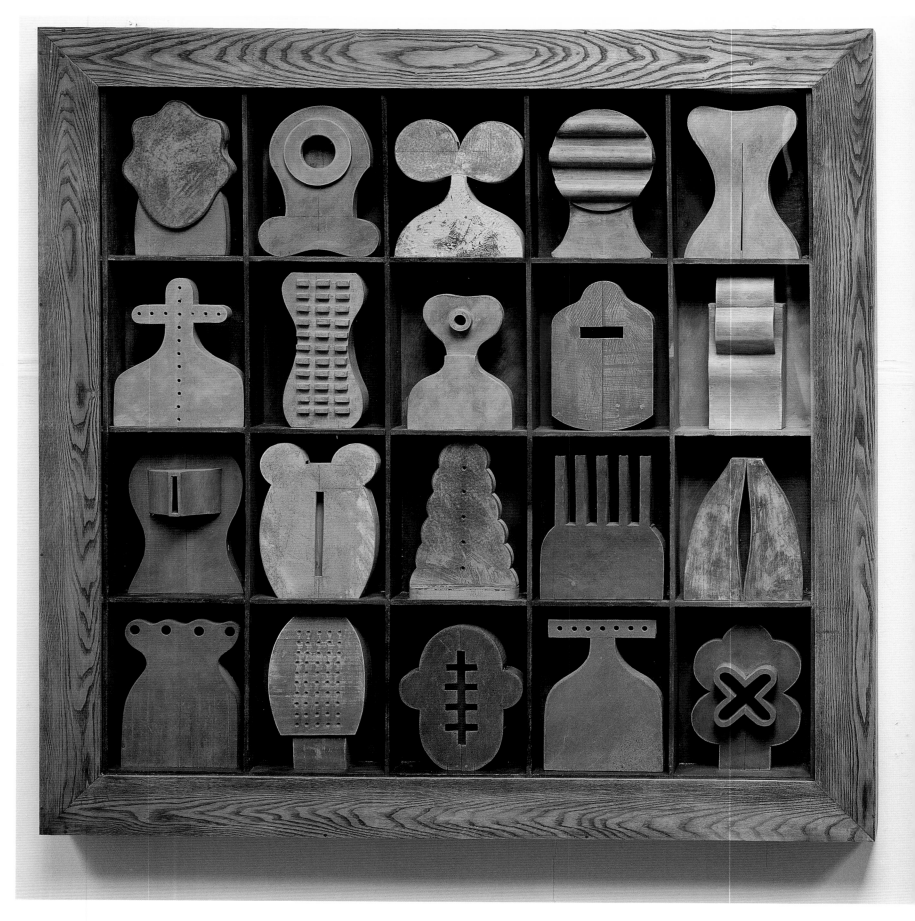

46

Doug Cocker

Many of Cocker's sculptures seem to allude to modern society's ongoing struggle with the aspirations of individual creative freedom and the deadening effect of institutionalised power and corporate consumer materialism. This takes on a particular personal significance in *Eyeless in Gaza* (1985). The allusion here is to the artist who is enthralled and threatened by the blind philistinism still found at all levels of public life, which places the pursuit of things material above those cultural. Within the practice of sculpture, especially working for public or corporate commissions, the artist's room for personal creative expression almost inevitably closes down. Thus, the long process of translating the initial spark of inventive imagination to the finished product can turn out to be a disheartening one. What can become lost in the long bureaucratic and fabrication processes is the original authenticity which, for the artist, is to be found in the outpouring of ideas in his first sketches. Drawing, for Cocker, is very close to the surrealist practice of automatism, where the artist allows forms and images to body forth with little or no rational restraint or control. These spontaneous outpourings are the testing ground, where the sculptor rejects or further develops ideas for possible three-dimensional work. Wherever appropriate, this openness of approach is continued through to the finished piece and its enigmatic title (for example, *Calvin's Tools* (1995) or *Diaspora* (1995)).

Cocker's sculpture demands attention, stimulates thoughts and discussions, and then renews the enquiry. Much of the power of his work lies in an inner tension between formal and philosophical debate. Such dialectical tension of oppositional forces — between nature and culture, private and public, spontaneity and manufacture, freedom and conformity, expression and silence — are actively present in the body politics of Doug Cocker's sculpture.

OPPOSITE: Oldbury Ring, 1993
Stainless steel, 427 cm high.
Collection of Black Country
Development Corporation,
Birmingham.
Photograph: Doug Cocker

BELOW: Flock, 1992
Sycamore, lead, 396 cm high.
University of Essex, Colchester.
Photograph: David Bartram

Martin Creed

The sculpture of Martin Creed draws its strength from at least two kinds of 'givens' which precede his own activities. Firstly, there is the contemporary gallery environment itself, and most particularly the exhibited work of other artists. Secondly are the western world's invented systems of numeracy and of music. Creed does all he can to reduce expressive intention in his work and ensure that his use of both the gallery situation and systematic models are treated with rigour and austerity.

It is still relatively early in Creed's career and so the majority of his exhibitions to date have involved other artists. In this context, he often makes objects which subtly and wittily undercut the authority of the white cube exhibition space — still the conventional way that much art is shown — and, by extension, the authority of those he exhibits alongside. The approach is to start from first principles and determine the precise type of activity he must undertake to create an art object. This fundamental aim was expressed in a text accompanying a work made in 1992: '… the problem was to attempt to establish, amongst other things, what material something could be, what shape something could be, what size something could be, how something could be constructed, how something could be situated, how something could be attached, how something could be positioned, how something could be displayed, how something could be portable, how something could be packaged, how something could be stored, how something could be certified, how something could be presented, how something could be for sale, what price something could be, and how many of something there could be, or should be, if any, if at all.'

Fittingly, the sculpture in question, titled *Work No. 74*, was stringent to an absurd degree in its construction — numerous one-inch pieces of masking tape stuck on top of each other to make a tiny solid cube. To reinforce the humour and the discreteness of his chosen method, Creed's objects work best when inserted into the conventional gallery space, such as *a protrusion from a wall (Work No. 102)* (1994), a smooth, hillock-shaped form which rises immaculately from the white gallery wall. It mocks high modernist aesthetics yet, paradoxically, it is also an appealing, if modest object in its own right. The unassuming *a sheet of A4 paper crumpled into a ball (Work No. 88)* (1995) also relies on paradox, simultaneously mimicking the act of destruction yet holding the resulting ball of paper up as an artwork and therefore worth preserving.

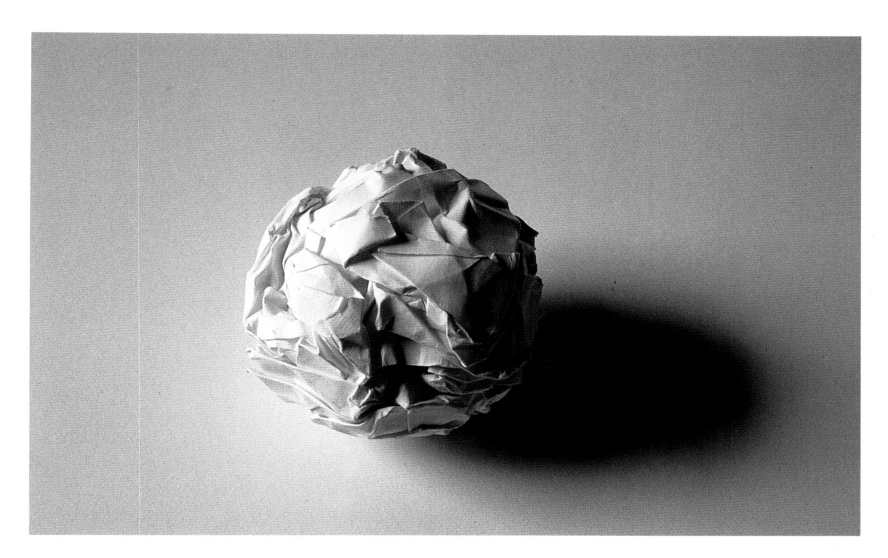

ABOVE: a sheet of A4 paper crumpled
into a ball (Work No. 88), 1995
Paper, approx. 5 cm diameter,
unlimited edition. Published by
Imprint '93, London

OPPOSITE: a large piece of furniture partially
obstructing a door (Work No. 169), 1996
Photograph, paper, ink, 13 x 9 cm

The artist has been noticeably influenced by the Fluxus movement of the 1960s, particularly in its anarchic disregard for institutionalised art. Many Fluxus works were in the form of instructions for performances and events, or fashioned from paper and other cheap materials. Most significantly for Creed, very often Fluxus helped to blur even further the distinction between the activities of art and those of everyday life.

Other works by the artist are disruptive in more obvious ways, particularly those which physically restrict entrance into the gallery — for example, placing furniture so that it prevents movement, or fixing doorstops inconveniently behind the doors. Creed explores both the semantic and actual relationship between 'objects' and 'obstacles'. By doing so, he illustrates how little need be done by an artist to make his or her presence felt. Yet Creed is also aware of the paradoxical difficulty of creating original work in a world that seems to absorb all new ideas with ease. He formulated his understanding of this irony in a text work of 1996 which read: 'The whole world + the work = the whole world.'

Creed sees no real distinction between his sculpture and the increasing amount of work he has done in sound. Using the discipline of tempo and of notational scales in music, he has made numerous sound sculptures, one of which involved setting a number of metronomes at varying speeds. Like many artists interested in systems, Creed explores the point at which order, if manipulated and multiplied, can easily become a kind of chaos.

He has also written and performed music as part of his three-piece band, Owada, who, as an extension of his sculpture, perform songs that are entirely systems- or sequence-based, such as one which simply ascends and descends a scale, or one whose lyrics count upwards from one to one hundred. In Creed's work, the expressive decision-making process often associated with art is replaced as far as possible by the seeking out of humankind's most simple and fundamental rules.

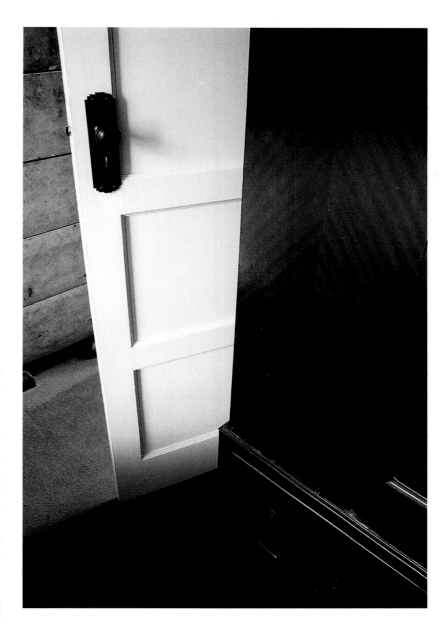

ABOVE: a door opening and closing
(Work No. 129), 1995
Automatic door operator, door, dimensions variable, edition of 2

OPPOSITE: a protrusion from a wall
(Work No. 102), 1994
Plaster, paint, 23 x 46 cm diameter, edition of 2

Dalziel + Scullion

Scotland has a landscape of extremes, with heavily populated and highly undeveloped areas existing side by side. It is also a place of economic contrasts, no better illustrated than the north-east region where, in the 1970s, massive North Sea oil finds resulted in relative wealth and multinational investment, and introduced into that exposed and elemental coastline a new phase of industrialisation. It has been the project of some artists in the West, including Dalziel + Scullion, to create sculptures and installations which register the subtle but telling contrasts that occur when technology and nature find themselves next to each other.

Collaboration between two individual artists, although now an established strategy on the international art scene, is still rare in Scotland. Matthew Dalziel and Louise Scullion have become its most highly regarded resident exponents, and their working relationship allows them to bring a range of qualities to bear on the collaborative sculptures and installation projects they undertake.

When they became partners in 1992, both artists already had promising futures. Scullion's work depended for its inspiration on processes of data-gathering and surveillance, much of which looked at the landscape with a particularly militarised slant (this was partly inspired by the changes that had taken place in recent years near the town of her birth, Helensburgh, with the building of various domestic and United States submarine bases).

Dalziel also worked with scientific and technological subjects, but he used photography and video. One large work, directed at the ecological impact of the oil industry on the landscape, followed a residency at the St Fergus plant of the Shell oil company, located in a remote area north of Aberdeen and close to where both artists now have made their permanent residence.

Since Scullion and Dalziel began working together, they have extracted subjects from this highly romantic yet deeply politicised location on the north-east coast of Scotland. They have chosen to live in an area which was once entirely dominated by the local industries of fishing and farming but now also accommodates the newer industries of state-of-the-art defence installations and oil discovery, processing and administration sites. It is not lost on them that they live in a place where issues of conservation and the distribution of economic wealth between the companies that pay for oil extraction and the local population who support the industry has remained contentious on the widest political and national scale. While finding inspiration in a remarkably beautiful landscape would hardly distinguish them from many other sculptors in Scotland or further afield, Dalziel + Scullion work in an individual way to make a sculpture rooted in landscape which nevertheless employs the technologies and materials more familiar in an industrial and post-industrial world.

In their first collaboration, *The Bathers* (1993), they created an installation of three glass cubicles in which were projected images that encapsulated the serenity and evocative power of the coastal area they were coming to know. Three looped films show a female bather, a man running down sand dunes and birds crisscrossing above the sea; each is a study that relates to individuals from the artists' village.

The artists do not deal with narrative in any obvious sense; rather, their intention is to prompt a subtle range of psychological states in the viewer. Their installations hint at diverse meanings, but most particularly these centre around the delicate and troubled interface between nature and modern life. To this end, they often seek to site sculpture somewhere between the

ABOVE: The Horn, 1997
Stainless steel, digital sound equipment, 2400 cm high, tapering from 400 x 200 cm to 100 x 100 cm wide at base. Commissioned by West Lothian Council, Scotland. Photograph: Dalziel + Scullion

OPPOSITE: Television Cloth, 1994
Silk organza, ink, metal, unlimited edition in two versions (14-inch and 21-inch television screens). Commissioned by National Touring Exhibitions, London and Centre for Contemporary Arts, Glasgow. Photograph: Dalziel + Scullion

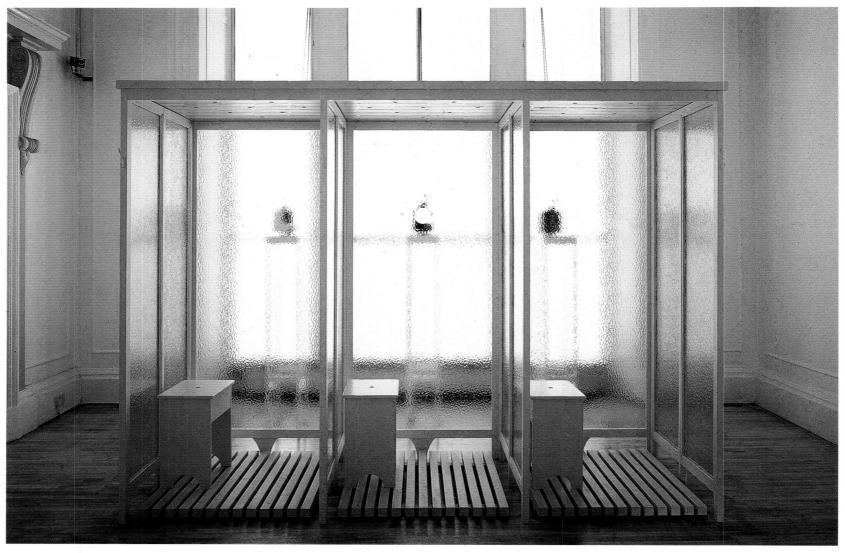

ABOVE: The Bathers, 1993
Glass, timber, Super-8 film,
200 x 300 x 100 cm.
Installation at the French Institute, Edinburgh.
Commissioned by Fotofeis.
Photograph: Kevin MacLean

OPPOSITE: Endlessly, 1996
Installation, video projection.
Sea structure 260 x 260 x 240 cm.
Angel structure 260 x 400 x 90 cm.
Commissioned by the Northern Gallery for
Contemporary Art, Sunderland.
Photograph: Antonia Reeve

landscape and the city, as with their ambitious work, *The Horn* (1997). Along Scotland's busiest motorway which connects Edinburgh and Glasgow in an east–west axis, the artists placed a tall, horn-shaped steel structure intended to broadcast various sounds, music and words to passing motorists. *The Horn* becomes a kind of latter-day oracle, speaking directly to drivers as they travel between Scotland's two major cities.

An impressive video installation, *Endlessly* (1996), consisted of two large screens framed inside cleanly modernist structures which faced each other. The images on each are familiar to the conventions of romantic art: a graveyard angel carved in stone and a sea with no horizon. The angel appears as a serene, if rather antiquated, sculpted symbol representing a Christian idea of eternity, while the sea, in all its shifting variety, is another kind of representation of the concept of infinity.

Almost all the projects and installations by Dalziel + Scullion seek to set up a space for experiencing art which, while acknowledging the surface texture and sophistication of the modern world, offers in return a quasi-religious and restrained sanctuary in which to reflect and rest from that world.

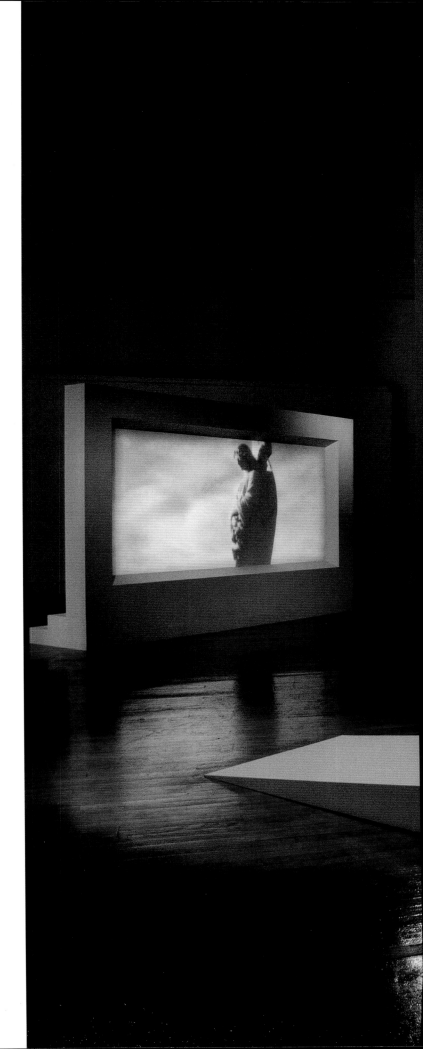

Ian Hamilton Finlay

OPPOSITE: Tree-column Base:
Michelet, 1981
Stone. The Garden, Little
Sparta, Scotland.
Photograph: Peter Davenport

BELOW: Et in Arcadia Ego
(with Annet Stirling), 1989
Portland stone, maquette for
an inscription at the mouth
of a sewer stone.
Photograph: Antonia Reeve

Ian Hamilton Finlay is one of the most critically respected contemporary Scottish artists working in Europe. In a career notable for its fearless engagement with grand conceptual themes, he has practised three interrelated activities — that of poet, gardener and neoclassical artist — each of which have been realised with rigour and sensitivity.

Setting out in the 1960s as a concrete poet, his early predilection for compounding many layers of textual and visual allusions stayed with him when he began to concentrate more on visual art practice. As early as 1964, he was composing poems designed to be set in environments, a way of working that he was able to carry through two years later when he moved to Stonypath, the site of his current home and garden. While Finlay uses words in his work as abstractions or signs, they are also real physical objects which assert themselves in space; hence, many of his relief sculptures are in the form of poetic inscriptions carved in stone (executed by one of his many craftworker collaborators).

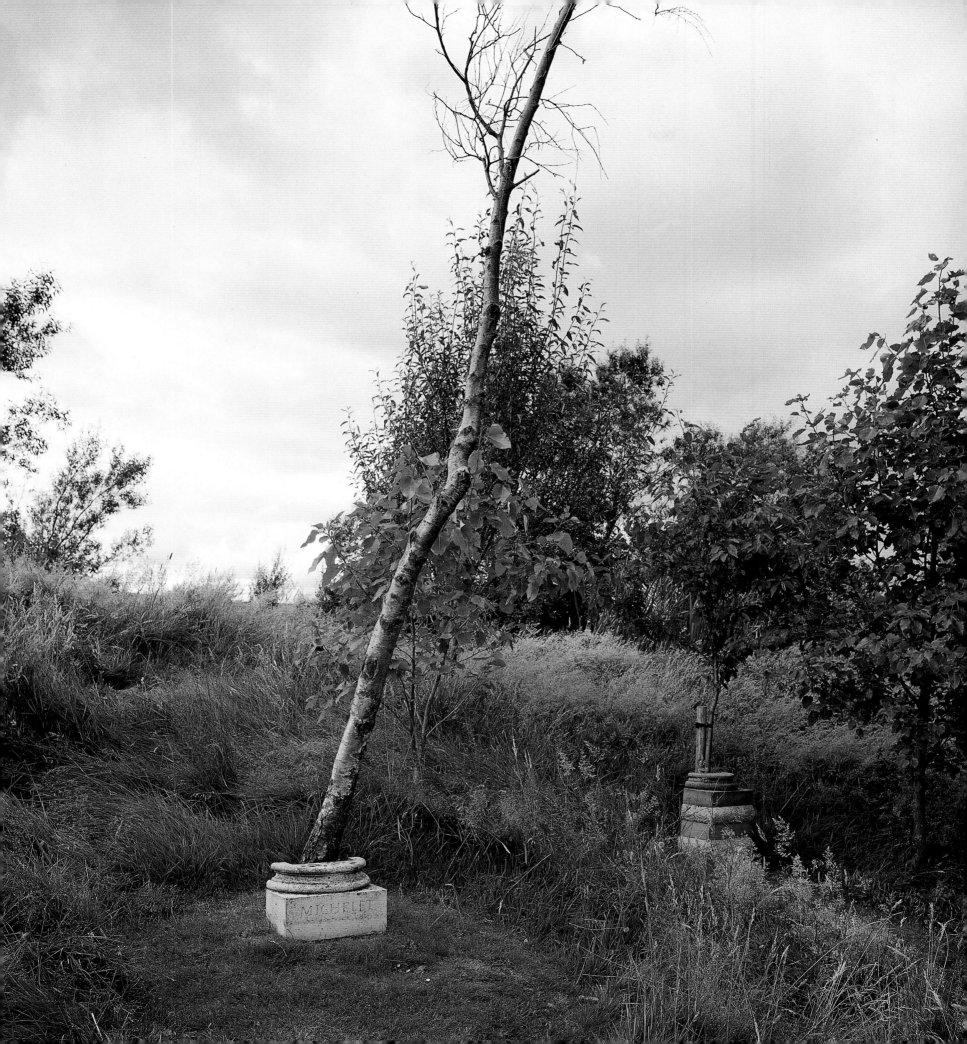

60

Some of these sculptures are placed around the garden of his home in what came to be called Little Sparta, a unique creation set in rural Lanarkshire, lying some way between Glasgow and Edinburgh. Over the thirty years the artist has been there, he has designed a classical garden in the great European tradition, where many pathways, vistas and enclosures articulate his interest in the relationship between nature and culture. Finlay creates visual tableaux by drawing on themes from classical literature and philosophy — high points in western culture that were themselves later commandeered by cultural figures of the French Revolution, such as Rousseau, St Just and the great history painter, David. In one of Finlay's typically pointed interventions, he placed classically carved columns at the base of planted trees, thereby alluding to the way high architecture of 'enlightened' society seeks authority through abstractions from the natural world. The column, as the echo of a tree trunk, signals the aspiration of those who designed it to be both 'cultured' and 'natural'.

There is often a simplicity and succinctness in Finlay's art, despite the dense layers of reference. In 1991, the artist bemoaned the art press who failed to appreciate this, when he wrote: 'Why doesn't anyone write about the CLARITY in my work, and its LYRICISM, and its (frequent) LOVE of the ordinary.' Indeed, Finlay leads a very simple, even stoic life and has not left his Little Sparta home in thirty years. This has given each of his numerous public, private and site-specific works a singular sense of place wherever they have been exhibited around the world, and an intellectual and emotional resonance which emanates directly from the garden's existence in Scotland.

Finlay's interests in interrelating themes of militarism, terror, nature and pastoralism might be traced back to his Second World War experiences as a serviceman in Germany. There he saw at first hand the social and architectural monoliths created by national socialism. In contrast, this period was immediately followed by a time spent working in one of the most pastoral environments possible, as a shepherd in the Orkney Islands, off the north coast of Scotland. In these two extreme periods in the artist's life we have, in miniature, a means to understand much of his subsequent art.

Whatever the impetus, his use of some of the more indigestible symbols of the French Revolution and of twentieth-century totalitarianism have led him into direct confrontation with liberal-minded critics and national commissioners at home and abroad, for whom his work challenges too directly their own — what the artist would term complacent — beliefs. This has been paralleled by a long-running tax dispute with his local regional authority (he insists that the garden at Little Sparta should be designated a religious site, not a secular one). Finlay has made much of these legislative battles in his art — for him, they are an aspect of his morally motivated activity, not a diversion from it.

Despite radical changes in fashion in the international art market since he started working in sculpture, Finlay has secured a place of distinction which continues to mark him out from virtually all his artist counterparts.

opposite: Woodwind Song
Slate. The Garden, Little Sparta, Scotland

61

Gareth Fisher

Gareth Fisher's sculpture aims to register the impact of the city and modern life as the all-encompassing influence on the contemporary world. Such an ambitious theme has been tackled by numerous artists this century, yet Fisher has made a significant and intensely personal contribution to the subject.

The artist's early work of the 1970s was architectural in feel, adopting diagrammatic and systems-based imagery. Despite its apparent clinical approach, it anticipated his later concerns by proposing that three-dimensional space was a kind of parallel to our internal state of mind — an interior world shaped, distorted even, by advertising, media, information overload and the ever-present contours of the built environment. Similarly, from the outset, he has enjoyed mixing visual languages, employing drawing, photography and relief. This complex synthesising process has carried through into his later sculpture.

The artist has spoken of his dislike of mass-produced, plastic commodities whose prefabricated appearance denies any sense of the processes and changes the materials undergo as part of their creation. His interests are rather different from those associated with pop art (particularly the American variety) — a celebration of the iconic power of new consumables. In contrast to the gleaming surfaces of plastic, aluminium and spray paint admired through the works of such artists as Andy Warhol and Claes Oldenburg, Fisher creates organic, fragmented and dense sculptural constructions where the fluid decisions made as part of the creative process are revealed. This tendency to open out and destabilise solid objects, of course, has its roots in earlier twentieth-century sculpture, starting with Auguste Rodin and moving through cubism, futurism and constructivism.

Fisher is reluctant to make reference to the streamlined, functional look of modernist sculpture; rather, his monuments are made from what seem like archaeological fragments (for example, *Regeneration* from 1986). He recalls the architecture of past and present empires (from classical Greek and Roman to Victorian and twentieth-century American), whereby, in melancholic mood, we reflect on the rise and fall of cultures over the centuries. He is a 'sculptor of modern life' who meditates, in the manner of Baudelaire, on the character of the city to be able to create 'forms of beauty' which, in the poet's words from 1846, 'contain an element of the eternal and an element of the transitory — of the absolute and of the particular'.

Bird in the City, 1993
*Elm, bronze, glass, 122 x 61 cm. Collection of
the artist. Photograph: Colin Ruscoe*

LEFT: Regeneration, 1986
Plaster, mixed media, 150 x 60 cm.
Artwork since destroyed.
Photograph: Duncan MacQueen

OPPOSITE: Sprouting Head, 1983
Plaster, mixed media, 45.7 x 25.4 x 25.4 cm.
Collection of the artist.
Photograph: Prudence Cuming

It is significant that Fisher often uses plaster in his work, a material considerably less resilient than stone or metal. This allows his sculptures to shun grandeur and finality as artworks, and to mirror more closely the processes of creation and decay which govern all objects, aesthetic or otherwise.

Fisher, over the past fifteen years, has made related groups of sculptures into which he has inserted found objects, as in *Sprouting Head* (1983) and *Bird in the City* (1993). We are presented with a fragile world, always seeming to be in a process of change, and one which leaves viewers very much to their own devices as to how they interpret the loosely bound images they find.

Clearly, the artist enjoys tackling themes of a grand kind, but in many works he inflects this with child-like magic. His conglomerations in plaster, metal, glass and found objects can have the appearance of elaborate mechanical toys which have been buried and only recently unearthed. Images of toys are a means of taking us out of an overelaborate world and returning us to our first memories. Playing with ideas of time and memory points us towards a strong and discernible social message embedded in the artist's work. Fisher expresses unease with commercial strategies, such as built-in obsolescence, for example, where such commodities as cars are built from the outset to be quickly superseded and replaced. Taste and fashion move on at such a ferocious pace, recycling public demand so quickly that our deeper psyche struggles to keep up. By contrast, Fisher's sculpture allows us a period of reflection, as he finds evocative ways to make us recognise the complex forces which press upon the human mind today.

Andy Goldsworthy

The inspirational and dramatic landscape of Scotland has attracted numerous artists over recent centuries, from the pre-Raphaelites to Joseph Beuys. For good and bad, Scotland belongs to the northern European romantic tradition, whereby artists and writers have sought to understand humankind's relation to the natural world. Andy Goldsworthy is an English artist who, for years, has lived and worked north of the Border, where he makes sculpture from natural materials but in ways clearly indebted to the innovations of earlier conceptual artists — innovations which significant numbers of Scottish sculptors seem little aware. Perhaps unusually for a successful international sculptor, he also creates intricate and striking works which are widely enjoyed and appreciated among the uninitiated.

Goldsworthy works exclusively with natural materials. Since the mid-1980s, he has lived in Dumfriesshire, an agricultural region in south-west Scotland. However, being brought up and trained as an artist in England, one can only properly understand him in relation to the pioneering conceptual work of other English land artists, particularly Richard Long and Hamish Fulton. Goldsworthy is an artist who similarly works in remote terrain, often unaided, and so embodies a familiar image of the lone artist facing the elements to define himself and his work.

Each of Goldsworthy's sculptures registers change and instability within the landscape by somehow recording and reflecting on the passing of time. The impermanence of his solid constructions is a crucial part of his guiding

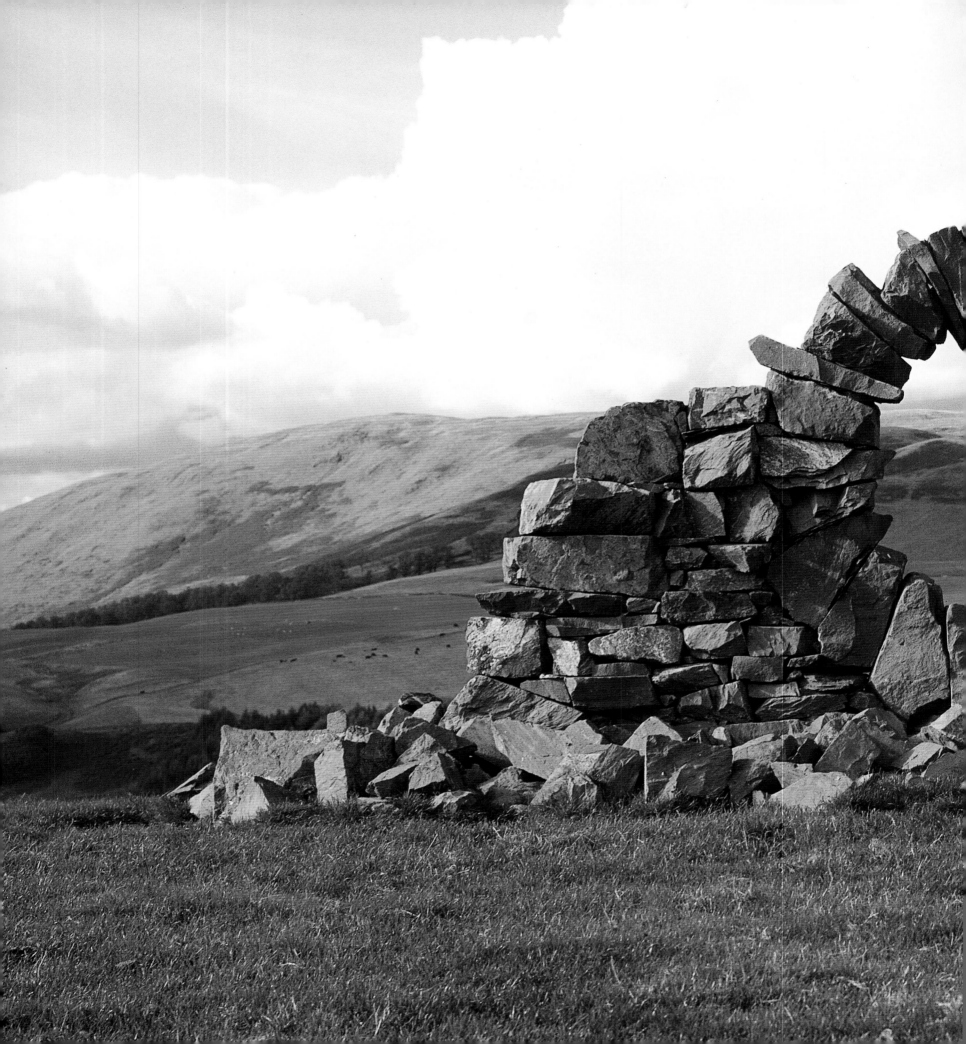

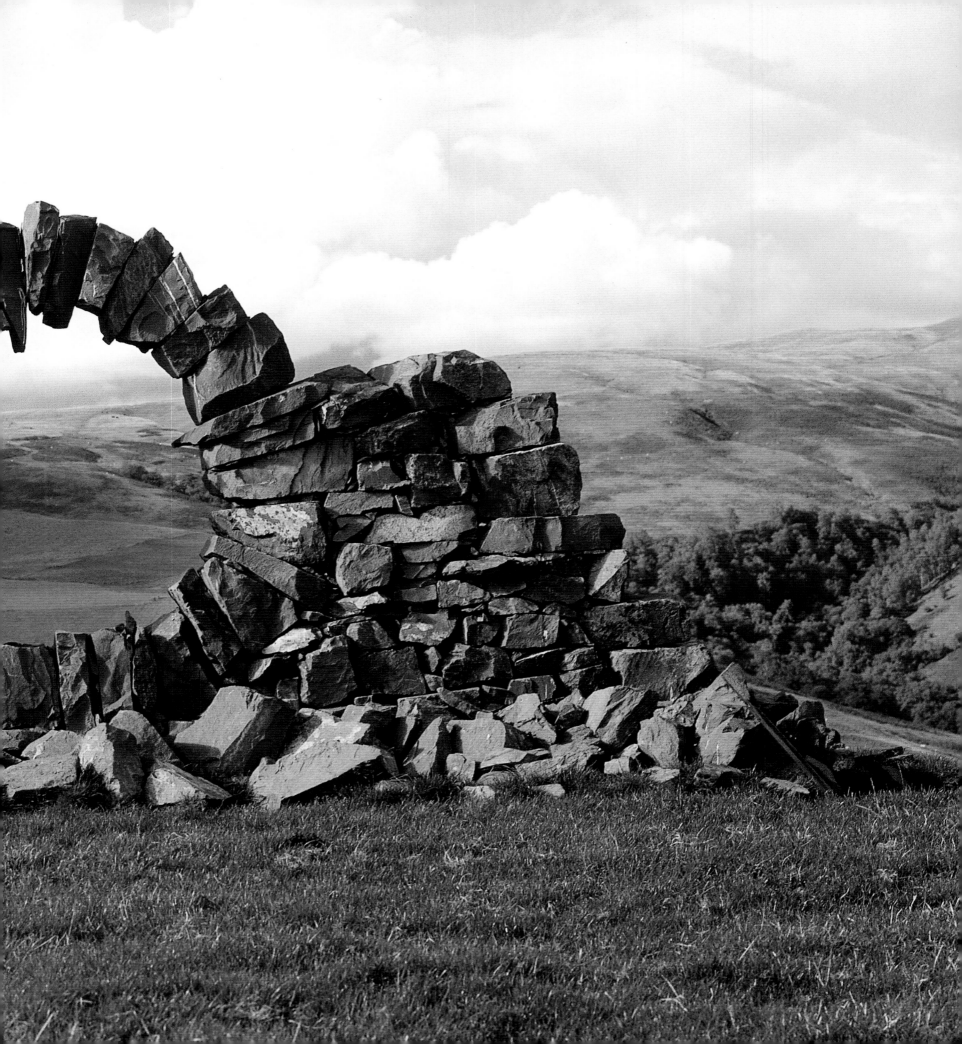

concept. Using stone, slate, wood, bone, ice, earth, leaves and petals, his painstaking process involves making visually beautiful objects, constructions or temporary interventions within either a museum (such as a fragile screen of intertwining twigs partitioning a gallery) or a natural setting (such as an arched bridge made in ice).

Goldsworthy seeks intimacy and clarity of vision by underlining the distinctive characteristics of the materials he uses for making sculpture, such as the natural patterning across veins of leaves or the flexibility of branches. He avoids acting as a controlling force, and his method never obscures the processes which govern natural order. The artist merely taps the energies of a nature that already exists. As such, he works in a way quite distinct from American land movement artists, such as Robert Smithson, who came to prominence through their writings and interventions in the landscape when Goldsworthy was training in the 1970s. These artists deliberately sought to lay permanent claims on the environment in which they worked, sometimes working with, sometimes against, the spirit of the location.

Almost all Goldsworthy's materials are found and meticulously sorted fragments from the landscape, such as splintered rock, fallen leaves, burnt sticks or animal bones, and each is assembled to illuminate some of the ordering principles to be found in nature. Spines of leaves are connected to each other to make hollow cubes. Rocks, carefully graded by colour and size, are built up as cairns or arches before being left to crumble back to the ground.

Goldsworthy's activities in nature share something of the intensity of performance art, although the building of his sculptures is never done before an audience, and the only time others are directly involved is when he needs skilled craftsmen to assist (as in the case of his drystone wall constructions). As an extension of this activity, and as a second part of the work's realisation and display, the artist takes high-quality photographs to record the work. Photography helps to counteract the ephemeral existence of each sculpture. This practice is particularly important when working with ice or water, where the effect he achieves, such as rubbing coloured earth into a rock pool, may last only minutes.

As with other artists working creatively with landscape, Goldsworthy's travels across the world — from Scotland to the United States, Japan, France and the North Pole — always result in a response to the characteristics of local materials and climate. Whether making work specifically for an art gallery or for outside, the artist is aware of the collaborative nature of what he does, and so aims to make sculpture which reasserts humankind's sense of connection to its surroundings, rather than underscoring the differences.

OPPOSITE: Burnt Sticks, 1995
Installation at San José Museum.
Courtesy of Michael Hue-Williams
Fine Art Ltd, London.
Photograph: Andy Goldsworthy

Douglas Gordon

Douglas Gordon has established himself as the most internationally regarded young artist in Scotland. Reacting, along with his peers from the Glasgow School of Art, against the earlier success of painting graduates, he preferred instead to engage with the work of conceptualism, post-minimalism and video art, making reference to such artists as On Kawara and Lawrence Weiner. Consequently, Gordon has developed a series of interrelated concerns, rather than an identifiable style as such.

He would not automatically consider himself a sculptor, preferring to work across and with media rather than in any single form. His artistic activities have included text-based wall works, performance, video installations and paintings, the meanings of which are deliberately ironic and ambiguous. His video installations, for example, engage not with the two-dimensionality of film (he is not a film-maker in any meaningful sense) but with the transition between the public and formal rituals governing cinema-going and the more informal domestic environment in which we invariably view video. In most cases, the screen is installed as a three-dimensional object leaning on a support, and so we register the work as operating in a constructed space.

Much of the artist's work seeks to produce in the onlooker a transformed state of mind triggered by a deliberate overloading of the senses. Exploring the polarity between subjectivity and objectivity, he extracts and places in new contexts highly emotive images from the world of media. In this regard, his most central technique is the deliberate and sometimes drastic manipulation of time as he 'borrows' existing clips from both popular and

RIGHT: 24 Hour Psycho (detail), 1993
24-hour video installation, dimensions variable. Collection of Kunstmuseum Wolfsburg, Germany. Courtesy of Lisson Gallery, London.
Photograph: John Riddy

OPPOSITE: A Divided Self II, 1996
Video installation, dimensions variable, edition of 2.
Courtesy of Lisson Gallery, London.
Photograph: Marcus Leith

cult movies and from archival medical films. These are slowed down and projected as silent video, often on a large scale.

The video installation, *Predictable Incident in Unfamiliar Surroundings* (1995), uses an excerpt from *Star Trek*, one of the world's most affectionately remembered television programmes. The scenes he extracts, however, focus on unsettling and discomforting moments that thwart too comfortable a reading, specifically the captain of the starship encountering and kissing female aliens. This strikes us now as symbolic of conflicts between male and female, and the dominance of the 'normal' over the 'alien'.

Gordon's most notable video installation, *24 Hour Psycho* (1993), involved slowing down the famous 1960 Hitchcock thriller, *Psycho*, to about three frames per second — a simple intervention which stretches the film to one day in length. On a formal level, the work is an elegant hybrid of film and photography. But on a psychological level, by slowing down a familiar film the narrative pace of the original is lost entirely, and *24 Hour Psycho* makes a troubling play on our own (no doubt uncertain) memories of one of Hollywood's best known films, including one of the most notorious scenes of male violence.

Despite his international success, Gordon is very much part of a Scottish cultural context. His fascination for such themes as the battle between good and evil originates in his firm religious upbringing. Spurred by this background, he has found inspiration in two Scottish literary classics, Robert Louis Stevenson's *The Strange Case of Dr Jekyll and Mr Hyde* and James Hogg's T*he Confessions of a Justified Sinner*. The first informs *A Divided Self II* (1996), a video work in which the artist, after shaving the hairs from his right arm, records both arms engaged in various couplings, ambiguously sexual and violent in nature. The work's title, by making reference to Scottish psychiatrist R. D. Laing's classic book, *The Divided Self*, further situates Gordon's work in relation to Scots' concern with fiction, science, schizophrenia and the loss of personal identity.

The early medical films Gordon has used invariably deal with distressing cases of trauma, hysteria or other extreme states of mind. *Hysterical* (1995) is a video projection based on one such 'found' documentary, showing a woman being restrained by two male doctors. The fraught scene depicts the excesses of male control in the name of science, yet the artist complicates any moral response we may wish to offer by not making it clear whether this is a 'real' event or the enactment of an idea.

This, as in all his installations, sets up a situation in which we are obliged to engage actively, and thereby more personally, with the compelling themes contained in his work. At best, Gordon draws out what already is there in our own mental landscape.

Jake Harvey

Much twentieth-century sculpture has struggled with the seemingly opposing notions of the global and the local. Jake Harvey's work is an example of how it is possible to make reference to the complex traditions in sculpture from around the world and, at the same time, ground it in personal and familiar imagery.

Harvey's sculpture has at least two distinct sources of inspiration: tactile objects (such as tools, for which handling and intimacy is vital) and sacred objects (traditionally, these are untouchable, mythic). Each object is distinct from any other but each is used by Harvey as a direct way of connecting to his experience of the Scottish landscape and, more generally, to humankind's many interventions in the natural world.

Harvey was born and brought up directly adjacent to England in the rolling landscape known as the Borders. Historically, those who lived there used such traditional materials as stone or metal for building, tool-making and furniture. The artist uses the same materials for his own carving and forged work and, so, is instinctively reluctant to distinguish between his own sculpture and archetypal objects, such as spades, axes, hammers and saws, each fashioned by need and daily use. For him, there exists an underlying connection between art and artefact.

Many of the artist's images and sculptural groups, of which *Calanais* (1994–95) is a major example, derive from the physical traces of Pictish and

OPPOSITE: Calanais, 1994–95
*Carved granite, Irish limestone, basalt,
Lewissian gneiss, 130 x 160 x 771 cm.
Collection of the artist.
Photograph: Jonathan Cosens*

BELOW: Night Drum, 1993
*Carved limestone, 53 x 79 x 68 cm.
Collection of Aberdeen Hospital.
Photograph: Joe Rock*

The Hugh MacDiarmid Memorial
Sculpture, 1982–84
Corten steel and cast bronze,
330 x 420 x 82 cm. Collection of
Dumfries and Galloway District
Council. Photograph: Colin Gray

Jake Harvey

OPPOSITE: Open Sketchbook, 1981–85
Forged and welded steel,
112 x 149 x 23 cm.
Collection of Scott Plumber.
Photograph: Joe Rock

Celtic cultures to be found in Scotland, such as crosses, standing stones, mysterious carved stone balls, and cup-and-ring designs cut into stone. His simplifications of such iconography, translated into cut, forged and welded sheet metal, or carved into granite and basalt rock, allude to the rich mythic and transcendental belief systems of early Scotland, the precise natures of which are lost to us today.

There are links in Harvey's work to the discovery in Europe of the 'primitive' as a source for a considerable amount of modernist art and theory. The paintings and sculpture of Pablo Picasso in the first decade of this century, 1920s surrealism and Carl Jung's writings on myth and symbol each sought to reconnect modern culture with its supposedly less complex, precivilised incarnations. The sculpture of Constantin Brancusi, for example, is steeped in the artist's experiences in rural Romania, and its introduction in Paris produced a revolution in the way sculpture was to develop this century. The Romanian's work has for many reasons been an inspiration to Harvey, who produced his own series of stacks and columns in the early 1980s. However, Harvey makes use of specifically Scottish folk cultural artefacts, ranging from fence posts and standing stones to altars and gravestone heads carved in rock.

His early work, extending to the early 1990s, was predominantly constructed, forged, welded or carved in shallow relief. The subjects were presented in an 'imagistic' way (as in *Open Sketchbook*, 1981–85), with motifs such as fish, a hillside, animals and the moon clearly extracted from rural life. However, their treatment is far from folk naive, owing much to the American sculptor David Smith and the Spaniard Julio Gonzalez. Harvey's most ambitious work of this time was *The Hugh MacDiarmid Memorial Sculpture* (1982–84), sited on a hillside overlooking the great poet's Borders village of Langholm. Despite the artist's indebtedness to modern international sculpture, Scottish symbolism of some sort is never lost — the crescent moon, which features in the memorial sculpture and many other works, is a reference to the threatened eclipse of national culture by England. MacDiarmid, due to the insight of his poetry, prose and political discourse, was and remains the key creative touchstone for the artist.

More recently, Harvey has developed new directions in his sculpture, mainly by carving stone directly into architectural but still ambiguous shapes. He draws to some extent on minimal art, while allowing for more conscious theatricality and possible readings. The modernist plinth is transformed into an altar on which holy objects are placed. In some works, the religious and the functional come together, such as in *Night Drum* (1993), where the forms suggest naturalistic details — such as stretched animal skin over wood — but the presentation is highly ritualised. Harvey's skill is in suggesting many readings, but this ambiguity is deliberate, not vague — whatever his sources, the sculpted objects seem complete and fully formed.

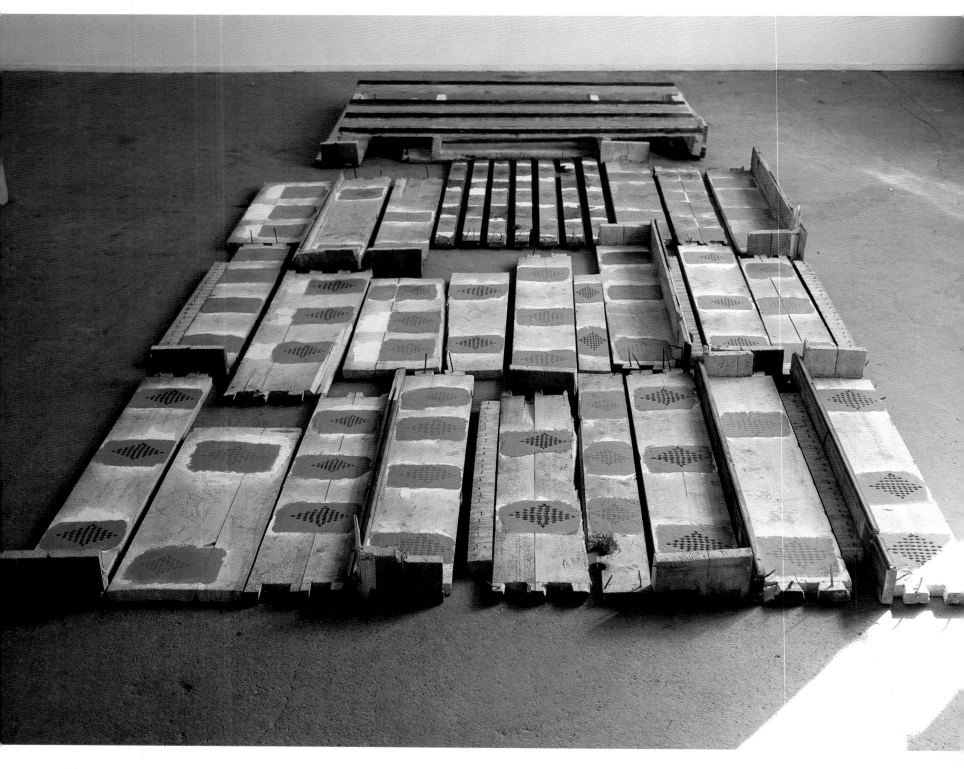

Kevin Henderson

Over the past twenty years or so, there has been increasing attention paid by artists and critics to the specifics of the actual languages of art. This has taken the shape of a deliberate, self-conscious questioning about the mechanics of looking and understanding, and artists have explored in their own artworks how the objects they make are different from, or similar to, other things which exist in the world. Kevin Henderson is an artist who has made this exploration a central part of his sculpture and time-based performance work.

In many respects, he takes his cue from minimalism, the first movement in art to try to escape the link made habitually between an object fashioned by an artist and a specific meaning represented. Henderson uses a variety of untraditional materials open to sculptors to challenge further the connection between objects and meanings in art. These materials also have an obvious history preceding the moment they come to him. He invariably displays the materials he selects in a quasi-scientific way, devoid of confusion and drama. In a comment on his own work in 1989, he anticipated the way in which later work would explicitly challenge his own sense of the term 'sculpture': 'I don't see the work as "sculptural". They are organisations of things — laid out in the simplest way possible.'

An early work, *Propaganda Cradle* (1989), was made from joints of wood extracted from a demolished house. The laid-out sections still had protruding nails and workmen's scribbles, testifying to their previous life. On top of these sections, the artist painted in orange and blue eighty-nine enigmatic symbols derived from a twelfth-century Ottoman calendar. In a way that precedes future directions, commonplace materials became intensely strange and poetic; the more the viewer considered them, the less easy it was to establish any specific meaning in the work, although the prominent themes were marked in time, decay and change.

To further obstruct recognition by the viewer in relation to his sculpture, Henderson opens up the creative process to scrutiny by making work or undertaking performances in the actual gallery space. This allows visitors to talk to the artist before the work is properly complete. Such an approach deliberately mixes introspection and public display — an artist's traditionally valued privacy is exchanged for audience response and thus creates a chance for the artist to reconsider or reflect on his motives. It is not a tactic which suits all artists, but it has become for Henderson an eloquent solution

OPPOSITE: Propaganda Cradle, 1989
Wood, oil, paint, 520 x 245 x 15 cm.
Photograph: Catriona Grant

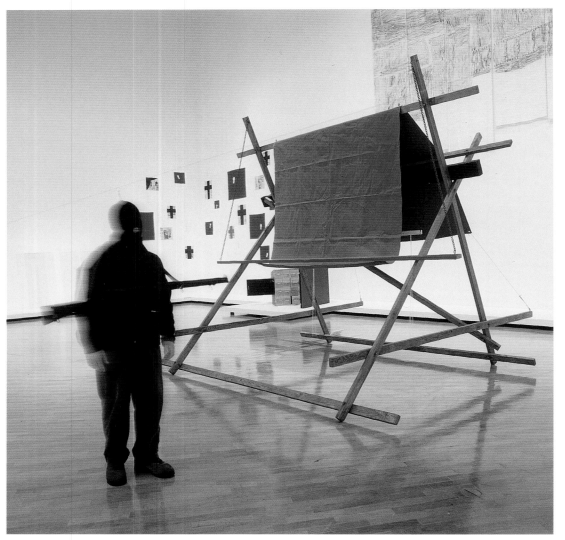

LEFT: The Operative: An 8 hour patrol along the line, 1993
Performance, December 21, 1993,
National Gallery of Australia, Canberra.
Collection of National Gallery of Australia,
Canberra

OPPOSITE: Pool, 1996
Performance duration, 100 gallons of water
into steam, 10.25 a.m., September 23 – 8.14 p.m.,
September 29, 1996 (continuous),
dimensions variable.
Installation at Context Gallery, Derry.
Photograph: Hugh Mulholland

to the obvious mistrust that contemporary art engenders in an excluded public.

Understanding the effects that time can have on making artworks has become crucial to Henderson's method. Increasingly, his performances have lasted far longer than conventional time-based events, such as *The Operative: An 8 hour patrol along the line* (1993). The artist wore a balaclava helmet and was armed with a modern rifle, but he had also modified an already unusual situation in a number of ways: by sewing up the balaclava's eyeholes, and by linking himself to a steel wire which limited him to walking back and forth along one line. Over the time of the performance, the gun became an object carried as a burden rather than solely as a weapon. His careful manipulation of a dramatic scenario had the effect of making the elements seem strange and arresting, not dissimilar in a way to his earlier three-dimensional objects with their enigmatic calligraphic marks.

The work titled *Pool* (1996) was even more of an endurance test, lasting seven continuous days and consisting simply of the artist performing two tasks: systematically polishing the leather surface of an office table with black shoe polish, and converting one hundred gallons of water into steam using a domestic wallpaper stripper. The event, being situated in a gallery, allowed visitors to ask questions and enter into the process. As in all of Henderson's works, there is almost complete transparency in what is taking place or what materials are being used; it is their combination and adaptation which is distinctive and surprising. This, and the physical lengths he goes to, determine what possible meanings might be overlaid on the actions and the subtle objects he creates.

Ian Kane

Ian Kane explores a series of very complex concerns through the sculpture he makes, both on an aesthetic and a social level. He has talked of his work 'dealing with the cyclical nature of things, beginnings, endings, continuums'. His work makes subtle reference to existing objects but always so indirectly as to be beyond recognition, and there is always the sense that his sculpture is not fixed in space for ever but holds the possibility of changing into something else.

The American sculptor Robert Morris sought, from the 1960s onwards, to get 'beyond objects' and so explore a new area for sculpture. Rather than make a parallel image of three-dimensional reality, he invested his sculpted objects with a certain independence from familiar references. He believed, as Kane does, that art is not static but should be part of the processes of change itself. Kane develops Morris's notion that sculptures are contemplative objects which, if we absorb them fully, take us beyond objects and into an imaginary realm filled with forms for which, in a manner of speaking, a use has yet to be invented.

Like the classic minimalists before him, Kane works in serial and through subtle variation. His wall relief works often consist of rows of mysterious forms, each slightly more transformed than the last, such as folding further and further over or into each other, work by work.

Kane pays considerable attention to the type of materials he uses and seeks a cohesion between form and substance. He uses natural but never raw materials, each having been industrially or manually processed, such as dyed cloth, hand-carved wood, copper tubing or neothene rubber. The artist skilfully balances the need to keep his objects independent of specific references while still maintaining an air of what he calls 'functional anonymity'. The artist becomes, then, a vital part of the processes which the materials undergo in their transitions over time.

Most of the artist's work appears as if it has been collected from the industrial production line and exhibits similarities to articles as varied as cushions, commercial blanketing, railway track section and steel handles. He does not borrow them unchanged, in the manner of 1960s pop art or 1980s appropriation art, but transforms and abstracts their identity, after which they become considerably more mysterious as objects. The identical, repeated

RIGHT: Untitled, 1994
Found galvanised buckets painted white,
dimensions variable. Collection of the artist
Diary, 1994, for Alexander Johnstone
Steel, enamel, gold leaf, bolts, ten panels,
each 80 x 80 x 10 cm. Collection of the artist.
Photograph: Keith Price

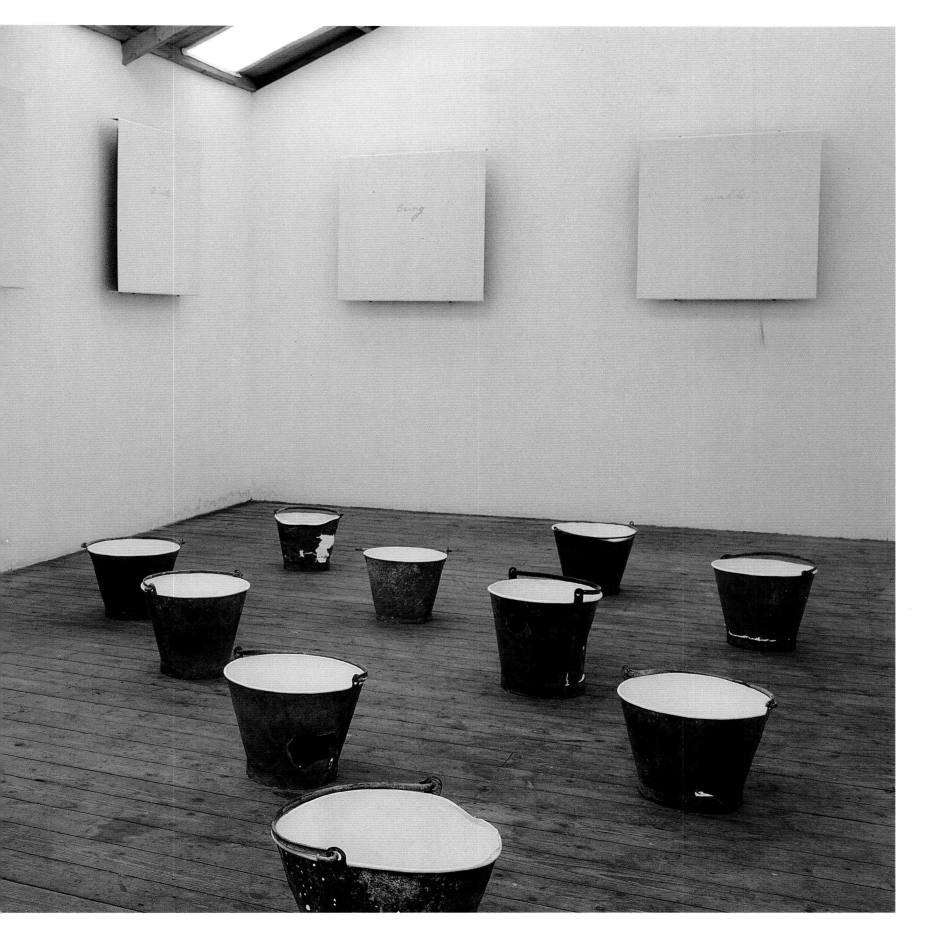

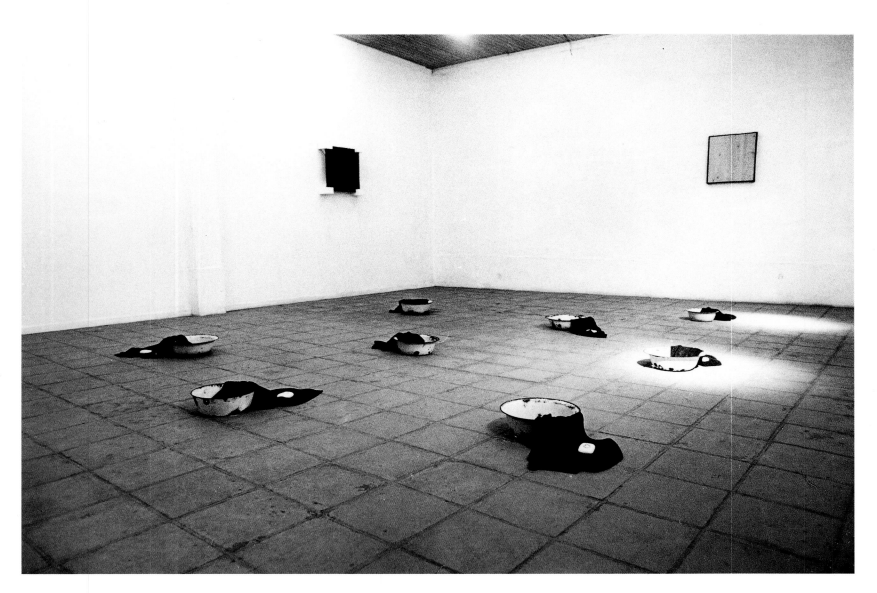

ABOVE: Pure Installation, 1991
Found enamelled basins, dyed towels, soap,
crown of thorns inserted into each soap, and
wall pieces of steel, wood, enamel, oil paint.
Installation at Moving Space Gallery, Ghent.
Collection of the artist.
Photograph: Ian Kane

OPPOSITE: Filter Installation, 1991
Lead, rubber, screening, dried flowers,
cast bitumen, dimensions variable.
Installation at Moving Space Gallery, Ghent.
Collection of the artist.
Photograph: Ian Kane

PAGES 92–93: Filter Installation (detail), 1991
Lead, rubber, screening, dried flowers,
cast bitumen, 113 x 31 x 1.5 cm.
Installation at Moving Space Gallery, Ghent.
Collection of the artist.
Photograph: Heidi Kosaniuk

elements in *Filter Installation* (1991) seem like sections from a huge industrial plant (an association underlined in the title), but the parts also seem deliberately unconnected to the space, as if laid down momentarily before being 'installed' elsewhere in the building. Kane's skill is in avoiding too specific a reading while giving the eye and mind something engaging to contemplate.

Following the innovations in the 1960s and 1970s of arte povera, in which a number of European artists created sculpture of grand ambition by using materials of insubstantial or poor quality, over recent years Kane has begun using discarded sections of metal, bricks and burnt sticks. These works differ from his enigmatic 'industrial' sculpture, yet develop his interest in the transformation and recycling of matter. Corroding metal buckets have been used in more than one work, including *Untitled* (1994), suggesting a number of possible interpretations relating to cultural production, the universality of simple implements and balance. His buckets are of the same order as Marcel Duchamp's assisted ready-mades, although distinctly more shabby and disintegrated, unable to fulfill even their original function of holding water. The buckets in *Untitled*, with their brightly painted insides and patently worn-out exteriors, seem to contain an ironic message about high culture. When the work is installed in a typical modernist gallery space, the gallery's internal white walls are mimicked directly.

Using different strategies over the past decade, the artist has continued his concern with process and change. Beneath the stern and abstract forms he uses, his work perhaps offers a pointedly political, rather than abstract, message based on his experience of the Scottish environment.

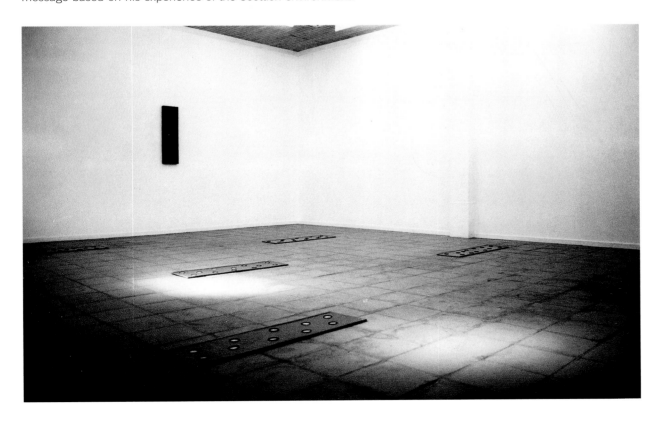

Aileen Keith

Abstraction in the twentieth century, whether in sculpture or painting, has allowed artists to harness the power of the subjective view. In particular, abstract sculpture encourages ambiguity and offers the enquiring onlooker multiple readings into artists' work. The best abstract sculpture has an intrinsic sense of mystery about it, and, as such, is an ideal medium for exploring the theme of memory. This complex subject has fascinated Aileen Keith since she began working as a sculptor.

Keith responds, as have many before her, to the power that small details seem to contain in evoking the past. Memories are something like objects in becoming increasingly fragmented over time. What may start as a concrete experience in the past — for example, a simple conversation between two people — is stored and transformed in very different ways thereafter, depending on a person's subjective reality. Keith seeks to work through the paradoxical truth that memory itself is never static or fixed for ever because, in the constantly expanding time between the past event and the present, intervening experiences are changing us, and our memories along with them.

The sculptures created by Keith often have a domestic quality evocative of containers, children's toys or kitchen utensils — objects which become familiar over time. They are never based on specific articles but archetypal ones, and so allow their associations to be wide and general.

Following visits to the historical displays in the Royal Museum of Scotland in Edinburgh, one key series of work was inspired by ancient moulds used for casting cloak pins and brooches. To the artist they spoke, in a reverse language, of the formation of things, of the secure boundaries around objects as they are brought to life. The moulds might also be read in a different way as kitchen containers used in the storing and cooking of food, but perhaps even further as a general metaphor for womanhood and motherhood as the prime creative source. Each of these unconnected symbols embraces a formal notion of containment and nurturing; a resilient outer surface inside which something organic is created.

LEFT: Trapped, 1993
Plaster, copper, lead,
77 cm high

PAGES 96–97: Bedded Down, 1994
Plaster, lead, copper, rubber,
zinctec, 220 x 220 x 20 cm.
Photograph: AIC Photographic
Services

95

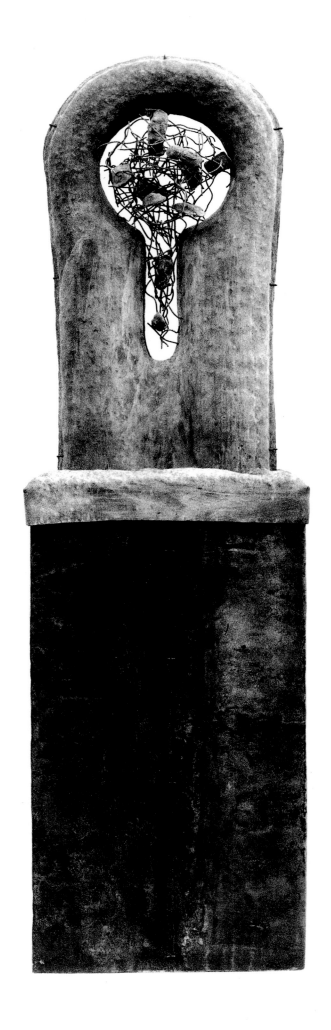

This was the starting point for *Homage to the Housewife* (1993), a series of eight mixed-media objects made from shaped lead and copper elements inserted into plaster bases. Under the overarching theme of memory, Keith establishes the link between domesticity and archaeology. It is, after all, by the study of the living quarters, particularly kitchens and refuse areas, that archaeologists learn most about bygone cultures. *Homage to the Housewife* consists of objects that appear to be part household implement and part Neolithic hand tool — metaphors for how we have traditionally fashioned materials around us in pragmatic ways and to diverse ends.

Much of Keith's work seems like a collection of fragments, snapped off from a once whole entity. She has spoken of 'filing away' fragments of events or conversations in the creation of a kind of personal archaeology. In the floor piece *Bedded Down* (1994), abstract shapes protrude or recede in space in ranks five deep and wide. Each motif is related to, but also separated from, its neighbour, rather like the way each of us tries to organise our past experiences into understandable patterns.

Keith's drawings are made in tandem to her sculpture, and so provide an area of cross-fertilisation in the creative process. In both, she returns to certain forms — such as the crescent moon or the bell — and repeats them in the same work, sometimes dramatically transformed, at other times unchanged. There is a comment here on the way the mind recalls specific objects, phrases or situations, remembering them with varying degrees of emphasis, depending on the moment. Keith uses assemblage in her sculpture to articulate the way specific memories are put together, like jigsaw pieces. In contrast, her drawings are more concerned with visual ambiguity, and allude to the vagaries of memory. Whether working in two or three dimensions, Keith uses abstraction to set up a conscious parallel between the visually intelligible and the mentally accessible. This encourages a far more complex effort of interpretation on the part of the onlooker.

Despite the use of archaeological metaphors in her exploration of memory, she rightly insists that her intentions are 'not nostalgic, not a longing to go back. It is curiosity. Acceptance. Making sense of the present by considering the past.'

OPPOSITE: You'll Never Drown, 1993
Lead, copper, 160 cm high

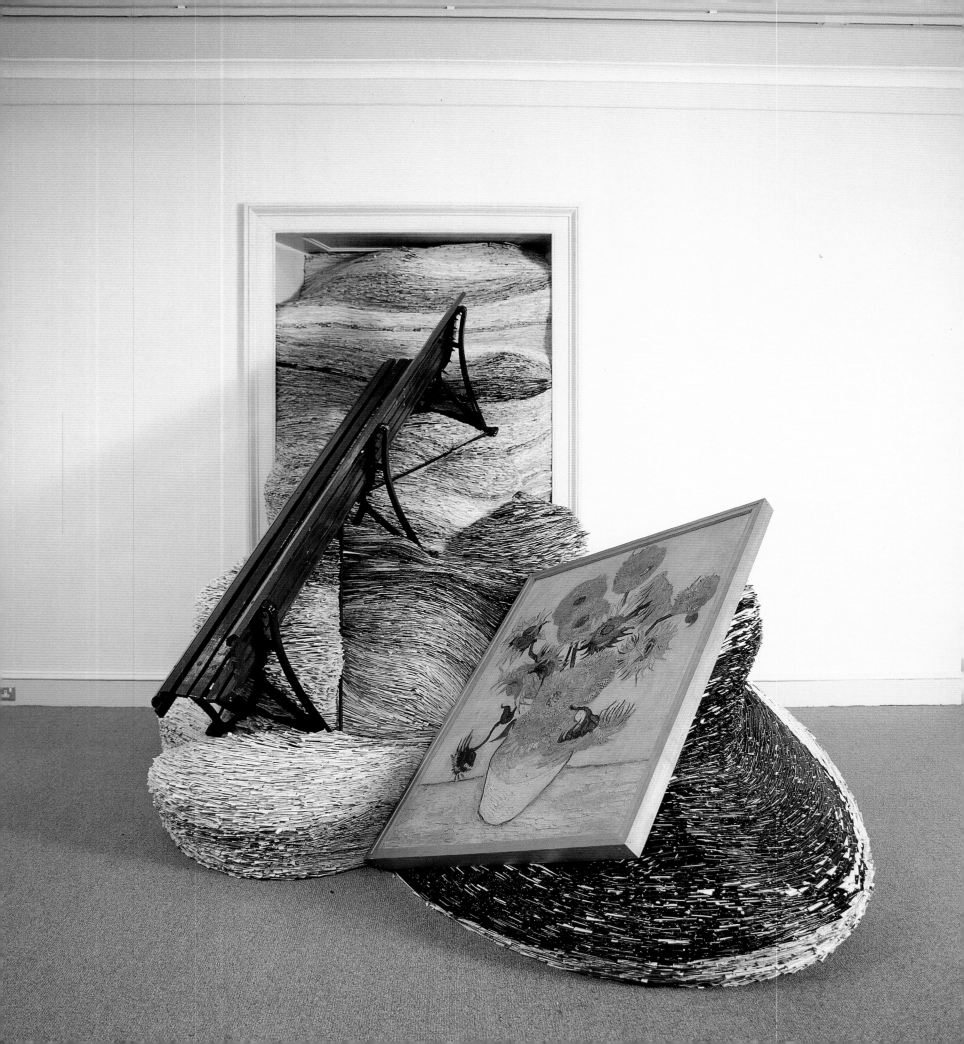

David Mach

Ever since the sixteenth century, the Baroque period in Europe, painters and sculptors have sought dramatic ways of involving the passing observer, sometimes by almost threatening the space he or she occupies. David Mach is among the most imaginative inheritors of this tradition, most particularly in his magazine and newspaper sculptures which tumble and issue forth like water or molten lava. These installations carry with them all manner of familiar objects and have become one of the most striking and engaging forms of sculpture realised in recent years. As the artist states: 'I love the idea of being excessive with art, making huge statements, grand gestures.'

From his days as a student in the 1970s until 1985, Mach typically worked with multiple units of accumulated objects, such as tyres, bottles and printed material, which were carefully assembled in the shape of other distinctive objects. The inspiration came initially from summer jobs in factories where he was struck by the impressiveness of racks of bottles and canned foods. The best known work of this early period is *Polaris* (1983), a submarine form temporarily sited in London and made solely from tyres. Unlike other British sculptors of his generation, such as Tony Cragg and Bill Woodrow, he chose not to cut into or embellish the consumer objects which caught his eye but to work with them as predetermined forms, each identical in shape.

Rather than planning the shapes his newspaper installations make, he seeks to respond intuitively to the paper quality, thickness and even content of each batch, as one would to the grain of wood or stone, before finding ways of relating to the actual site he works on, be it in a gallery or more unconventionally at a shopping mall, swimming baths or dockside. While the works have the appearance of a minutely planned installation, in fact on-the-spot decision making is central.

None of the artist's materials is second-hand or reused; rather, they are surplus and unwanted by the original manufacturer. The mass accumulation of magazines in particular is a function of the 1980s consumer boom — an economic reality of overproduction which Mach purposefully resists criticising. There is no message to be read into his work about recycling or environmentalism; he prefers instead that viewers appreciate the alternative use he makes of exceedingly familiar goods and for them then to draw their own conclusions.

The items he returns to repeatedly — whether it be gossip magazines, Barbie dolls, plates, coat-hangers or transport containers — have a clear international currency. He has commented: 'A container is like a fantastic building block, a huge plinth, a minimal work of art in its own right. At the same time it represents all of the goods transported within it.' *Temple at Tyre* (1994), a particularly successful work temporarily constructed above Leith Docks, near Edinburgh, made reference to each of these aspects.

Since about 1990, the artist has also made work which does not involve mass accumulations of materials but instead brings diverse objects together. *The Trophy Room* (1993) mocks a different kind of acquisitiveness, that of the art collector and connoisseur, by employing the metaphor of the

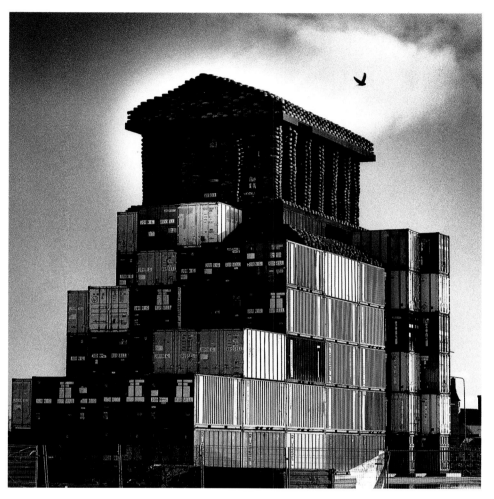

ABOVE: Temple at Tyre, 1994
Containers and tyres. Installation at
Leith Docks, Edinburgh.
Photograph: Ant Critchfield

OPPOSITE: Outside In (detail), 1987
Installation at Scottish National Gallery
of Modern Art, Edinburgh.
Photograph: Ant Critchfield

David Mach

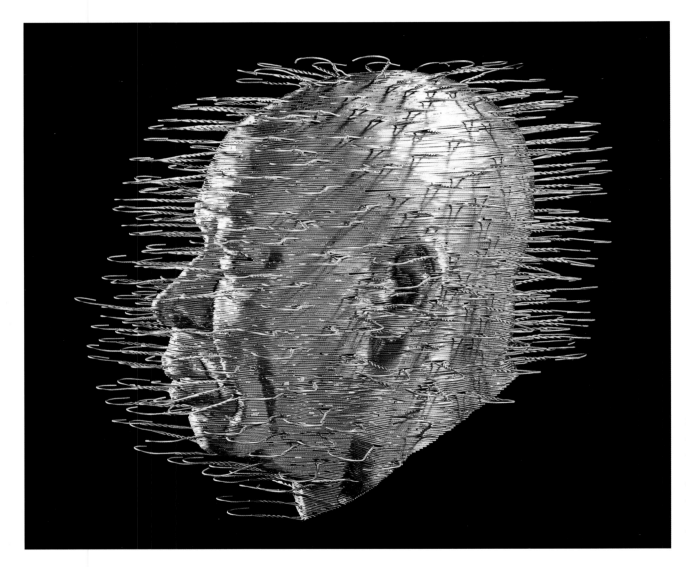

LEFT: Eko, c. 1992
Metal coat-hangers.
Photograph: Ant Critchfield

OPPOSITE: The Trophy Room, 1993
Installation at Ujazdowski
Castle Center for Contemporary
Art, Warsaw.
Photograph: Ant Critchfield

gentleman's club. In different ways over much of his career, Mach has made striking use, too, of the surrealist method of juxtaposing different orders of objects.

Putting his theory of immediacy into practice, his working method involves many assistants and external contacts, thus encouraging a spirit of collective organisation and energy. In the same way, being able to account for his actions before an enquiring public and so demystify the creative process of making art is crucial to Mach's philosophy. He is suspicious of overly serious, arcane and internal debates which serve to seal off too much contemporary art from those who may find much to enjoy. In refusing to make critical moral judgements about the objects he gathers for use, he similarly colludes with the media interest which his larger work often generates. For Mach, art should spring naturally from the world and not exclude itself from either the negative or positive aspects of the society in which he, like any artist, works. His sculpture might be said to concern itself with the connection between excess and accessibility.

Tracy Mackenna

OPPOSITE: Blanket, Stories, Posters, 1996
Wool blanket, 160 x 240 cm. Rotterdam

PAGES 106–107: Dispersion, Glasgow, 1993
Linoleum inlaid with text,
880 x 1080 cm

BELOW: August 1988, The Setting, 1991
Steel, glass, water, photocopies, labels,
cloth, conté crayon on wall,
460 x 300 x 240 cm

In the years shortly after her training at art school, Tracy Mackenna's sculpture transformed from semi-abstract welded forms to a much more complex and expanded notion of sculpture which continues to draw heavily on issues of language and identity.

Her interest particularly in translation has driven a considerable amount of her work over the past ten years. This stems in the first instance from her experience as a Scot of Italian extraction and latterly through her regular travelling as part of the process of exhibition-making. In 1986–87, she stayed for an extended period in Hungary, and her contact with Eastern Europe continues. A text-work titled *Dislocation* (1993) followed her early visits to Romania, and was based on numerous diary entries she had made. An illuminating passage reads: 'Categorisation of image difficult; poor visibility, erratic wandering, lack of certain course. Not stationary; irregular, unpredictable behaviour.' Inspired by her direct contact with this part of Europe, which struggles painfully at political and cultural levels to settle issues of identity and borderlines, much of her work draws attention to the ways in which citizens and, as a consequence, languages experience conflict and fluctuation. With this in mind, Mackenna often returns to words in her work — such as rubbing, grinding, silting, cracking, steaming, shrinking, drift — which imply the eroding effects of time.

Mackenna has become interested in using language as a physical material, and is specifically concerned with the translation of the contents of her ongoing series of notebooks to the public display of text. Spontaneous jottings of first thoughts imply an immediate recording of the artist's experience and, like any artist who uses notation, she usually records a mixture of fears, anxieties, desires and poetic reflections on what she sees and feels. She is interested in the ways in which people subconsciously reinvent themselves when travelling to new places, out of a sense of insecurity. Such 'situational identities', as she calls them, are particularly

105

Twelve hours into the day

Eleven feet and seven inches,
an unpolished space where
the earthquake split the
virgin unwritten land

were noticed and pictured

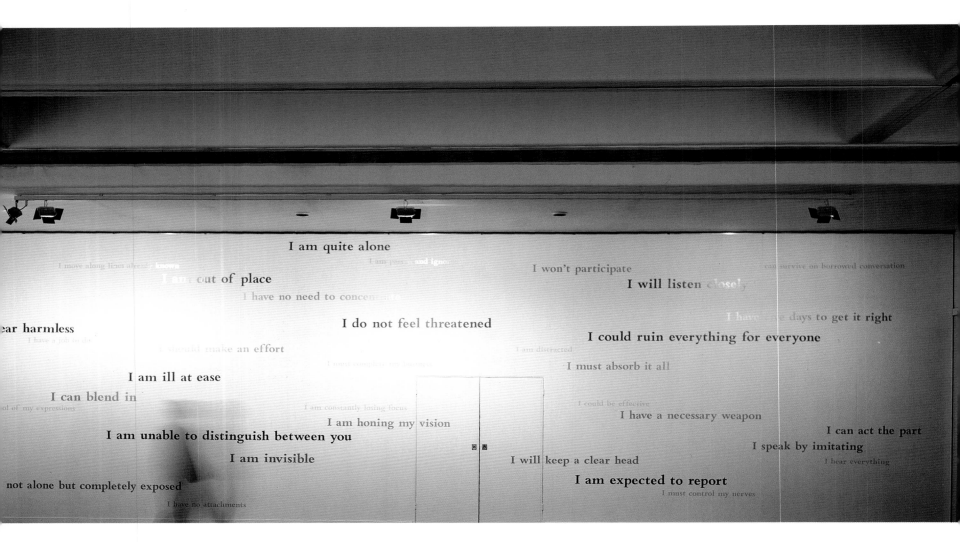

Not a Shred of Evidence (detail), 1995
Text on wall, 1320 x 1200 x 400 cm

Tracy Mackenna

prevalent in international business, the art world and, more dramatically, with migrations of displaced populations — now commonplace in Africa, as well as in Eastern and Central Europe.

Like other artists who have worked with installation and text, such as On Kawara, Joseph Kosuth and Lawrence Weiner, Mackenna blurs the boundaries between actual experience and our mental life which recalls memories through words. The way her wall-work *Not a Shred of Evidence* (1995) uses differing grades of tone in the typography indicates a sedimentary layering of thoughts and memories. An excerpt such as 'I must control my nerves' is fainter than 'I am out of place', and therefore recedes. One has the uneasy impression of witnessing the thought processes of an exposed individual steeling herself in public.

In *Dispersion, Glasgow* (1993), we not only read words but must walk over and around them as they are inlaid in cushioned wall-to-wall linoleum. Red lines thread across the floor and appear as cracks, implying a slow breaking up of the surface. This operates as a metaphor for memory traces, but, more generally, the artist is trying to break through familiar gallery experiences and produce new sensations within us. One of the strange and poetic texts reads, 'Breathing is regular, red and linear.' Carefully constructed combinations of visual, sensory and linguistic means are used to unsettle the senses of the viewer.

Mackenna has also worked with computer animation, whose digital format produces overlaying and successive words on screen. The artist's selection of differing fonts, sizes, colour combinations and speed of disclosure play with the reader's pace of understanding and perception of language. She has also produced a series of blankets onto which specific words and sentences have been appliquéd; these are words taken from conversations the artist has had with visitors to the gallery. On one level, such works seem to imply a notion of a 'security blanket' — an intimate object of attachment — but conversely they are mobile and public. Each is passed around for a time to those who were involved in the original fabrication, offering a comment on the social and fluid aspects of language and communication.

Mackenna shares with other post-conceptual artists of her generation a concern with the relationship between images and texts and, from that, the uneasy link between what we see and what we can be sure we understand. Her creative use of semantics in visual art can be extremely challenging, even perplexing, for the viewer, but if taken on board it can make us conscious and deeply aware of the instability of our world. Mackenna's sculpture proposes a world in which everything seems to be in a state of becoming, moving seamlessly from one identity to another, and where little of our lives is legible in every way.

Will Maclean

As a collection of island communities, the United Kingdom demonstrates on many cultural and political levels its sense of the sea. Almost all Will Maclean's art has its inspiration in the sea — its effects on the lives of those who live by it, those who have crossed it as emigrants or fishermen, the myths that emerge around it, or the wildlife that inhabits it. As well as the great poetic and artistic traditions around this subject, Maclean has been influenced by the facts of its hard economic reality, out of which great themes in art still manage to emerge.

Maclean works in painted relief and small object sculpture, supplemented by series of prints and by very occasional outdoor sculpture. One of the intentions of the artist is to make clear through what he does that there exist profound connections between our present day and the times of our ancestors. Most of the images and objects in Maclean's art are treated to make their surfaces appear worn, eroded, weather-beaten or regularly handled over years. The impression of age and familiarity is important to an artist who views the sea as a mythic, eternal force with the power to bestow life and yet threaten death. In dealing with such universal themes, Maclean often specifically draws on Celtic and ancient sources which relate directly to his own Highland lineage.

The found objects, resin casts and painstakingly carved sculptural elements often arranged in Maclean's reliefs use assemblage (the bringing together of disparate materials and symbols) to evoke the passage of time. Excavation and archaeology are crucial reference points — not only in a literal sense as an evocative way of recalling the past, but as a way of indicating the importance of memory on a personal and psychological level. Mainly through the use of images rather than objects themselves, Maclean shows that things which have been buried and lost can be dug for and recovered. His approach has many precedents in twentieth-century art, chiefly in surrealism — particularly in the work of American artist Joseph Cornell and in the early work of Alberto Giacometti.

Maclean's fastidiously crafted art is certainly not limited by nostalgic impulse and mythic symbolism. He is passionate about the political implications of memory. Scottish Highlanders were forcibly evacuated from their lands in the last century to make way for highly profitable agricultural industries — a process called The Clearances. The indigenous population either had to relocate to the coast and learn the fishermen's art or emigrate to the United States, Canada or Australia to seek a new life. Both alternatives were crucially bound up in sea travel, so Maclean's source of inspiration marks him out as an artist deeply motivated by Scottish cultural and economic history. He uses religious or ancient terminology in the titling of sculpture — such as totem, altar, lectern, fetish and memorial — a practice which points to the traditional place that religion has had in negotiating the relations between people and the sea and, at its most general, expresses the wish to pacify the fiercely indifferent forces of nature.

Highland history and culture offers inspirational source material through its folklore, music, poetry and working craft skills. Maclean has looked further afield to find parallel themes of loss and disaffection in other parts of the world, particularly along the north-east coast of the United States, a place where early immigrants from Scotland settled. In 1989, he visited the whale museums of New England; there, the resourcefulness of the people who lived by whaling was vividly demonstrated in the way they fashioned objects from bone and wood. The artist was also alert to the dire social impact on a community which had once depended so heavily on a declining industry, a parallel which could not be lost on anyone living in post-industrial Scotland. The power of the work Maclean has made using North American subjects is a moving demonstration of how pertinent the use of another's culture in contributing to one's own can be.

ABOVE: Symbols of Survival, 1976
Wood, bone, acrylic,
84 x 104 x 10 cm.
Private collection, Scotland.
Photograph: Will Maclean

OPPOSITE: Leviathan Elegy, 1982
Painted wood and bone,
203 x 137 x 10 cm.
Collection and photograph:
Aberdeen Museum and Art Gallery

113

Land Raid Memorial, 1996
Stone and earthwork,
stone structure 281 x 500 x 150 cm.
Isle of Lewis. Builder: Jim Crawford.
Photograph: The Stornoway Gazette

115

Eduardo Paolozzi

Eduardo Paolozzi has been making art of considerable power since the late 1940s; it is an oeuvre that spans literally half a century and one which has achieved great stature internationally. In 1987, in a memorable dedication, the British science fiction author J. G. Ballard suggested 'that if the entire 20th century were to vanish in some huge calamity, it would be possible to reconstruct a large part of it from his sculpture and screenprints'. Despite the enormous variety in his work, expressed through the media of sculpture, printmaking, film, mosaic and ceramics, his art is fundamentally one of collage explored in myriad ways.

From his earliest experiences to his development as a young artist after the Second World War, there have been significant aspects of Paolozzi's world which have crucially informed his sculpture. His interest in collage began as a child, as scrapbooks were a way to acquire fantasy images from science fiction and American culture in general which enthralled the artist, as it did many of those growing up in the austere years on either side of the war. This was complemented by a passion for museum culture, starting with Paolozzi's exposure as a student to the ethnographic collections in Edinburgh, Oxford and London, with their extensive displays of artefacts closely juxtaposed.

His interest in non-western art expanded enormously in 1947 when he went to Paris with fellow Scottish sculptor William Turnbull. However, he was drawn to the French capital chiefly to study and meet with the main dada and surrealist artists. His sculpture, while never politically satirical in the dadaist sense, has been profoundly affected by the magical and bizarre innovations in painting and sculpture made by Paul Klee, Max Ernst, Kurt Schwitters and Marcel Duchamp. Viewing himself very much as a surrealist in the classic sense, he has developed a way of juxtaposing images using assemblage and collage which presents a metaphor for how we look at and experience modern life. With little regard for formalism or for a hierarchy between popular and high cultural artefacts, he returns tirelessly to motifs extracted from technical manuals, music sheets, urban planning designs and art books and to objects designed and built on the factory floor.

ABOVE: Manuscript of Montecasino (detail), 1991
Bronze. Picardy Place, Edinburgh.
Photograph: Antonia Reeve

OPPOSITE: Portrait of an Actor (for Luis Buñuel), 1984
Bronze, 35 x 27.5 x 19.5 cm

117

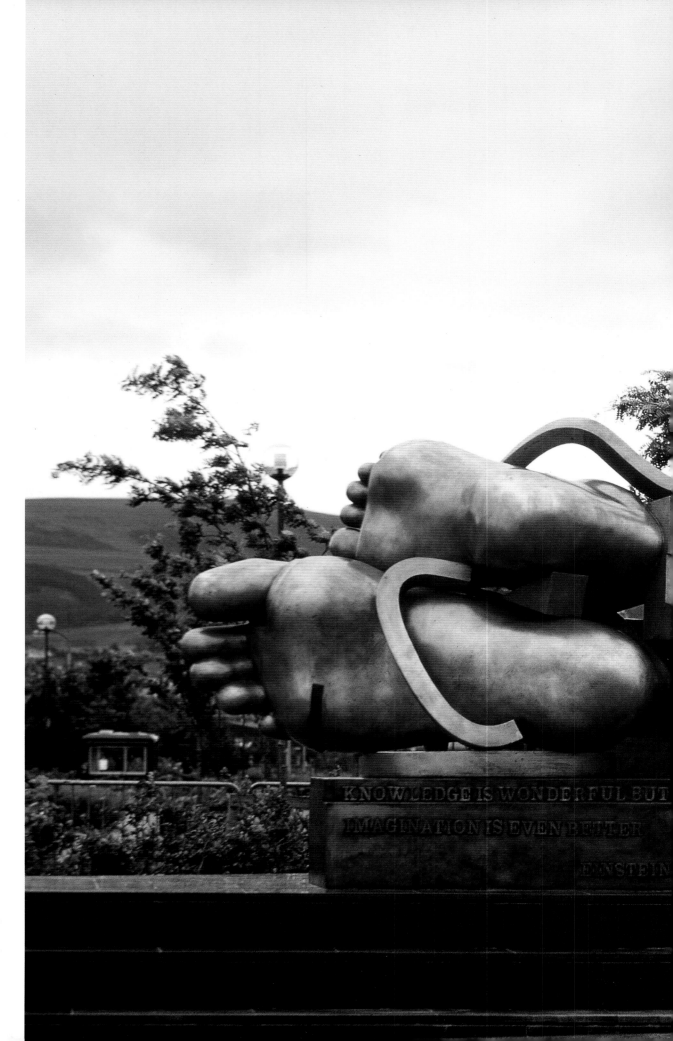

The Wealth of Nations, 1992–93
Bronze.
Photograph: Antonia Reeve

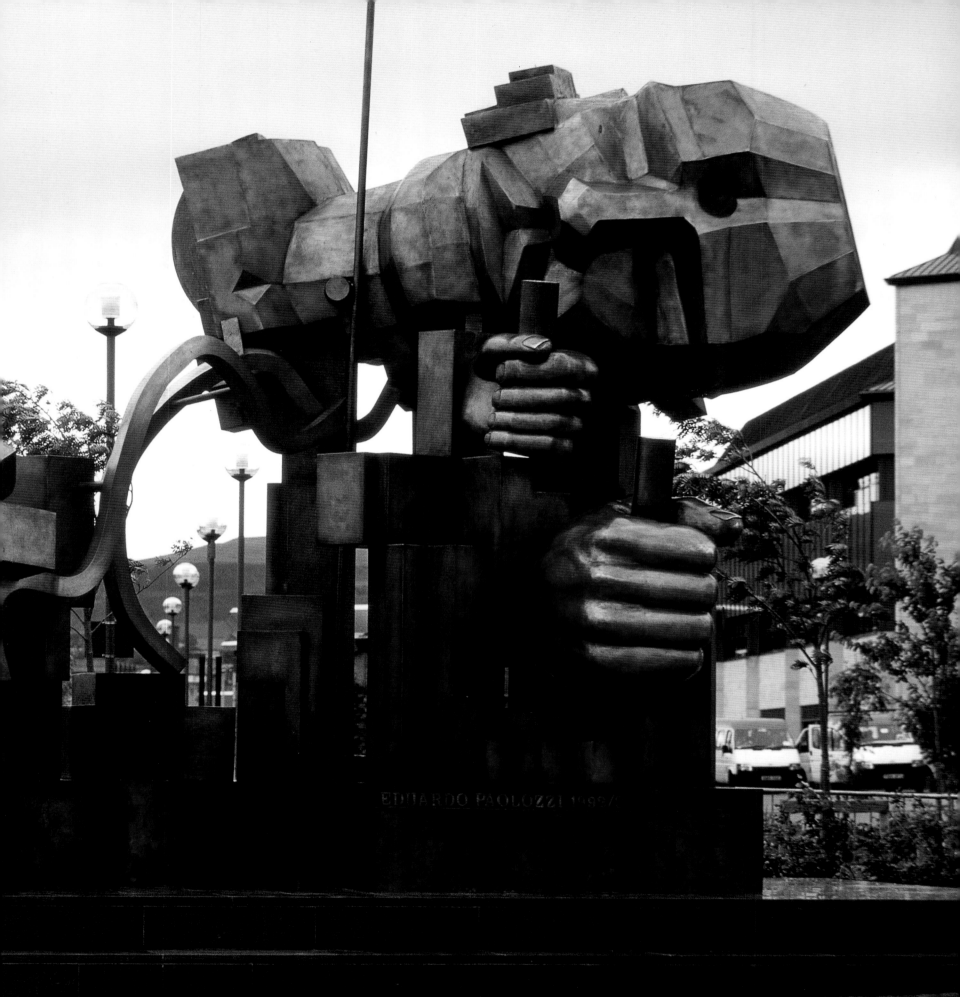
EDUARDO PAOLOZZI 1999

Paolozzi's appointment in 1981 to the chair of sculpture at the Akademie der Bildenden Künste in Munich expanded his interest in the classical sculpture held in the museums there. The fragmented remains of ancient sculpture have become the inspiration for recent publicly sited work, such as *The Artist as Hephaestus* (1987), *The Wealth of Nations* (1992–93), and the pair of figures, *Parthenope* (1997) and *Erigea* (1997). Classicism may seem an unexpected interest for an iconoclastic artist such as Paolozzi, but, at its most moral, classical art aspired to express a sympathetic relationship between man and the natural world. There is an additional resonance to the artist's use of the classical past as a ground from which images and objects are re-assembled, in that he is himself always seeking fresh and surprising combinations from his own past concerns — such as the vertically and horizontally sliced collage heads of the early 1950s which were transformed into distorted head sculptures in plaster and bronze in the mid-1980s. They should be read as a powerful representation of fragmenting identity and psychological pressure.

The techniques of collage and assemblage operate for Paolozzi as a syntax for daily life, but as much in a critical way as celebratory. In the late 1970s, he began to see his natural inclination to recycle imagery as partly ecological in impulse and concerned with the destructive proliferation of commercial and military hardware. He has spoken of his return in the 1980s and 1990s to figurative sculpture in humanist terms; this comment is from 1988: 'If you do choose to make a figure you can't just make it homogenous … You've also got to show that it's constructed, which is the twentieth century condition … Sometimes the different pieces don't fit. And that again becomes a projection of "if the world doesn't fit any more, how does man?"'

Recently, an increasing amount of the artist's energies have been directed at undertaking ambitious public commissions. Paolozzi, believing in a tradition of public art which extends back to the arts and crafts movement of the late nineteenth century, exemplifies with conviction the social potential of sculpture and thereby the social responsibility of the artist.

OPPOSITE: The Artist as Hephaestus, 1987
Bronze, 264 x 107 x 76.5 cm.
Commissioned by London and Bristol Developments, London

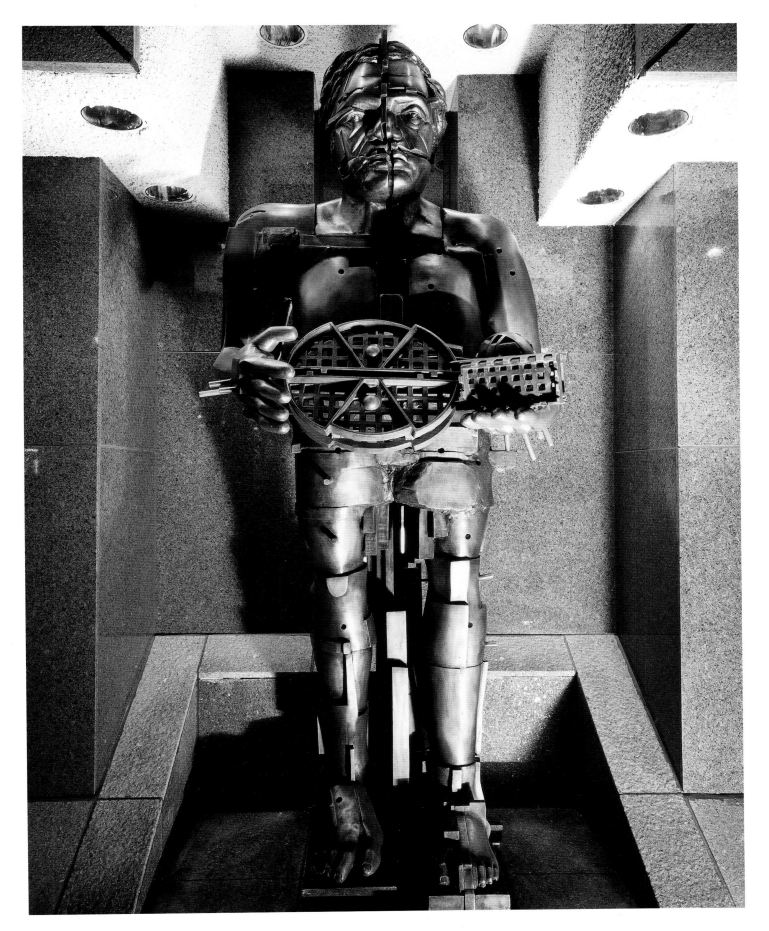

Bill Scott

OPPOSITE: Rig and Platform, 1978/85
Mild steel, paint, 96 x 45.5 x 35.5 cm.
Collection of Mr and Mrs Bill Hare

BELOW: Five Small Monuments, 1994
From left to right: History, Land,
People, Folklore, Institutions.
Heights: 203 cm, 183 cm,
183 cm, 127 cm, 127 cm.
Collection of the artist

Bill Scott's main influence on the Scottish art scene has been through his role as an educator. Unlike the previous generation of art college lecturers in sculpture, Scott has taken a very open approach to his discipline, encouraging young students to seek out their own particular interests and experiences as the basis for the inspiration of their work. Also the means by which they express themselves in sculptural forms should be directly appropriate to the nature of their chosen subjects — nothing should be 'second-hand'.

This openness of approach makes Scott an 'honest' sculptor and craftsman and, not surprisingly, he practises what he preaches in his own work. This is clearly demonstrated in his sculpture of the 1970s and 1980s. Moving from making the single human form his central focus of attention, Scott began to create pieces which dealt more with human environments, such as the home ('Pad' series) and the workplace. For example, in *Rig and Platform* (1978/85), Scott's subject is the engineering ingenuity of the North Sea oil industry. However, his intricate metal construction is not a miniature

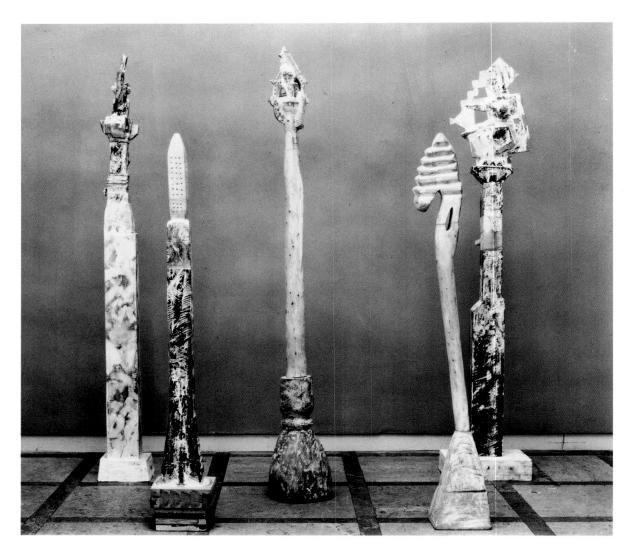

Spiral Journey, 1996
Wood, paint, 61 x 61 x 20.5 cm.
Collection of the artist

Bill Scott

version of the real thing, like a ship in a bottle, but rather a means to convey the essential animating forces behind the technological function and the human community of such an industrial enterprise.

Scott's work of this earlier period was mostly in metal and had a strong constructivist character to it. Since then, he has concentrated on working in wood and so the feeling of his sculpture has become much more organic. This is most clearly seen in an ongoing series of pieces which he calls 'Monuments' and 'Markers'. Scott is an artist who wishes his work to engage seriously with speculations about human nature, human rituals and human society. In the 'Monument' series, for example, the sculptor seems to be posing questions as to the past status and future role of sculpture in the civic environment. These various pedestal-supported totem figures which are made from various blocks of wood but encrusted with worn-away painted traces of obscure iconography seem to relate back to the beginnings of human social rituals and forward to the disintegration and irrelevance of public monuments.

In his most recent work, presented in his last major exhibition, 'Constructs from Common Sense', Scott has brought these two strands of his development together. The primitivistic wooden pieces are now presented much more within a larger interrelated arrangement so that they become part of a staged environment as seen in his most ambitious work to date, *Constructs on a Platform* (1994–97). The most striking feature of these installations is the contrast between the heavyweight density of the compact solid sculptures (*From the Base*, 1992) and open, light airiness of such pieces as *Ladder Pyramid* (1994). Many of these individual works can stand on their own, but they also complement each other, creating an environment of organic and engineered community.

As with much twentieth-century sculpture, Scott's work has a strong elemental feel to it. As he states: 'My thinking sometimes tries to emulate the approach of a primitive builder when faced with the need to solve a particular problem. For example, when making a good utilitarian object the workman often makes something which has authority and rightness of form which shows an admirable creative invention.'

Similar to Scott's motives in teaching and his relationship with his students, his ultimate motive is to release the greatest potential in his art through the humanity of his subject matter, the intrinsic nature of the material he works with, and the instinctive empathy his sculpture generates in viewers. In the best of Scott's work, art and craft, the manufactured and the natural, the sensual and the intellectual come together in the most direct and harmonious way.

Air Intake, 1994
Wood, 71 x 76 x 20.5 cm.
Collection of the artist

William Turnbull

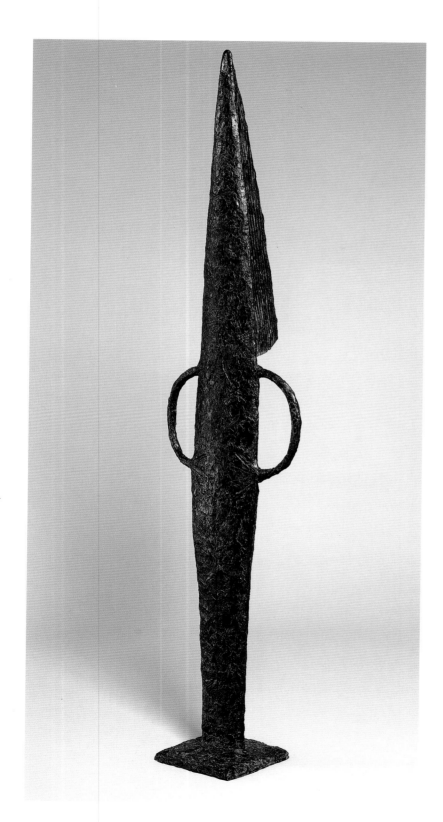

Ever since the pioneering sculpture of Constantin Brancusi, Pablo Picasso and Henri Matisse, western artists have grappled with the formal inventiveness of non-western art. These Europeans were among the first to realise the importance of the African and Asian craftworkers whose plundered work lay neglected in the great ethnographic museums of Paris. In the latter part of the twentieth century, we have become highly sensitised to the issue of colonialism on which those museums were constructed and, in reappraising the best sculptors of the modernist generation who studied non-western art, of which William Turnbull is certainly one, we have been forced to find new readings of their work.

Turnbull is one of the most senior and significant Scottish artists. His work is rooted in surrealism and what was once termed 'primitivism', and his sculptures from all periods are characterised by their elegant, monumental and sensual appearance. Reaching artistic maturity not long after the Second World War, it is a testament to the artist's creativity that he still is exhibiting to critical acclaim today.

From 1946 to 1948, Turnbull studied at the Slade School of Art in London, along with Eduardo Paolozzi. In 1948, they both moved to Paris for two years, recognising the importance of the French capital as the centre of surrealism and of the great collections of art and craft from Egypt, West Africa, the Far East and Oceania. Turnbull was also deeply inspired by direct personal contact with major figures of the modern movement, such as Alberto Giacometti, Fernand Léger and Tristan Tzara, and from absorbing the city's dynamic metropolitan atmosphere.

In 1950, he returned with Paolozzi to London where he continued to respond in his work to many of the most advanced styles in post-war sculpture in Europe and the United States. He has added to this his own lexicon of imagery, some of which comes directly from his interest in Celtic art from Scotland and Ireland. Titles for works often make reference to animal,

LEFT: Female, 1990
Bronze, 168.9 x 41.9 x 31.7 cm,
edition of 6. Collection of the artist.
Courtesy of Waddington Galleries, London.
Photograph: Richard Thomas

OPPOSITE: Horse's Head, 1994
Bronze, 82 x 57.2 x 24 cm,
edition of 6. Collection of the artist.
Courtesy of Waddington Galleries, London

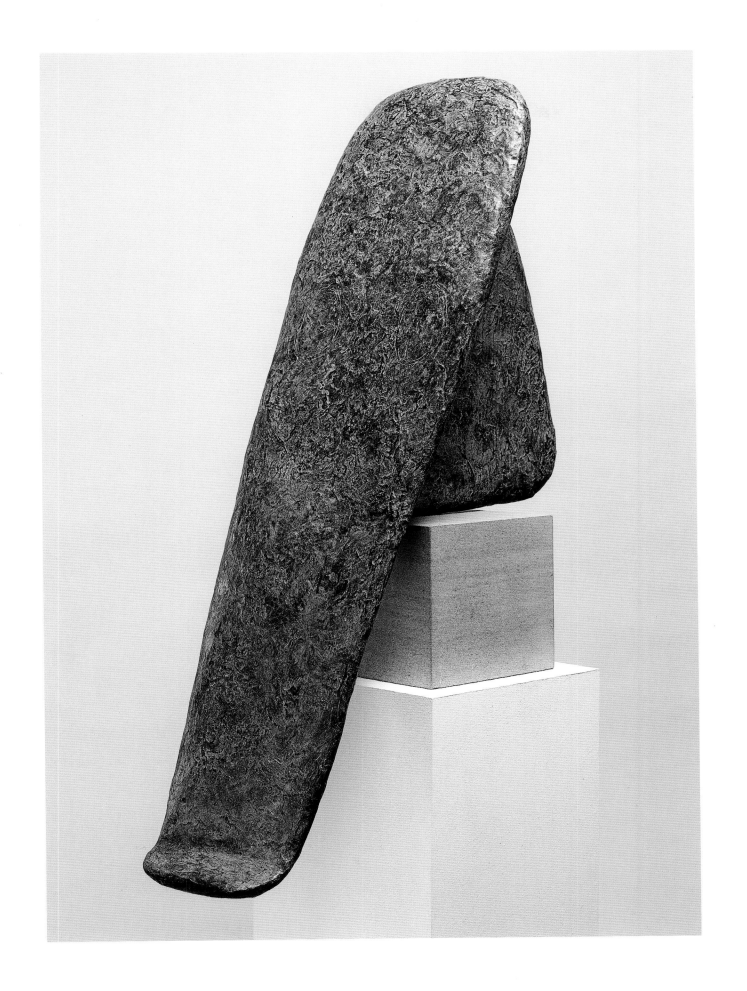

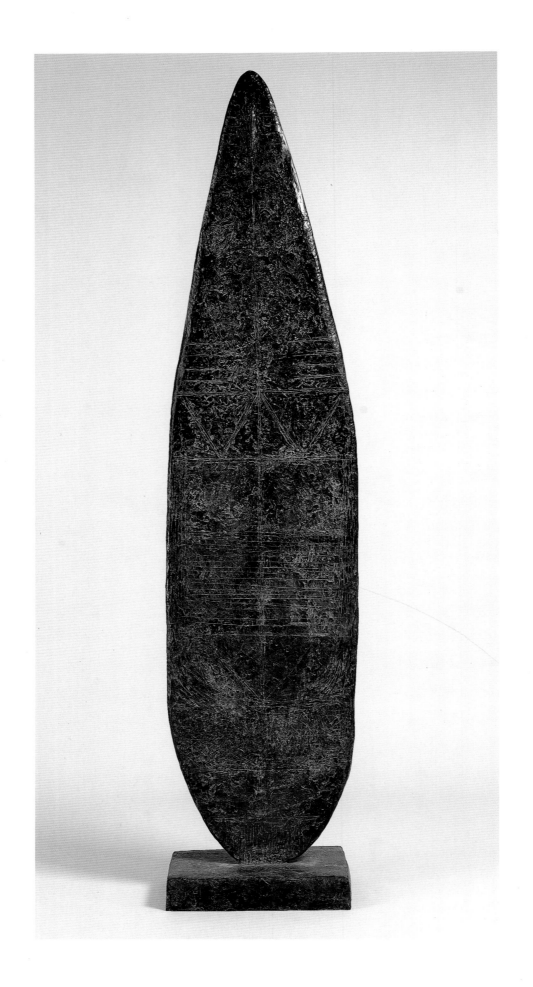

William Turnbull

mythical or religious figures, such as *Venus*, *Oedipus*, *Leda*, *Queen*, *Horse* and *Oracle*. (Typically, many such sculptures form part of a series which can extend over several years.) In the citing of mythological sources, and in the actual formal appearance of the works themselves, Turnbull gives focus to the way in which cultures across the world have endowed objects, animals and deities with enormous power. It is a truism that, in recognition of this, modern sculpture has often sought to 'borrow' some of this aura.

Turnbull makes sculpture in the traditional materials of wood, stone and bronze, by carving, modelling and casting. His sculptures share with that of their quasi-religious sources a sense of stasis, veneration and reverie; they are presented to us as objects unearthed from another time and place. To underscore this quality of authenticity and age, the surfaces are intensively marked with indentations, incised lines and patina finishes.

In his series of horse heads, begun in the 1950s and continued to this day, each work's flattened and schematised nose and neck relates to at least three identifiable sources — firstly, the forms of archaic animal carving, then modern semi-abstract sculpture, and also to archaic agricultural tools and axes (or Egyptian adzes). There is here a fitting parallel between the mechanical chopping action of a wielded axe and the vertical head movement of a horse. The artist's most recent sculpture has become more two-dimensional, where their clearly delineated shapes seem to derive in outline from seeds, paddles, spears, stringed instruments and masks. The deliberate and generous mixing of these various forms encourages a multi-layering of associations. They seem to overflow with meaning, yet, in true surrealist fashion, it would be futile to try to pin down a precise message.

Despite the seriousness which marks Turnbull's art, he is aware that sculpture must connect with people as they experience the world. To this end, he has created simple works which consciously suggest chopping knives, seesaws, skateboards and other everyday items — objects which offer a new, rather more informal set of archetypes and which help to establish concretely the underlying spiritual link between the artefacts we fashion for ourselves today and the tradition of object-making, for whatever end, in all parts of the world.

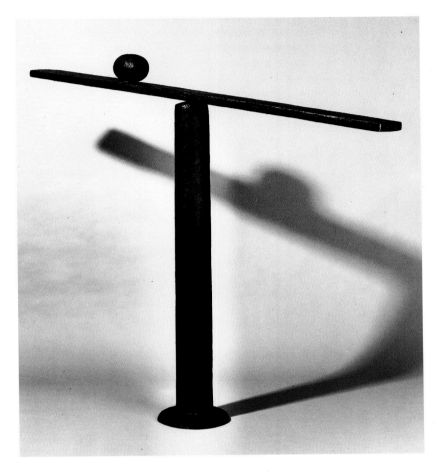

ABOVE: Tall Balance, 1992
Bronze, 155.6 x 180.4 x 28 cm,
edition of 6. Collection of the artist.
Courtesy of Waddington Galleries,
London

OPPOSITE: Queen 2, 1988
Bronze, 214 x 49.8 x 29.2 cm,
edition of 4. Collection of the artist.
Courtesy of Waddington
Galleries, London.
Photograph: Richard Thomas

Craig Wood

The sculptures and installations of Craig Wood purposely interrogate some of the main directions in international sculpture that have taken place over the past thirty years.

Wood rose to prominence in the late 1980s and early 1990s alongside fellow graduates from the prestigious Goldsmith's College in London. At that time, he was making installations using clear polythene bags filled with water. These were shallow, regular and slab-like in configuration laid in accordance with the existing floor structure. While they looked natural — mimicking sheets of ice across a frozen lake — the artificiality of 'wrapped' water sectioned off in serial arrangements was consciously paradoxical. Certainly, these water objects were manufactured to order, and appeared to be untouched by the artist's hand. The works made reference to Carl Andre, one of the supreme artists associated with minimalism, whose floor pieces in metal are laid out like tiles across the floor. True to the exacting logic of minimalism, Wood's works were untitled, and relied on viewers drawing their own conclusions.

Later work sourced elements of everyday commercial objects and led to complex interplay between ideas such as creativity and destructiveness, desire and depression. He became interested in the processes of decay associated with nature, set against the unbiodegradability of chemically based plastic objects.

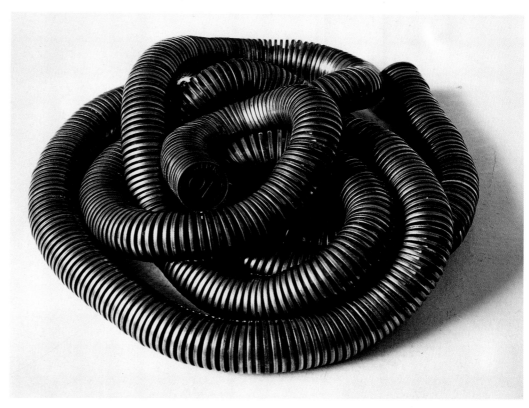

ABOVE: Small Change, 1996
Collection of 10-pfennig coins, self-adhesive pads,
12 x 35 x 35 cm. Collection of the artist.
Photograph: Werner Zellien

OPPOSITE: Father and Son, 1996
Colour print, 120 x 90 cm (soup tin contains
photograph of 'The artist and his father
covered in soup'). Collection of Damien Hirst.
Photographs: Judith Rees, Craig Wood,
Werner Zellien

A series of drawings, representing an archive of disposability, was begun where the outline of objects was represented by a linear sequence of dots. This technique stemmed from the artist's earlier training in archaeology, the standard method of delineating excavated objects being through dotted outlines.

The mysteriousness of coding used to identify batches of plastic bottles and containers intrigued the artist and inspired one group of drawings. A related series translated the outlines of environmentally hazardous 'hygiene' products, such as domestic insecticides, air fresheners and bleach bottles, into wall-based relief works. These 'cut-outs' were displayed in galleries — sanitised spaces which Wood seems to be slyly likening to kitchens or bathrooms. Despite Wood's seemingly scientific technique, he remains quietly humorous.

The artist likes to see one of his functions as recording for posterity and making monumental those products which are obsolete the moment 'new and improved' versions take their place. In some cases, his works are the only existing record of redundant designs. One of the artist's messages is that, while plastic as a material is not biodegradable, it suffers a different kind of entropy by being superseded at the design stage. The artist is very much alive to the melancholy surrounding objects of all kinds, where little is cherished for any great length of time and soon falls out of use.

Earlier wall-works anticipate a much larger project of 1996, *Green, Bored, Monument* being one of three such works. Here, the silhouette is created with a jigsaw to reveal the supporting structures beneath the gallery wall. There is a delicate balance established between the shape as wall drawing

and the dominating architectural space (a huge contemporary art museum in Barcelona) which forms the work's backdrop. The act of cutting into gallery spaces to reveal the construction, both literally and symbolically, of the sanctified world of art originated with conceptual artists in the 1960s and 1970s, and it is typical of Wood to mimic the seriousness of such intentions with a cartoon-like shape and a quirky title.

Andy Warhol, the quintessential pop art icon, receives similar treatment in Wood's *Father and Son* (1996). For this work, the artist turns the image of a Campbell's soup tin — used so famously by the American artist — back into a homely image, where the artist and his father are the figures within the tin and become the ludicrous centre of focus. This work marks something of a change in direction over recent years, in which time the artist has increasingly used consumer items, such as hi-fi systems, lamps and electric heaters, and placed them in bizarre or slightly disturbing juxtaposition to each other.

Despite the elegance and objectivity Wood often exhibits in his work, he in no sense seeks to bring clarity to the way we might understand objects. On the contrary: he maintains and encourages the inscrutability of the visible world.

George Wyllie

The approach of George Wyllie has been described as 'unseriously serious', an attitude the artist continues to develop with a freshness, enthusiasm and idealism which marks him out from many of his contemporaries. He came to art in his forties, after half a lifetime in the Royal Navy and as a customs official. Undoubtedly, his aspirations to take art whenever possible beyond the gallery and to encourage the widest possible collaboration is rooted in his sense of difference from the established art world. This equivocalness is reciprocated by an art community in Scotland which, in the main, suspects that the wit and theatricality are at odds with philosophical seriousness.

Since the 1970s, Wyllie has made numerous sculptures, such as *A Machine for Applauding Paintings* (1976), which explicitly mock the self-importance of art. Wyllie has entertainingly described the experience of gallery exhibition as 'like having a bath with your socks on'. Although occasionally exhibiting in traditional ways, he prefers to make large public sculptures which often become catalysts for performances in schools, theatres and in the remote countryside. The process involves working in the United Kingdom and abroad with ex-shipbuilders, public servants, commercial directors and industrialists, arts administrators and helpers of all kinds, galvanised by the good humour and showmanship which is very much part of the artist's style.

Wyllie's approach has been highly influenced by Joseph Beuys's belief in 'social sculpture', which, in the German's view, meant 'moulding and shaping the world in which we live'. Beuys's performance on Rannoch Moor in 1970 was celebrated sixteen years later by the siting of one of Wyllie's wooden spire sculptures — the only type of work he does which is absent of humour and in keeping with the German artist's sobriety. The spires are constructed in simple materials, such as sticks and stones, as well as in engineered stainless steel. They are also, in the artist's words, 'a sculptural indicator of man-made and natural materials, given free movement by gravity in balance with the air which surrounds it'. As such, they each become an ambitious metaphor for equilibrium on a global scale.

Wyllie's greatest challenge is to maintain the optimism and celebratory quality of much of what he does while allowing for more philosophical and humanitarian concepts to flourish. For many years now, he has developed the term 'scul?ture' as a

LEFT: Just in Case (A Monument to Uncertainty), 1997
Stainless steel, 640 cm high.
Installation in Glasgow

OPPOSITE: The Paper Boat, 1989
Installation in New York, 1990

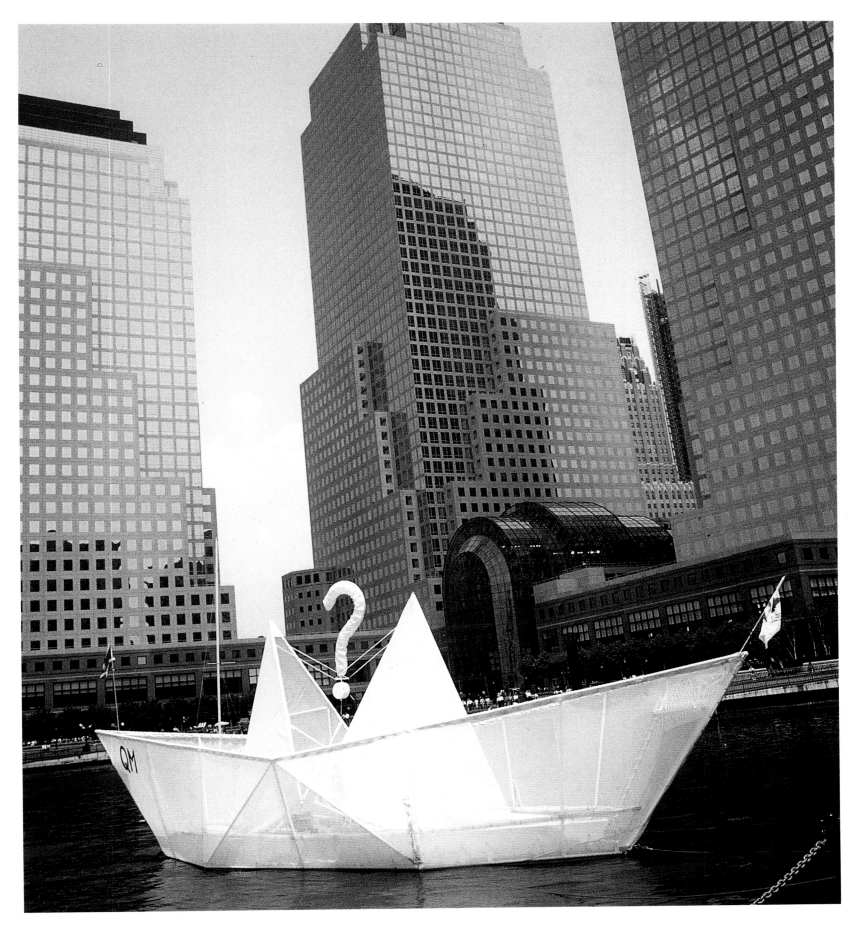

George Wyllie

questioning alternative to the belief in absolute truths which our post-Enlightenment society still holds to. For Wyllie, a question mark lies at the centre of everything.

His public sculpture seeks to capture the mood of the times and to make an emblem for the community with whom he works. Two examples are *The Straw Locomotive* (1987) and *The Paper Boat* (1989), the first of which was a 40-foot-long sculpture of a steam engine built from metal and straw. It was suspended above the city of Glasgow from an historic hammerhead crane by the dockside, which once lifted thousands of locally built trains for worldwide export. A matter of weeks later, the artist and many members of the community who once were employed by the North British Locomotive Works ceremonially burned the train on the site of their disused factory. The undoubted romanticism of the event was a deeply affecting — indeed, cathartic — moment and *The Straw Locomotive* quickly entered the popular psyche of the city. Through this event, Wyllie lamented a lost industry and yet appealed for the creative energy of those who once fuelled Glasgow's prosperity to be tapped once more.

The artist returned to this theme with *The Paper Boat*, an origami-style, seaworthy vessel of 75 feet. On its bow was printed the deliberately ambiguous QM — The Queen Mary, or question mark, or something else? The artist took the floating sculpture around ports in the United Kingdom and to the Hudson River adjacent to New York's Wall Street. The American audience, more than most, clearly understood the artist's message concerning the relation between empires past and present, and the instability of commerce and the labour market.

His interest in philosophy, particularly around the theme of uncertainty, continues to develop and has resulted in *Just in Case (A Monument to Uncertainty)* (1997), a giant metal safety pin (in the style of Claes Oldenburg) erected in public to encapsulate the urge to 'keep everything together'. In his restless state of creativity, Wyllie has held true to his assertion that 'art should no longer be appended to human activity but become part of it. Definitions exist which attempt to relate art to society, but are inadequate simply because they are definitions.'

OPPOSITE: The Berlin Spire, 1988
Stainless steel, wood, stone. Installation
at the Reichstag, Berlin

BELOW: The Straw Locomotive, 1987
Suspended from Finnieston Crane, Glasgow.
Commissioned by TWSA-3D, Glasgow

Artists' Biographies

Christine Borland

1965 Born Darvel, Ayrshire, Scotland
1983–87 BA (Hons), Glasgow School of Art
1987–88 Master of Arts, University of Ulster, Belfast
1996 DAAD Scholarship, Berlin

Selected solo exhibitions
1994 'From Life, Glasgow', Tramway, Glasgow and Kunst-werke, Berlin
1995 'Inside Pocket', The British Council Gallery, Prague
1996 'From Life, Berlin', Kunst-werke, Berlin
 'Christine Borland', Galerie Eigen & Art, Leipzig
 Gallery Enkehuset (part of 'Sawn-Off'), Stockholm
 Sean Kelly Gallery, New York
1997 Lisson Gallery, London
 'Christine Borland', Skulpturen Projeckte, Münster
 'Christine Borland', Frac Languedoc Roussillon, Montpellier
 Turner Prize Exhibition, Tate Gallery, London
1998 Museum für Gegenwartskunst, Zurich
 Galerie Serge Le Borgne, Paris
 De Appel, Amsterdam

Selected group exhibitions
1990 'Self Conscious State', Third Eye Centre, Glasgow
 'Once Supported But Now Removed', Collective Gallery, Edinburgh
 'Human Being' (three-site work as part of 'Sites/Positions'), Glasgow
1991 'Kunst Europa', Kunstverein Karlsruhe, Germany
 'Speed', Transmission Gallery, Glasgow
 'The Living Room Project' (curated by Gianni Piacentini for his living room), Glasgow
1992 'Contact', Transmission Gallery, Glasgow
 'Guilt by Association', Irish Museum of Modern Art, Dublin
 'In and Out/Back and Forth', 578 Broadway, New York
 'Artists Show Artists', Galerie Vier, Berlin
1993 'Two Person Exhibition', Chisenhale Gallery, London
 'Underlay' (curated by Gavin Brown), Spring Street, New York
 'Aperto' (curated by Matthew Slotover), Venice Biennale, Venice
 'Fontanelle' (curated by Christoph Tannert), Kunstspeicher, Potsdam, Germany
 '2nd Tyne International' (curated by Corinne Diserens), Newcastle
 'Wonderful Life', Lisson Gallery, London
 'Walter Benjamin's Briefcase' (curated by Andrew Renton), Oporto, Portugal
 'Left Luggage' (part of 'The Corridor' exhibition in a suitcase), Paris and touring
1994 'The Spine', De Appel Foundation, Amsterdam
 'Watt', Witte de With Center for Contemporary Art, Rotterdam and The Kunsthal, Rotterdam
 'The Gaze' (curated by Hou Hanru), Carré des Arts, Parc Florale de Paris, Paris
 'Ik & De Ander, Dignity for All: Reflections on Humanity', Beurs van Berlage, Amsterdam
 'East of Eden' (site-specific works for castle and grounds), Schloss Mosigkau, Mosigkau, near Dessau, Germany
 'Riviera' (group show of five Glasgow-based artists), Oriel Mostyn, Llandudno, Wales
 'Little House on the Prairie', Marc Jancou Gallery, London
 'Art Unlimited: Multiples of the 1960s and 1990s from the Arts Council Collection', South Bank Centre National Touring Exhibition, Centre for Contemporary Arts, Glasgow and UK tour
 'Heart of Darkness', Rijksmuseum Kröller-Müller, Otterlo, Holland
 'Institute of Cultural Anxiety', Institute of Contemporary Arts, London

1995 'Eigen & Art at the Independent Art Space', Independent Art Space, London
 'In Search of the Miraculous' (in honour of Bas Jan Ader), Starkmann Library Services Ltd, London
 'External Links', Mackintosh Museum, Glasgow School of Art, Glasgow
 'Swarm', Scottish Arts Council Travelling Gallery
 'Maikafer Flieg', Hochbunker Cologne/Ehrenfeld
 'The British Art Show 4', Uppercampfield Market, Manchester (touring to Edinburgh and Cardiff)
 'You Show', Galerie Hans Knoll, Budapest
 'Breakfast in Budapest', Uljak Exhibition Hall, Budapest
 'Pulp Fact', The Photographers Gallery, London
 'New Art in Britain', Museum Sztuki, Lodz, Poland
 'Wild Roses Grow by the Roadside', 152c Brick Lane, London
1996 'Christine Borland, Roddy Buchanan, Jaqueline Donachie, Douglas Gordon', Galerie Eigen & Art, Berlin
 'The Cauldron', Henry Moore Sculpture Studio, Halifax
 'Were We Conscious?', Provinciaal Museum voor Aktuele Kunst, Hasselt
 'Are You Talking to Me', Specta Gallery, Copenhagen
 'Nach Weimar', Museum for Contemporary Art, Weimar
 '21 Days of Darkness', Transmission Gallery, Glasgow
 'Strange Days', The Agency, London
 'Life/Live' (curated by Laurence Bosse and Hans Ulrich Obrist), Musée d'Art Moderne de la Ville de Paris
 'Girls High', The Mackintosh Gallery, Glasgow School of Art; Glasgow Fruitmarket, Glasgow
 'Full House', Kunstmuseum Wolfsburg
1997 'Life/Live', Centro Cultural de Belem, Lisbon (touring show from Paris)
 'Wish You Were Here Too', 83 Hill Street, Glasgow
 'Material Culture', Hayward Gallery, London
 'Connections Implicites', École Nationale Superieure des Beaux-Arts, Paris
 'Flexible', Museum für Gegenwarts Kunst, Zurich
 'Letter and Event', Apex Art CP, New York
 'Hebben Wij Het Geweten?', Galerie van Laetham, Hasselt
 'Christine Borland, Kristijan Godmundsson, Juliao Sarmento', Kopavogur Art Museum, Reykjavik and touring
 'Pictura Britannica: Art From Britain', Museum of Contemporary Art, Sydney (touring to Art Gallery of South Australia, Adelaide and City Gallery, Wellington)
1998 'Close Echoes', City Gallery, Prague (touring to Kunsthalle Krems)
 'New Art from Scotland', Museet for Samtidskunst, Oslo
 'Artists' Editions', The Modern Institute, Glasgow
 'New Art from Britain', Kunstraum Innsbruck, Innsbruck
 'Groupshow', Sadie Coles HQ, London
 'Transpennine '98', Tate Gallery, Liverpool
 Cent 8 Gallery, Paris
 'Manifesta: European Biennale of Contemporary Art', Luxembourg
1998–99 'transistors', Hashimoto Museum of Art, Morioka, Japan; Royal Museum of Scotland, Edinburgh

Bibliography
Self Conscious State, exhibition catalogue, Third Eye Centre, Glasgow, 1990
Kunst Europa (essay by Lorna J. Waite), exhibition catalogue, Kunstverein Karlsruhe, Karlsruhe, Germany, 1991
Guilt by Association (essay by Tom Lawson), exhibition catalogue, Irish Museum of Modern Art, Dublin, 1992
In and Out/Back and Forth, exhibition catalogue, 578 Broadway, New York, 1992
'*Frieze* Pilot Issue! Shot from Behind', *Frieze*, Issue No. 6, 1992
Ian Hunt, 'Guilt by Association', *Frieze*, Issue No. 7, 1992
Aperto (essay by Ian C. Hunt), exhibition catalogue, Venice Biennale, Venice, 1993
Fontanelle, exhibition catalogue, Kunstspeicher, Potsdam, Germany, 1993
2nd Tyne International, exhibition catalogue, Tyne and Weir Museums, Newcastle, 1993
Two Person Exhibition (with Craig Richardson; essay by Ian C. Hunt), exhibition

catalogue, Chisenhale Gallery, London, 1993
Michael Archer, 'Christine Borland and Craig Richardson at Chisenhale Gallery', *Art Monthly*, April, 1993
Andrew Renton, 'Ouverture', *Flash Art*, Issue No. 171, 1993
Tom Lubbock, 'Wonderful Life', *The Independent*, August 10, 1993
Richard Dorment, 'Wonderful Life', *The Daily Telegraph*, August 11, 1993
Andrew Wilson, 'Walter Benjamin's Briefcase', *Art Monthly*, Issue No. 172, 1993
Marius Babius, 'Fontanelle', *Kunst Forum*, November, 1993
Art Unlimited: Multiples of the 1960s and 1990s from the Arts Council Collection (essay by Andrew Patrizio), exhibition catalogue, South Bank Centre National Touring Exhibition, Centre for Contemporary Arts, Glasgow and UK tour, 1994
East of Eden (essays by Charles Esche and Frances McKee), exhibition catalogue, Dessau, Germany, 1994
The Gaze (essay by Hou Hanru), exhibition catalogue, Carré des Arts, Parc Florale de Paris, 1994
Ik & De Ander, Dignity for All: Reflections on Humanity, exhibition catalogue, Beurs van Berlage, Amsterdam, 1994
Institute of Cultural Anxiety, exhibition catalogue, Institute of Contemporary Arts, 1994
Stuart Morgan, 'The Spine', *Frieze*, February, 1994
Project for *Creative Camera* magazine, February–March, 1994
Riviera (essay by Andrew Wilson), exhibition catalogue, Oriel Mostyn, Llandudno, Wales, 1994
The Spine (essays by Saskia Bos and Edna van Duyn), exhibition catalogue, De Appel Foundation, Amsterdam, 1994
Andrew Renton, 'Whose Things', *Art + Text*, Issue No. 49, 1994
Ross Sinclair, 'Faster Than A Pool of Piss on a Hot Summer Sidewalk', *Real Life*, Issue No. 23, 1994
Michael Gibbs, 'The Spine', *Art Monthly*, Issue No. 174, 1994
Jeff Kastner, 'A New Powerhouse', *Art News*, September, 1994
Andrew Wilson, 'From Life', *Art Monthly*, Issue No. 181, 1994
The British Art Show 4, exhibition catalogue, Uppercampfield Market, Manchester, 1995
Marina Benjamin, 'Trigger Happy', *British Journal of Photography*, London, May 17, 1995
Judith Findlay, 'Trust. Tramway, Glasgow', *Untitled*, London, Summer, 1995
Roger Bevan, 'Home-made Youth', *The Art Newspaper*, Issue No. 53, London, November, 1995
Simon Grant, 'Institute of Cultural Anxiety', *Art Monthly*, Issue No. 183, 1995
Stuart Morgan, 'From Life', *Frieze*, Issue No. 20, 1995
Stuart Morgan, 'The Future's Not What It Used To Be', *Frieze*, Issue No. 21, 1995
The Cauldron, exhibition catalogue, Henry Moore Sculpture Studio, Halifax, 1996
Jon Ippolito, 'Where Has All the Uncertainty Gone?', *Flash Art*, Issue No. 189, Milan, 1996
Ian Hunt, 'Serious Play', *Frieze*, Issue No. 26, January–February, 1996
Uta M. Reindl, 'Maikäfer Flieg', *Kunstforum*, Issue No. 33, February–April, 1996
Richard Cork, 'Get Some Bones, Get a Life', *The Times*, London, April 29, 1996
Katrina M. Brown, 'Sawn Off', *Art Monthly*, Issue No. 196, London, May, 1996
Jutta Schenk-Sorge, 'Christine Borland: From Life', *Kunstforum*, Issue No. 134, May–September, 1996
Gunnar Arnason, 'What's All This Talk About Glasgow', *Siksi*, Vol. XI, No. 1, Helsinki, 1996
David Burrows, 'Strange Days', *Art Monthly*, September, 1996
Christine Vidal, 'Christine Borland Dissonances', *Le Voyeur*, Autumn, 1996
Andrew Wilson, 'Life v Art', *Art Monthly*, November, 1996
Christine Borland, *The Monster's Monologue*, Institute of Modern Art, FRAC Languedoc-Roussillon, 1997
The Turner Prize (essay by Virginia Button), exhibition catalogue, Tate Gallery, London, 1997
Adrian Searle, 'Bring On the Naked Dwarf', *The Guardian*, London, May 6, 1997
Anna Moszynska, 'Sugar and Spice: The Turner Prize', *Untitled*, Issue No. 14, Winter, 1997
Sotiris Kyriacou, 'Christine Borland, The Lisson Gallery', *Art Monthly*, June, 1997
Joelle Rondi, 'British Spring', *Artpress*, Issue No. 225, June, 1997
Rob Stone, 'The Woman in Possession: 9 mm Beretta Pistol', *Make 76*, June–July, 1997
David Barrett, 'Christine Borland', *Frieze*, Issue No. 35, July, 1997
Céline Mélissent, 'Anatomie du crime', *Omnibus*, Issue No. 21, Paris, July, 1997
John Slyce, 'Material Culture: The Object in British Art, at Hayward Gallery', *Flash Art*, Issue No. 75, 1997
R. L. Withers, 'On the Gallop', *Make*, Issue No. 77, London, September–November, 1997
Martin Kemp, 'Hidden Dimensions', *Tate Magazine*, Issue No. 13, 1997

David Green, 'Bringing It All Back Home', *Contemporary Visual Arts*, Issue No. 16, 1997
Ewan Morrison, 'Three Steps in the Demise of Deconstruction', *Variant*, Vol. 2, No. 4, 1997
Melissa E. Feldman, 'Christine Borland at Lisson', *Art in America*, November, 1997
Martin Coomer, 'Rogues' Gallery', *Time Out*, November 26 – December 3, 1997
Andrew Graham-Dixon, 'The Female Gaze', *Vogue*, December, 1997
The Monster Monologue, limited-edition compact disc and book, The Modern Institute, Glasgow, 1998
transistors, exhibition catalogue, Hashimoto Museum of Art, Morioka, Japan; Royal Museum of Scotland, Edinburgh, 1998

Boyle Family

Mark Boyle, Joan Hills, Sebastian Boyle and Georgia Boyle
Selected solo exhibitions

1963	Traverse Gallery, Edinburgh Festival
	Citizen's Gallery, Glasgow
	Woodstock Gallery, London
1966	The Bristol Arts Centre, Bristol
	Indica Gallery, London
	Bluecoats Arts Forum, Liverpool
1969	'Journey to the Surface of the Earth', Institute of Contemporary Arts, London
1970	Gemeentemuseum, The Hague
	Institute of Contemporary Arts, London
	Bela Centre, Copenhagen
1971	Henie-Onstad Museum, Oslo
	Paul Maenz Gallery, Cologne
	Akademi der Kunste, Berlin
1972	Henie-Onstad Museum, Oslo
1973	Kelvin Hall, Glasgow
	Gallery Muller, Stuttgart
	McRobert Centre, Stirling, Scotland
	Walker Art Gallery, Liverpool
1974	Paul Maenz Gallery, Cologne
1975	Serpentine Gallery, London
1977	Felicity Samuel Gallery, London
1978	British Pavilion, XXXIX Venice Biennale, Venice
	Kunstmuseum, Lucerne
	Henie-Onstad Museum, Oslo
	Kulturhuset, Stockholm
1979	Louisiana Kunstmuseum, Humlebaek, Denmark
	Museum Am Ostwall, Dortmund, Germany
1980	Adelaide Festival, Adelaide
	Charles Cowles Gallery, New York
	Richard Hines Gallery, Seattle
1981	Seattle Art Museum, Seattle
	Newport Harbor Art Museum, Newport, US
1982	Institute of Contemporary Art, Boston
	San Francisco Museum of Modern Art, San Francisco
1983	Nishimura Gallery, Tokyo
1985	Henie-Onstad Museum, Oslo
	A Notional Gallery, London
1986	Cornerhouse Art Centre, Manchester
	Hayward Gallery, London
1987	Southampton City Art Gallery, Southampton
	Glasgow Art Gallery and Museum, Glasgow
	Museum of Modern Art, Oxford
	Museum Sztuki, Lodz and the BWR Gallery, Sopot, Gdansk, Poland
	XIX Bienal de São Paulo, Brazil
	Gardner Centre, Brighton
	Warwick Arts Centre, Coventry
	Turske & Turske Gallery, Zurich
	Turske & Whitney Gallery, Los Angeles
1988	Galerie Lelong, Paris
	Paco Imperial, Rio de Janeiro

	Richard Gray Gallery, Chicago
1989	Turske & Turske Gallery, Zurich
1990	Friedman-Guiness Gallery, Frankfurt
	Nishimura Gallery, Tokyo

Selected group exhibitions

1963	'In Memory of Big ED' (event in collaboration with Ken Dewey, Charles Lewson and Charles Marowitz), Edinburgh Festival, Edinburgh
1964	Traverse Festival Exhibition of International Contemporary Art (Richard Demarco), Edinburgh
	'The Street' (event), London
1967	Prize for painting, V Biennale de Paris, Paris
	'Studies towards an experiment into the Structure of Dreams', Arts Lab., London
1968	Toured United States as 'Sensual Laboratory' producing Light-Environments for Jimi Hendrix and Soft Machine
	'Bodily Fluids and Functions', Roundhouse, London
	'Arts Lab.', collaboration with George Brecht, Cornelius Cardew and John Tilbury, London
1978	'Arts Council of Great Britain Collection Acquisitions', Hayward Gallery, London
1980	'British Art 1940–80: The Arts Council of Great Britain Collection', Hayward Gallery, London
1985	'Boyle Family Archives', Henie-Onstad Museum, Oslo
1986	'Forty Years of Modern Art, 1945–1985', Tate Gallery, London
1987	'British Art in the 20th Century', Royal Academy, London and Staatsgalerie, Stuttgart
1988	'Modern British Sculpture', Tate Gallery, Liverpool
	'British Contemporary Sculpture', Musée des Beaux-Arts, Le Havre and touring
1998–99	'transistors', Hashimoto Museum of Art, Morioka, Japan; Royal Museum of Scotland, Edinburgh

Collections

Aberdeen Art Gallery and Museum
Arts Council of Great Britain
Auckland City Art Gallery
National Gallery of Australia, Canberra
Basle Art Museum
Bochum Museum, Germany
The British Council
The Carnegie Institute, Pittsburgh
Gemeentemuseum, The Hague
Glasgow Art Gallery and Museum
Glasgow District Council
Henie-Onstad Museum, Oslo
Hiroshima Museum of Contemporary Art, Japan
Huntsville Museum, Alabama
Iwaki Museum, Japan
Kaiser Wilhelm Museum, Krefold, Germany
Kunstmuseum, Lucerne, Switzerland
Münster Museum, Germany
Museum Moderna Kunst, Vienna
Museum of South Australia, Adelaide
National Film Archive, London
The National Museum of Wales, Cardiff
Newport Harbor Art Museum, Newport, US
Reklinghausen Museum, Germany
San Francisco Museum of Modern Art
The Scottish Arts Council
Scottish National Gallery of Modern Art
Seattle Art Museum
Stuttgart Staatsgalerie
Tate Gallery, London
Tochigi Museum, Japan
The Tokyo Metropolitan Museum
Toledo Museum, Ohio
Ulster Museum, Belfast
Walker Art Gallery, Minneapolis
Walker Gallery, Liverpool
Washington State University Museum
Wiesbaden Museum, Germany
Wuppertal Museum, Germany

Bibliography

Journey to the Surface of the Earth. An Exhibition to launch an Earthprobe by Mark Boyle, The Sensual Laboratory & The Institute of Contemporary Archaeology, exhibition catalogue, Institute of Contemporary Arts, London, 1969
Journey to the Surface of the Earth. Mark Boyle's Atlas and Manual (with a commentary by David Thompson), edition Hansjorg Mayer, Cologne, London and Reykjavik, 1970
J. L. Locher, *Mark Boyle's Journey*, edition Hansjorg Mayer, Stuttgart and London, 1978
Mark Boyle, *British Pavilion, Venice Biennale*, exhibition catalogue, British Council, London, 1978
Mark Boyle und Joan Hills' Reise um die Welt (Mark Boyle and Joan Hills' Journey to the Surface of the Earth), exhibition catalogue, Kunstmuseum, Lucerne, 1978
Louisiana Revy, *Mark Boyle at Opdage Virkeligheden*, exhibition catalogue, Louisiana Museum, Humlebaek, 1979
Mark Boyle und Joan Hills' Reise um die Welt (Mark Boyle and Joan Hills' Journey to the Surface of the Earth), exhibition catalogue, Museum am Ostwall, Dortmund, 1979
Mark Boyle and Joan Hills' Journey to the Surface of the Earth 3 The Swiss Site, exhibition catalogue, Kunstmuseum, Lucerne, 1980
Boyle Family Archives, exhibition catalogue, Henie-Onstad Foundation, Oslo, 1985
Beyond Image, Boyle Family, exhibition catalogue, Arts Council of Great Britain, Hayward Gallery, London, 1986
Familia Boyle, exhibition catalogue, XIX São Paulo Bienal, British Council, 1987
transistors, exhibition catalogue, Hashimoto Museum of Art, Morioka, Japan; Royal Museum of Scotland, Edinburgh, 1998

William Brotherston

1943	Born Edinburgh, Scotland
1965	BA (Hons), Cantab. (History and Fine Art)
1970	DA (Edin.), Sculpture, Edinburgh College of Art
1971–78	Post-graduate diploma, Edinburgh College of Art
	Part-time lecturer, Sculpture, Edinburgh College of Art
1978–	Full-time lecturer, Sculpture, Edinburgh College of Art
1983–88	Committee member, Federation of Scottish Sculptors
1984–88	Board of directors, Scottish Sculpture Workshop
1985–94	Board of directors, WASPS (Workshop and Artists Studio Provision Scotland)

Selected group exhibitions

1974	'Eight Edinburgh Sculptors', Dunfermline, Scotland
1977	4/6 Albany Street Lane, Edinburgh
1978	'Small Sculpture', Scottish Arts Council Touring Exhibition
	'Small Works', Newcastle Polytechnic, Newcastle
1978–80	'Brotherston, Kempsell, Scott', Fruitmarket Gallery, Edinburgh and Crawford Art Centre, St Andrews
	LYC Gallery, Brampton, Newcastle Polytechnic and Manchester Polytechnic
1980	'RSA Award Winners', Artspace, Aberdeen
1984	'Putting Sculpture on the Map', FSS, Talbot Rice Art Centre, Edinburgh
1984–85	New 57 Gallery, Edinburgh and Pier Art Centre, Stromness, Scotland
1985	'Hands Off', Crawford Art Centre, St Andrews
1985–86	'Scottish Sculpture Open 3', Kildrummy Castle, Aberdeenshire and Cramond Sculpture Park, Edinburgh
	'One Cubic Foot', Artspace, Aberdeen and Talbot Rice Art Centre, Edinburgh
1986	'Spring Festival Sculpture Exhibition', City of Edinburgh
1988	Kingfisher Gallery, Edinburgh
1989	'Scottish Connection', Feeringbury Manor, Essex and Cramond Sculpture Park, Edinburgh
	'10 Years On' (Scottish sculpture workshop), Aberdeen Art Gallery, Aberdeen
1991	'Scottish Art in the 20th Century', Royal West of England Academy, Bristol
1992	'Modern Masters', City Art Centre, Edinburgh
1994	'Nine Sculptors in Scotland', Edinburgh College of Art

1994–95 'Scandex' (Scottish sculpture workshop), Aberdeen Art Gallery, Aberdeen Art Gallery, Stavanger Kultierhus, Lulea Konstenshus, Kemin Taidemuseo, Stavanger, Norway
1998–99 'transistors', Hashimoto Museum of Art, Morioka, Japan; Royal Museum of Scotland, Edinburgh

Collections
East Lothian District Council, Haddington
Edinburgh District Council
Scottish Arts Council
Tranent Library, East Lothian, Scotland

Bibliography
Small Sculpture Exhibition, exhibition catalogue, Scottish Arts Council, 1978
Interview by Peter Hill, 1984
Exhibition catalogue, New 57 Gallery, 1984
Aspects, Summer, 1984
transistors, exhibition catalogue, Hashimoto Museum of Art, Morioka, Japan; Royal Museum of Scotland, Edinburgh, 1998

Jim Buckley

1957 Born Cork, Ireland
1995– Joint Head of Sculpture, Grays School of Art, Robert Gordon University, Aberdeen
Lives and works in Glasgow, Scotland

Selected solo exhibitions
1991 'Intervals' (consecutive installations, three artists), Mayfest, Glasgow
 'Illuminations', The Collective Gallery, Edinburgh
1992 'Access', Collins Gallery, University of Strathclyde, Glasgow, Tully House Museum and Art Gallery, Carlisle, England
 'Access', Walsall Museum and Art Gallery, England and Gracefield Art Centre, Dumfries, Scotland
1994 'New York', Kyoni Gallery, Tokyo
 'Interim', Triskel Art Centre, Cork
1995 Green on Red Gallery, Dublin
 Morioka Crystal Gallery, Morioka, Japan

Selected group exhibitions
1990 'New Directions in Scottish Sculpture', Barbican Centre, London
 'Two Person Exhibition', Riverrun Gallery, Dublin
 'Fruitmarket Open', Fruitmarket Gallery, Edinburgh
1991 'EspaCe', RHA Gallagher Gallery, Dublin
 'Parable Island', Bluecoat Gallery, Liverpool
 'Kunst, Europa', Kunstverein, Konstanz, Germany
 'Speed', Transmission Gallery, Glasgow
1992 'Human Properties', Ikon Gallery, Birmingham
 'Salon Glasgow', Centre for Contemporary Arts, Glasgow
1993 'Open Crossing', BBK Gallery, Dusseldorf
 'Home and Away', Intermedia Gallery, Glasgow
 'A Barrel of Whisky', Kyoni Gallery, Tokyo
 'Myogata Symposium Exhibition', Meiho, Japan
 Baguio Art Festival, Convention Centre, Baguio, The Philippines
1994 'Small World–Small Work', Galerie + Edition Caoc, Berlin
 'Meiho International Art Symposium', Meiho, Japan
 'Worlds in a Box', City Art Centre, Edinburgh; Graves Art Centre, Sheffield; Sainsbury Centre, Norwich, England; Whitechapel Art Gallery, London
 'The Sum of All Parts', City Art Centre, Edinburgh
 VIVA Art Festival, Baccold, The Philippines
 'New Visions', International Festival of Video and Film, Glasgow
 'Jim Buckley and Sandra Johnston', Front Art Gallery, Berlin
 'Irish Days II', Baltic Art Centre, Ustka, Poland
1995 'Fairytale in the Supermarket', The Scotland Street Museum, Glasgow
 'Irish Steel', The Model Art Centre, Sligo and Crawford Gallery, Cork
 'Alchemy', Cooper Gallery, Duncan of Jordanstone College, Dundee
 Ricen Museum, Cebu, The Philippines
 'Swarm', Scottish Arts Council Travelling Gallery
 'Building Blocks', Ikon Touring, Birmingham

Suri Sumi Kohen Kankio Center, Meiho, Japan
1996 'Imaginaire irlandais', @Art Connexion, Lille, France
 'Imagine all the people …', Transmission Gallery, Glasgow
 'City Limits', Staffordshire University, Stoke
1997 'European Couples and Others', Transmission Gallery, Glasgow
1998–99 'transistors', Hashimoto Museum of Art, Morioka, Japan; Royal Museum of Scotland, Edinburgh

Commissions
1990–91 'Glasgow Milestones', Dennistoun Sculpture, Glasgow
1993 'Flood', Meiho, Japan
1994 'The Witches Tower', Slupsk, Poland
1995 'Neon Installation', Fitzwilliam Square, Dublin
1996 'Connexion Mauve', Lille, France
 'Night Spectrum' (computer-generated video projection), Stoke-on-Trent

Bibliography
Graeme Murray, *Art in the Garden — Installations*, exhibition catalogue, Glasgow Garden Festival, Edinburgh, 1988
Clyde Built, Five Artists in Govan, video, Strathclyde University, Glasgow, 1988
Scottish Connection, exhibition catalogue, Feeringbury Manor, Essex and Cramond Sculpture Centre, Edinburgh, 1989
McGrigor Donald Sculpture Prize, exhibition catalogue, Scottish Sculpture Trust in association with The Scottish Gallery, Edinburgh, 1989
New Directions in Scottish Sculpture, exhibition catalogue, Barbican Centre, London, 1990
EspaCe, exhibition catalogue, The Sculptors Society of Ireland, Dublin, 1991
Fiona Byrne Sutton, 'Intervals', *Variant*, Issue No. 9, 1991
Kunst, Europa, exhibition catalogue, Arbeitsgemeinschaft Deutscher Kunstvereine, Germany, 1991
Brian McAvera, *Parable Island: Some Aspects of Recent Irish Art*, exhibition catalogue, Bluecoat Gallery, Liverpool, 1991
Jim Buckley, *Illuminations*, exhibition catalogue, Collective Gallery, Edinburgh, 1991
Craig Richardson, 'Recent Art in Glasgow', *Variant*, Issue No. 12, 1992
Jim Buckley, *Access*, exhibition catalogue, Collins Gallery, Glasgow, 1992
Robert Clark, 'Human Properties', *Guardian*, 1992
'Jim Buckley, Flood, news exhibitions', *Art & Design*, Issue No. 36, 1994
Sandra Johnson and Brian Connolly, 'Irish Days II', *Circa 69*, 1994
Takahiko Honda, 'Interview with a Key Person in Tokyo', *Gallery*, Issue No. 12, 1994
Angela Jeffs, 'Artists boxes reveal other dimensions', *The Japan Times*, September 18, 1994
Euan McArthur, *Jim Buckley*, The Robert Gordon University, Aberdeen, 1994
Worlds in a Box, exhibition catalogue, South Bank Centre, London, 1994
Jane Warrilow, *The Sum of All Parts*, exhibition catalogue, City Arts Centre, Edinburgh, 1994
'Jim Buckley', *The Sunday Times*, May 7, 1995
Judith Findlay, 'There's Not Much Art That's Like a Good Story', *Art & Design*, Issue No. 46, 1996
transistors, exhibition catalogue, Hashimoto Museum of Art, Morioka, Japan; Royal Museum of Scotland, Edinburgh, 1998

Robert Callender

1932 Born Mottingham, Kent, England
1948–49 South Shields Art School
1951–54 Studied medical illustration, Edinburgh University
1954–59 Edinburgh College of Art
1959–60 Lecturer, Institute for American Universities, Aïx-en-Provence
1960–93 Lecturer, Edinburgh College of Art
1966 Elected associate member of the Royal Scottish Academy (resigned 1969)
1966–69 Director of New 57 Gallery, Edinburgh
1969–73 President of the Society of Scottish Artists
1974 Middlesborough International Drawing Biennial prizewinner
1976 Re-elected president of the Society of Scottish Artists
1983 Saltire Society Award Cumbernauld Mural
1988 Inverclyde Biennial prizewinner
Lives and works in Kinghorn, Fife

Selected solo exhibitions

1963	57 Gallery, Edinburgh
1965	Lane Gallery, Bradford, England
	Billingham Arts Centre, County Durham, England
	57 Gallery, Edinburgh
1967	57 Gallery, Edinburgh
1970	Retrospective exhibition, Edinburgh University
	Loomshop Gallery, Lower Largo, Fife
1974	Stirling Gallery (with Elizabeth Ogilvie)
1974–76	Scottish Gallery, Edinburgh
1977	'Pictures from the Point of Stoer' (with Elizabeth Ogilvie), Lyth Art Centre
1980	'Watermarks', Fruitmarket Gallery, Edinburgh, Scottish Art Council touring exhibition
	City Art Gallery and Museum, Aberdeen
	Third Eye Art Centre, Glasgow
1981	New Art Centre, Stoke-on-Trent
	Coelfrith Art Centre, Sunderland
	Serpentine Gallery, London
1985	'Between Tides', Talbot Rice Art Centre, Edinburgh
1986	'Between Tides', Aberdeen Museum and Art Gallery
	'Sea Changes', Crawford Art Centre, St Andrews University
	Mercury Gallery, London
	Aberdeen Museum and Art Gallery
1989	'Sea Salvage', Talbot Rice Art Centre, Edinburgh
1990	Mercury Gallery, London
	Pittenweem Arts Festival, invited artist
1991	'Sea Salvage', An Lanntair Gallery, Stornoway, Isle of Lewis
1994	Mercury Gallery, London
	Kirkcaldy Museum and Art Gallery
	Dunfermline Arts Festival, invited artist, Pittencrief Museum
1996	Pittenweem Arts Festival, invited artist
1997	Northlands Festival, invited artist, Helmsdale and Thurso

Selected group exhibitions

1962	Scottish Gallery, Edinburgh
1963	'Scottish Young Contemporaries', Scottish Arts Council Gallery, Edinburgh
1966	'Scottish Painting', Demarco Gallery, Edinburgh
1967	'Ten Years of the 57 Gallery', 57 Gallery, Edinburgh
1971	'The Edinburgh School 1946–71', Edinburgh Festival
1974	Middlesborough International Drawing Biennial
1976	'Aberdeen and Edinburgh', Demarco Gallery, Edinburgh
	'20th-Century Scottish Drawing', Royal College of Art, London
1980	'The Artist and the Sea', Scottish Arts Council, Travelling Gallery Exhibition
1981	'Art and the Sea', Third Eye Centre, Glasgow
	'Contemporary Choice', Serpentine Gallery, London
1982	Institute of Contemporary Arts, London
1983	City Art Centre Collection, Edinburgh
1985	'Stones', Scottish Arts Council Travelling Gallery
	'Floating Images' (with Elizabeth Ogilvie), Scottish Arts Council Travelling Gallery
	Edinburgh–Dublin Festival Exhibition, Edinburgh College of Art
	'About Landscape', Edinburgh Festival Exhibition, Talbot Rice Art Centre
1986	Museum in National de Belais Artes, Rio de Janeiro
1987	Mercury Gallery, London
1988	'Fruitmarket Open', Fruitmarket Gallery, Edinburgh
	'Making It', Edinburgh Festival, Edinburgh College of Art
	Greenpeace, Artists at the Irish Sea Conference, Dublin and European tour
1989	'Song of the Sea', Dundee City Art Gallery
1990	'Scottish Art Since 1900', Barbican Centre, London
	'The Art Machine', McLellan Galleries, Glasgow
1993–94	'Shoreline', City Art Gallery, Edinburgh and touring
1995	'Ultra Marine', Merseyside Maritime Museum, Liverpool
1996	'Claiming the Kingdom', Kirkcaldy Museum and Art Gallery
1998–99	'transistors', Hashimoto Museum of Art, Morioka, Japan; Royal Museum of Scotland, Edinburgh

Collections

Aberdeen Museum and Art Gallery
British Petroleum
Cumbernauld Development Corporation
Dunfermline Carnegie Trust
Dunfermline District Council Library
Dunfermline Museum and Art Gallery
Dunfermline Schools Collection
East Lothian Hospital Board
Edinburgh City Arts Centre
Edinburgh City Hospital
Edinburgh College of Art
Edinburgh Philharmonic Society
Edinburgh Schools Collection
Education Resource Service, Breton Hall, Wakefield
Fife Council Arts Library, Cardenden
Glasgow City Art Gallery
Grampian Region Hospital Board, Aberdeen
Horne Terrace Residents Association, Edinburgh
Institute for American Universities, Aïx-en-Provence
Jean Watson Trust, Edinburgh
Middlesborough City Art Gallery
National Government Collection, London
Nuffield Foundation, London
Royal Bank of Scotland
Scottish Arts Council
Scottish National Gallery of Modern Art
Stirling University
Strathclyde University
Teeside Museum and Art Gallery, Middlesborough
Western Isles Council

Bibliography

Exhibition catalogue, Lane Gallery, Bradford, 1965
Alan Bold, *The Times* educational supplement, October 15, 1965
Twenty by Fiftyseven (introduction by Cordelia Oliver), exhibition catalogue, New 57 Gallery, Edinburgh, 1969
William Buchanan and Richard Collins, *Twelve Scottish Painters*, exhibition catalogue, Glasgow, 1970
Edward Gage, *The Scotsman*, March 18, 1974
Cordelia Oliver, *The Guardian*, March 27, 1974
Emilio Coia, *The Scottish Field*, December, 1974
The Need to Draw (introduction by David Irwin), exhibition catalogue, Scottish Arts Council, Edinburgh, 1975
Twentieth Century Drawing (introduction by Emilio Coia), exhibition catalogue, Edinburgh, 1976
Pictures from the Point of Stoer (introduction by Paul Overy), exhibition catalogue, Lyth Art Centre, Edinburgh, 1977
Waterscapes, exhibition catalogue, University of Strathclyde, Glasgow, 1977
Edward Gage, *The Eye in the Wind: Scottish Modern Painters 1945–1978*, Collins, London, 1978
Painters in Parallel (introduction by Cordelia Oliver), exhibition catalogue, Scottish Arts Council/Edinburgh College of Art, 1978
Modernia Taidetta Skotlannista (introduction by Duncan Macmillan), exhibition catalogue, The Amos Anderson Gallery, Helsinki, 1978
Hugh Adams, *Watermarks*, exhibition catalogue, Scottish Arts Council, 1980
Miranda Strictland Constable, *Robert Callender*, exhibition catalogue, Serpentine Gallery, London, 1981
Art and the Sea, exhibition catalogue, Institute of Contemporary Arts, London, 1982
Between Tides (introduction by Robert Callender), exhibition catalogue, Talbot Rice Art Centre, Edinburgh, 1985
Floating Images (introduction by Diana Sykes), exhibition catalogue, Scottish Arts Council, 1985
Robert Livingstone, *Sea Changes, Images of Sea and Shore*, exhibition catalogue, Crawford Art Centre, St Andrews, 1986
Clean Irish Sea, Greenpeace, London, 1988
Sea Salvage (introduction by Judith Collins), exhibition catalogue, Talbot Rice Art Centre, Edinburgh, 1989
Deborah Krasner, *Celtic*, Thames & Hudson, London and Viking Penguin US, 1990
Duncan Macmillan, *Scottish Art, 1460–1990*, Mainstream, 1991
The Sea, Greenpeace, 1993

Christopher Andreae, *From the Sea of the Imagination*, Christian Science Monitor, 1994
Excavations (introduction by Christopher Andreae), exhibition catalogue, Dunfermline Museum and Art Gallery, 1994
W. Gordon Smith, 'Elemental My Dear Monet', *Scotland on Sunday*, 1994
John Plowman, *The Encyclopedia of Sculpting Techniques*, Headline, London, 1995
John Plowman, *Starting Sculpture*, Quarto Publishing, London, 1995
transistors, exhibition catalogue, Hashimoto Museum of Art, Morioka, Japan; Royal Museum of Scotland, Edinburgh, 1998

Doug Cocker

1945	Born Perthshire, Scotland
1963–68	Duncan of Jordanstone College of Art, Dundee
1972–82	Lecturer in Sculpture, Nene College, Northampton
1982–90	Lecturer in Sculpture, Grays School of Art, Aberdeen
1984	Elected associate of the Royal Scottish Academy
1991	Essex Fine Art Fellowship
1992	Wingate Scholarship
1992–96	Visiting lecturer, Edinburgh University, Glasgow School of Art, Grays School of Art, Dundee, Duncan of Jordanstone College of Art, Dundee

Selected solo exhibitions

1969	New 57 Gallery, Edinburgh
1975	Northampton Art Gallery
1977	Fruitmarket Gallery, Edinburgh
1978	Air Gallery, London
1981	Scottish Sculpture Workshop, Huntly
1982	Spectro Arts Workshop, Newcastle
	Compass Gallery, Glasgow
1984	Artspace, Aberdeen
1986	Third Eye Centre, Glasgow and touring
1989	Artsite, Bath
	Crawford Art Centre, St Andrews
1990	Woodlands Gallery, Blackheath
	Aberdeen Art Gallery
1992	Peacock Printmakers, Aberdeen
	Chelmsford Cathedral Festival
1995	Talbot Rice Gallery, Edinburgh and touring
	Perth Museum and Art Gallery, Perth Festival of the Arts
1996	Joan Hughson Gallery, Glasgow

Selected group exhibitions

1979–80	'British Art Show', Arts Council of Great Britain Touring Exhibition
1980	'Nature as Material', Arts Council of Great Britain Touring Exhibition
1981	'Art and the Sea' (touring exhibition)
1981–85	'Scottish Sculpture Open', Kildrummy Castle, Aberdeenshire
1983	'Built in Scotland', Third Eye Centre, Glasgow and touring
	'Views and Horizons', Yorkshire Sculpture Park
1984	'Graeme Murray Gallery at the Serpentine', Serpentine Gallery, London
1986	'Landscape Sculpture', Axiom Gallery, Cheltenham
	'The Unpainted Landscape', Scottish Arts Council Touring Exhibition
1988	Collegium Artisticum Sculpture Symposium, Sarajevo
	'New Sculpture in Scotland', Cramond Sculpture Park, Edinburgh
	Glasgow Garden Festival, Glasgow
1989	'Natural Art', McManus Galleries, Dundee
	'Scottish Art Since 1900', National Gallery of Modern Art, Edinburgh and Barbican Centre, London
	'Scottish Connection', Cramond Sculpture Park, Edinburgh and Feeringbury Manor, Essex
	'4 on Tour', Scottish Arts Council Touring Exhibition
1991	'Virtue and Vision', Royal Scottish Academy, Edinburgh
1993	Scottish Sculpture Open 7, invited artist
1994	'Nine Scottish Sculptors', Edinburgh College of Art, Edinburgh Festival
1995	'Celtic Connections', International Concert Hall, Glasgow and the Seagate Gallery, Dundee
	'Taking Form', Fruitmarket Gallery, Edinburgh
1996	'Chelsea Harbour Sculpture '96', Chelsea

'We Got Rhythm', Hunterian Art Gallery, Glasgow
'Peacock 21', Aberdeen Art Gallery

1997	'A Scottish Collection', Berwick Gymnasium Gallery
	'Scottish Sculpture Open', Kildrummy Castle, Aberdeenshire
1998–99	'transistors', Hashimoto Museum of Art, Morioka, Japan; Royal Museum of Scotland, Edinburgh

Commissions

1987	Hunterian Art Gallery, Glasgow
1988	City of Dundee
	Woodland Trust, Cambridgeshire
1989	Mobil (UK) Headquarters, Aberdeen
	Peterborough Development Corporation
1990	Atlantic House, Cardiff
	Kirkcaldy District Council
	Black Country Development Corporation, Birmingham
1991	Glasgow Milestone, Drumchapel
	Essex County Council, University of Essex
1993	University of Glamorgan
1994	Staffordshire County Council
	Kent County Council
1995	Kyle and Carrick District Council
	Perthshire Public Art Trust
	Tyrebagger Sculpture Project, Aberdeen
1996	Carley Hill School, Sunderland
	Sunderland Enterprise Park
	Sustrans Scotland, Caldercrux
	Dr Grays Hospital, Elgin
	Motherwell District Council
1997	Ben Lomond Memorial, Rowardennan
	Western Access Route, Stirling, Central Regional Council
	Town Square, Barrow-in-Furness
	Galloway Forest Park, Forest Enterprise
	Sunderland Enterprise Park
	Scottish Equitable, Edinburgh
	Hamilton Town Centre Redevelopment

Collections

Arts Council of Great Britain
BBC Scotland
City of Edinburgh Council
Essex County Council
Fife Education Authority
Glasgow Art Gallery and Museum
Greenshields Foundation, Montréal
Hunterian Art Gallery, Glasgow
King Alfred's College, Wincester
Kirkcaldy Museum and Art Gallery
Northampton Art Gallery
Perth Art Gallery
Perthshire Education Authority
Peterbourgh Art Gallery
Royal Scottish Academy Collection
Scottish Arts Council
The Scottish Office, Edinburgh
Worcester College of Education

Martin Creed

1968	Born Wakefield, England
1986–90	Slade School of Fine Art, London

Lives and works in London

Selected solo exhibitions

1993	Starkmann Limited, London
1994	Cubitt Gallery (Part 3 of 'Weekenders', curated by Matthew Higgs), London
	Marc Jancou Gallery, London
1995	Galerie Analix B&L Polla, Geneva

Galleria Paolo Vitolo, Milan
Camden Arts Centre, London
Javier Lrts Centre, London
1997 Galleria Paolo Vitolo, Milan
Victoria Miro Gallery, London
The British School at Rome, Rome

Selected group exhibitions
1989 The Black Bull (curated by Tess Jaray), London
1991 Laure Genillard Gallery, London
1992 'Outta Here' (curated by Douglas Gordon), Transmission Gallery, Glasgow
Angel Row Gallery (curated by Mark Dey), Nottingham
1993 'Wonderful Life', Lisson Gallery, London
1994 'Art Unlimited: Multiples of the 1960s and 1990s from the Arts Council
Collection', South Bank Centre National Touring Exhibition, Centre for
Contemporary Arts, Glasgow and UK tour
'Sarah Staton's Supastore Boutique', Laure Genillard Gallery, London
'Little House on the Prairie', Marc Jancou Gallery, London
'Modern Art', Transmission Gallery, Glasgow
'Domestic Violence' (curated by Alison Jacques), Gio' Marconi, Milan
1995 'Snow Job' (curated by Lionel Bovier), Forde, Geneva
'Just Do It' (curated by Stefan Kalmar), Cubitt Gallery, London
Laure Genillard Gallery, London
'Zombie Golf', Bank, London
'Unpop' (curated by Bob and Roberta Smith), Anthony Wilkinson Fine Art,
London
'Multiple Choice', Jibby Beane, London
'The Fall of Man', Three Rooms and a Kitchen, Pori, Finland
'In Search of the Miraculous', Starkmann Ltd, London
'Fuori Fase' (curated by Angela Vettese), Viafarini, Milan
1996 'Life/Live' (curated by Laurence Bosse and Hans Ulrich Obrist), Musée
d'Art Moderne de la Ville de Paris
'The Speed of Light, The Speed of Sound' (curated by Jeremy Millar),
Design Institute, Amsterdam
'Against', Anthony d'Offay Gallery, London
'Ace!', Arts Council Collection, Hayward Gallery, London and touring
'East International', Sainsbury Centre for Visual Arts, Norwich
'try', Royal College of Art, London
'weil morgen' (curated by Stefan Kalmar), Eis-Fabrik, Hanover
'Affinata' (curated by Carolin Lindig), Castello di Rivara, Turin
1997 'Lovecraft' (curated by Martin McGeown and Toby Webster), Centre for
Contemporary Arts, Glasgow
'Supastore de Luxe No. 1' (curated by Sarah Staton), Up & Co., New
York
'Imprint 93 (and other related ephemera)' (curated by Matthew Higgs),
Norwich Gallery, Norwich
'Answer "Affirmative or Negative"', Art Metropole, Toronto
'Snowflakes Falling on the International Dateline' (curated by David
Lillington), CASCO, Utrecht
1998–99 'transistors', Hashimoto Museum of Art, Morioka, Japan; Royal Museum of
Scotland, Edinburgh

Dalziel + Scullion

MATTHEW DALZIEL
1957 Born Irvine, Scotland
1981–85 BA (Hons), Fine Art, Duncan of Jordanstone College of Art, Dundee
1985–87 Higher National Diploma, documentary photography, Gwent College of
Higher Education, Wales
1987–88 Post-graduate in Sculpture and Fine Arts Photography, Glasgow School
of Art
1988–89 Artist-in-residence, Shell UK Exploration and Production, St Fergus Gas
Plant
1992 Artist-in-residence, Addenbrooke's Hospital, Cambridge
1994–95 Artist-in-residence, Banff and Buchan district
1995–97 Fine Art research fellow, Dundee University

Selected solo exhibitions
1988 'Mysterious Coincidences', London, Cardiff, California, Hong Kong and
Melbourne
1989 'Ways of Telling', Oriel Mostyn, Llandudno, Wales
'Unseen, Unheard But Measured', St Fergus Gas Plant, Peterhead
'Through Photography', Third Eye Centre, Glasgow
1990 'The British Art Show', McLellan Galleries, Glasgow, Leeds City Art Centre
and Hayward Gallery, London
'Either/Or', Kelvingrove Art Gallery, St Enoch Shopping Centre and
Billboard Art Works, Glasgow
1995 'The Most Beautiful Thing', Scottish Arts Council Commission for the
Travelling Gallery
1996 Centre for Contemporary Arts, Glasgow
Ikon Gallery, Birmingham
'British Waves' (curated by the British Council and Mario Codognato),
Studio Miscetti, Rome, British Festival of Arts
Arnolfini Gallery, Bristol
1997 'Goes Ah', Iain Irving Projects, Greenwards
'Endlessly', Scottish National Gallery of Modern Art, Edinburgh

Selected group exhibitions
1993 'Public and Private', Institut Français d'Écosse, Fotofeis International
Photographic Exhibition
1995 'Venice Biennale', Young British Artists, Scuola di San Pasquale
'Swarm', Scottish Arts Council Travelling Gallery
'Shadows on the Water', Fotofeis International Touring Exhibition
1996 'Luminous', Northern Gallery of Contemporary Art, Sunderland
'Girls High', The Mackintosh Gallery, Glasgow School of Art; Glasgow
Fruitmarket, Glasgow
1997 'If it wasn't for the mist we could see your home across the bay ...'
(curated by Judith Findlay), New York
1998–99 'transistors', Hashimoto Museum of Art, Morioka, Japan; Royal Museum of
Scotland, Edinburgh

Commissions
1992 'Blue & White', Tramway, Glasgow
'Satellites & Monuments' (large-scale light work), Lux Europae,
Edinburgh
1994 '4 Minutes', Science Museum, London
'Art Unlimited: Multiples of the 1960s and 1990s from the Arts Council
Collection', South Bank Centre National Touring Exhibition, Centre for
Contemporary Arts, Glasgow and UK tour
1995 'Arts Beast', Eastwood Arts Festival, Glasgow
1997 'Migrator', World Business Centre, Heathrow Airport, London
'The Horn', West Lothian Council for the M8 Motorway

LOUISE SCULLION
1966 Born Helensburgh, Scotland
1984–88 BA (Hons), Fine Art (Environmental Art), Glasgow School of Art
1989–90 Artist-in-residence, Smith Art Gallery and Museum, Stirling
1990–92 Artist-in-residence, Royal Cornhill Psychiatric Hospital, Aberdeen
1994–95 Artist-in-residence, Banff and Buchan district
1995–97 Fine Art research fellow, Dundee University

Selected solo exhibitions
1989 'Scatter', Third Eye Centre, Glasgow
1990 'The British Art Show', McLellan Galleries, Glasgow, Leeds City Art Centre
and Hayward Gallery, London
'Four Contemporary Sculptors', Bluecoat Gallery, Liverpool
1991 'Iris', An Lanntair Gallery, Stornoway, Isle of Lewis
1992 'The Furnished Landscape', Craft Council Gallery, London
1995 'The Most Beautiful Thing', Scottish Arts Council Commission for the
Travelling Gallery
1996 Centre for Contemporary Arts, Glasgow
Ikon Gallery, Birmingham
'British Waves' (curated by the British Arts Council and Mario Codognato),
Studio Miscetti, Rome, British Festival of Arts
Arnolfini Gallery, Bristol
1997 'Goes Ah', Iain Irving Projects, Greenwards
'Endlessly', Scottish National Gallery of Modern Art, Edinburgh

Selected group exhibitions

1993 'Public and Private', Institut Français d'Écosse, Fotofeis International
 Photographic Exhibition
1995 'Venice Biennale', Young British Artists, Scuola di San Pasquale
 'Swarm', Scottish Arts Council Travelling Gallery
 'Shadows on the Water', Fotofeis International Touring Exhibition
1996 'Luminous', Northern Gallery of Contemporary Art, Sunderland
 'Girls High', The Mackintosh Gallery, Glasgow School of Art; Glasgow
 Fruitmarket, Glasgow
1997 'If it wasn't for the mist we could see your home across the bay …'
 (curated by Judith Findlay), New York
1998–99 'transistors', Hashimoto Museum of Art, Morioka, Japan; Royal Museum of
 Scotland, Edinburgh

Commissions

1988 'Reconnaissance Bench', Glasgow Garden Festival
1992 'Vending Machines' (exhibition of works using light), Lux Europae, Edinburgh
1994 '4 Minutes', Science Museum, London
 'Art Unlimited: Multiples of the 1960s and 1990s from the Arts Council
 Collection', South Bank Centre National Touring Exhibition, Centre for
 Contemporary Arts, Glasgow and UK tour
1995 'Arts Beast', Eastwood Arts Festival, Glasgow
1997 'Migrator', World Business Centre, Heathrow Airport, London
 'The Horn', West Lothian Council for the M8 Motorway

Collections

Arts Council of England
Science Museum, London
Victoria & Albert Museum, London

Bibliography

Mysterious Coincidences, exhibition catalogue, Photographers Gallery, London, 1987
Ways of Telling, exhibition catalogue, Oriel Mostyn Gallery, Llandudno, 1989
Scatter, exhibition catalogue, Third Eye Centre, Glasgow, 1989
Through Photography, exhibition catalogue, Third Eye Centre, Glasgow, 1989
The British Art Show 3, exhibition catalogue, South Bank Centre, London, 1990
Power and Providence, exhibition catalogue, Cambridge Darkroom, Cambridge, 1992
Lux Europae, exhibition catalogue, Edinburgh, 1992
The Most Beautiful Thing — Dalziel + Scullion, exhibition catalogue, Scottish Arts
Council, Edinburgh, 1995
Judith Findlay, *Desire and the Work of Dalziel + Scullion*, Red Bluff Publications,
Glasgow, 1995
1995 *Venice Biennale Catalogue*, British Council, London, 1995
Small Living Things That Fly, Centre for Contemporary Arts, Glasgow, 1995
British Artists in Rome, exhibition catalogue, The British Council, Rome, 1996
Luminous, exhibition catalogue, Northern Gallery for Contemporary Art, Sunderland, 1996
Judith Findlay, *Art & Design*, 1996
The Scotsman, Duncan Macmillan, January 22, 1996
Art Monthly, Issue No. 193, February, 1996
Iain Gale, 'East Meets West in the Gardens of Paradise', *Scotland on Sunday*,
July 20, 1997
Keith Hartley, *Endlessly*, exhibition catalogue, Scottish National Gallery of Modern Art,
Edinburgh, 1997
transistors, exhibition catalogue, Hashimoto Museum of Art, Morioka, Japan; Royal
Museum of Scotland, Edinburgh, 1998

Ian Hamilton Finlay

1925 Born Nassau, Bahamas
1950s Published short stories and plays
1961 Founded The Wild Hawthorn Press with Jessie McGuffie
1962 Founded the periodical *Poor.Old.Tired.Horse*
1966 Moved to Stonypath with Sue Finlay
1975 Commenced permanent landscaped installations in Stuttgart, Otterlo,
 Vienna, Eindhoven, San Diego, Strasbourg and elsewhere
1978 Began 'Five Year Hellenisation Plan' for Stonypath garden, now renamed
 Little Sparta
1979–84 Founded the Saint-Just Vigilantes

1985 Shortlisted for Turner Prize, Tate Gallery, London
1987 Awarded honorary doctorate by University of Aberdeen
1991 Presented with a bust of Saint-Just by the French Communist Party
1993 Awarded honorary doctorate by Heriot-Watt University, Edinburgh

Selected solo exhibitions

1968 Axiom Gallery, London
1969 Pittencrief House, Dunfermline
 Demarco Gallery, Edinburgh
1970 Ceolfrith Bookshop Gallery, Sunderland
1971 Winchester College of Art
1972 Scottish National Gallery of Modern Art, Edinburgh
1974 National Maritime Museum, London
1976 Coracle Press, London
 'Homage to Watteau', Graeme Murray Gallery, Edinburgh
 City Art Gallery, Southampton
1977 Graeme Murray Gallery, Edinburgh
 Kettle's Yard Gallery, Cambridge
 Serpentine Gallery, London
1980 'Nature Over Again After Poussin', Collins Exhibition Hall, University of
 Strathclyde, Glasgow
 Rijksmuseum Kröller-Müller, Otterlo
 Graeme Murray Gallery, Edinburgh
1981 'Unnatural Pebbles', Graeme Murray Gallery, Edinburgh
1984 'Talismans and Signifiers', Graeme Murray Gallery, Edinburgh
 'Liberty, Terror and Virtue', City Art Gallery, Southampton
 Print Gallery, Peter Brattinga, Amsterdam
1985 Bluecoat Gallery, Liverpool
 Eric Fabre Galerie, Paris
 'Little Sparta and Kriegsschatz', Chapelle Sainte-Marie, Nevers, France
1986 Aberdeen Art Gallery
 'Marat Assassiné & Other Works', Victoria Miro Gallery, London
1987 'Inter Artes et Naturam', Musée d'Art Moderne de la Ville de Paris
 'Midway', Bibliothèque Nationale, Paris
 'Pastorales', Galerie Claire Burrus, Paris
 'Poursuites Révolutionnaires', Fondation Cartier pour l'Art Contemporain,
 Jouy-en-Josas
 Victoria Miro Gallery, London
1988 Musée d'Art Contemporain, Dunkerque
 'An Exhibition on Two Themes', Galerie Jule Kewenig, Frechen am
 Bachem, Cologne
 Victoria Miro Gallery, London
 Michael Klein Gallery, New York
1989 Galerie Wernicke, Stuttgart
 Städtische Galerie am Markt, Schwäbisch-Hall
 Kellie Lodging Gallery, Pittenween, Scotland
 'Paperworks', Galerie Hubert Winter, Vienna
 '1789–1794', Kunsthalle, Hamburg
 'Works', Butler Gallery, Kilkenny Castle
1990 Galerie Schedle & Arpagaus, Zurich
 Kunsthalle, Basel
 ACTA-Galleria, Milan
 Stampa, Basel
 Christine Burgin, New York
 Galerie Jule Kewenig, Frechen am Bachem, Cologne
 'Idylls', Victoria Miro Gallery, London
 'The Ocean and the Revolution', Gallery Burnett Miller, Los Angeles
 'A Wartime Garden', Graeme Murray Gallery, Edinburgh
 'Holzwege', Neuer Aachener Kunstverein, Aachen
 'Ian Hamilton Finlay and The Wild Hawthorn Press 1958–1990', Frith
 Street Gallery, London
1991 'Gulfs and Wars', Kunstverein Friedrichshafen
 Malerisamling Lillehammer, Norway
 'Ideologische Äusserungen', Frankfurter Kunstverein, Frankfurt am Main
 'Pastorales', Overbeck-Gesellschaft, Lübeck
 'Definitions', Galerie Sfeir-Semler, Kiel
 Galerie Stadtpark, Krems, Austria
 Tate Gallery, Liverpool

Wadsworth Atheneum, Hartford, Connecticut
Philadelphia Museum of Art
'Ian Hamilton Finlay and The Wild Hawthorn Press', Fruitmarket Gallery, Edinburgh
'The Poor Fisherman', Talbot Rice Gallery, Edinburgh
1992 'Instruments of Revolution and other Works', Institute of Contemporary Art, London
City Art Galleries, Leeds
'10 Maquettes for neo-classical structures', Victoria Miro Gallery, London
1993 CAYC, Buenos Aires
'A Wartime Garden', Tate Gallery, London
'Wildwachsende Blumen', Lenbachhaus Munich, Germany
'The Sonnet is a Sewing-Machine for the Monostitch', Crawford Arts Centre, Scotland
'Inscriptions', Massimo Minini Gallery, Brescia, Italy
'12/1794', Galerie Busche, Berlin
'A Proposal for The Leasowes and other works', MBC Dudley, England
1994 'Streiflichter: Fragments from the French Revolution', Nolan/Eckman Gallery, New York
'Icons and Proposals', Laumeier Sculpture Park and Museum, St Louis
'3 Sailboats', Victoria Miro Gallery, London
1995 Deichtorhallen, Hamburg, Germany
1997 Buro Sophia Ungers, Cologne, Germany

Selected group exhibitions
1983 Hayward Gallery, London
1985 'The British Show', British Council exhibition, Sydney
1986 'Between Object and Image', Madrid and Barcelona
1987 'Documenta 8', Kassel
'The Unpainted Landscape', Edinburgh
1988 'Pyramiden', Galerie Jule Kewenig, Frechen am Bachem, Cologne
'Starlit Waters, British Sculpture 1968–88', Tate Gallery, Liverpool
'Art in the Garden', Garden Festival, Glasgow
'Skulpturen Rebublik', exhibition of the Vienna-Festival, Vienna
Triennale Milano, Italy
'Camouflage', Curt Marcus Gallery, New York
1989 'British Sculpture 1960–88', Museum van Hedendaagse Kunst, Antwerp
'Prospect '89', Frankfurter Kunstverein/Schirn Kunsthalle, Frankfurt am Main
'2000 Jahre — Die Gegenwart der Vergangenheit', Bonner Kunstverein, Bonn
1990 'Glasgow's Great British Art Exhibition', McLellan Galleries, Glasgow
'Poesis', Graeme Murray Gallery, Edinburgh
'British Art Now: A Subjective View', Setagaya Art Museum, Fukuoka Art Museum, Nagoya City Art Museum, Japan
1991 'Rhetorical Image', The New Museum of Contemporary Art, New York
'Metropolis', Berlin
1992 'Lux Europae', Lux Europae Trust, Edinburgh
'Verzamelde Werken', Centrum Beeldende Kunst, Groningen, The Netherlands
1993 'Konfrontation', Museum Moderner Kunst, Vienna
'Die Sprache der Kunst', Kunsthalle Wien, Vienna and Frankfurter Kunstverein, Frankfurt am Main
1994 'East of Eden', Museum Schloss Mosigkau, Dessau-Mosigkau
'Das Jahrhundert des Multiples', Deichtorhallen, Hamburg
1998 'Wounds. Between Democracy and Redemption in Contemporary Art', Stockholm, Sweden
'Green Waters', The Pier Art Centre, Stromness, Orkney, Scotland
'La Biennale de Montréal', Centre International d'Art Contemporain de Montréal, Canada

Installations
1975 Garden of the Max Planck Institut, Stuttgart
Scottish National Gallery of Modern Art, Royal Botanic Garden, Edinburgh
1976 University of Liège, Belgium
1978 Bell's Garden, Perth, Scotland
1979 British Embassy, Bonn
1980 Kröller-Müller Sculpture Garden, Otterlo, Holland
1984 Celle, Garden of Giuliano Gori (near Florence), Italy

1986 Domaine de Kerguehennec, Brittany
Schweizergarten, Vienna
Van Abbemuseum, Eindhoven
1987 Münster Skulptur Projekt, Münster, Germany
Campus of the University of California, San Diego
Furka Pass, Switzerland
West Princes Street Gardens, Edinburgh
1988 Museum of Modern Art, Strasbourg
1989 Harris Museum and Art Gallery, Preston, England
Forest of Dean, England
1990 Private library of the German architect Ungers, Cologne
12th and K Office Tower, Sacramento, California
Railway Bridge, Glasgow
1991 Stockwood Park Nurseries in the Borough of Luton, England
Library of Baden, Karlsruhe, Germany
Overbeck-Gesellschaft, Lübeck
1992 Shenstone's Leasowes, Dudley, England
Floriadepark, Zoetermeer, The Netherlands
1993 Beelden op de Berg, Belmonte Arboretum, Wageningen, The Netherlands
1994 Laumeier Sculpture Park, St Louis
Schröder Münchmeyer Hengst & Co Bank, Frankfurt am Main
1995 Landesgartenschau, Grevenbroich, Germany
Kunsthalle, Hamburg
1996 Botanic Garden, University of Durham, England
1997 Kunsthalle, Hamburg
Hunter Square, Edinburgh
1998 Serpentine Gallery, London
The Ark, London
Den Haag, The Netherlands

Bibliography
Francis Edeline, *Ian Hamilton Finlay*, Atelier de l'Agneau, Paris, 1977
Ian Hamilton Finlay: Collaborations, exhibition catalogue, Kettle's Yard, Cambridge, 1977
Christopher McIntosh, *Coincidence in the work of Ian Hamilton Finlay*, Graeme Murray Gallery, Edinburgh, 1980
Yves Abrioux, *Ian Hamilton Finlay: A Visual Primer*, Reaktion Books, London, 1985
Daidalos, Issue No. 38, Berlin, 1990
William Howard Adams, *Grounds for Change — Major Gardens of the Twentieth Century*, Little, Brown and Company, Bullfinch Press, 1993
Madison Cox, *Artists' Gardens*, Abrams Inc., New York, 1993
Wildwachsende Blumen, exhibition catalogue, Stadtische Galerie im Lenbachhaus, Munich, 1993
Art and Design: Art and the Natural Environment, Academy, London, 1994
Streiflichter, exhibition catalogue, Nolan/Eckman Gallery, New York, 1994
Chapman, Issue No. 78/79, Edinburgh, 1994

Gareth Fisher

1951 Born Cumberland, England
1973 Diploma in Sculpture, Edinburgh College of Art
1974 Post-diploma, Edinburgh College of Art
1975 Second post-diploma, Edinburgh College of Art

Selected solo exhibitions
1977 New 57 Gallery, Edinburgh
1984 Mercer Union, Toronto
1985 Abbott Hall, Kendal, Cumbria
1986 Fruitmarket Gallery, Edinburgh
Artspace Gallery, Aberdeen
1987 Seagate Gallery, Dundee
1994 Sutton House, London
1997 'Binocular' (with John Mitchell), Svoboda Foundation, Prague
1998 Galleria Antonia Jannone, Milan

Selected group exhibitions
1978 Talbot Rice Art Centre, Edinburgh
1979 Artists Space Gallery, New York
Art Gallery of Nova Scotia

1981	Hatton Gallery, Newcastle
1983	'Built in Scotland', Edinburgh, Glasgow and Camden Art Centre, London
1984–85	'British Art Show', Birmingham, Edinburgh, Southampton, Sheffield
1985	Smith Biennial, Stirling
1989	'Scatter', Third Eye Centre, Glasgow
1991	John Gruzelier Fine Art, London
1992	Collective Gallery, Edinburgh
1994	'Nine Sculptors in Scotland', College of Art, Edinburgh Festival
	'Scandex', exhibition of Scottish sculpture touring to Scandinavia
1997	'Breath Poems', Galleria Antonia Jannone, Milan
	'Binocular', sculpture and photography, Sin Pod Pleknikovym Schodistem, Prague
1998–99	'transistors', Hashimoto Museum of Art, Morioka, Japan; Royal Museum of Scotland, Edinburgh

Commissions

| 1995 | Museum of Contemporary Art, Maglioni, Turin |

Publications by the artist

Breath Poems, artist's book collaboration with Italian poet Giovanni Tamburelli, Turin

Andy Goldsworthy

1956	Born Cheshire, England
1974–75	Bradford Art College
1975–78	BA (Hons), Fine Art, Preston Polytechnic, Lancaster
1985	Moved to Langholm, Dumfriesshire
1988	Established 'Stonewood', Scaur Glen, Dumfriesshire
	Residency, Yorkshire Sculpture Park
1993	Honorary BA degree, Bradford University
1995	Honorary fellowship, University of Central Lancashire
	The Royal Mail issued a series of stamps that featured five of Goldsworthy's works
	Collaborated with Ballet Atlantique to create 'Végétal', a ballet conceived by French choreographer Régine Chopinot
1996	Senior lecturer/practitioner, Fine Art/Craft, University of Hertfordshire

Selected solo exhibitions

1984	'Seven Spires', Grisedale Forestry Commission, Cumbria
1985	'Sidewinder', Grisedale Forest, Cumbria
1987	'Entrance', Hooke Park Commission, Dorset
1989	'Maze', Leadgate Commission, County Durham
	North Pole Project
	'The Wall', Stonewood, Dumfriesshire
1990	'Touchstone North', Dumfriesshire
1991	'The Wall that Went for a Walk', Grisedale Forestry Commission, Cumbria
	'Seven Holes', Greenpeace Commission, London
	'Two Autumns' (Channel 4 film), Arts Council of Great Britain
1994	Runnymede Sculpture Farm Project, California
	'Herd of Arches', Hathill Sculpture Foundation, Goodwood, Sussex
1996	'100 Sheepfolds' (start of project for Cumbria Year of Visual Art)

Selected group exhibitions

1993	'Group Show', Galerie Lelong, New York
	'Impermanence', Alderich Museum of Contemporary Art
	'Mid Winter Muster', Harewood House, Leeds
	'Parc de la Coneuve' (Paris installation)
	'Morecambe Bay Works', Scott Gallery and Storey Institute, Lancaster
	'Tikon Project', Tikon, Denmark
	'Trees. The Fourth State of Water', Kunstlerwerkstraat, Munich
	'Wood Land', Galerie Lelong, New York
	'Two Autumns', Tochigi Prefectural Museum of Fine Arts, Japan
1994	'Two Autumns', Setagaya Museum of Fine Arts, Tokyo
	'Stone', Michael Hue-Williams Fine Art, London; Haines Gallery, San Francisco; Galerie Aline Vidal, Paris; Laumeier Sculpture Park, St Louis, Missouri; Oriel Gallery, Cardiff
	'Time Machine', Department of Egyptian Antiquities, British Museum, London
1995	'Breath of Earth', San José Museum of Art

	'Four Stones', Galerij S65, Aalst, Belgium
	'Black Stones, Red Pools', Galerie Lelong, New York
	'Earth Memory', Musée de Digne les Baines, Haute-Provence, France
	'A Clearing of Arches. For the Night', Hathill Sculpture Foundation, Goodwood, Sussex
	'For the Night', Green on Red Gallery, Dublin
	'Time Machine', Museo Egizio, Turin, Italy
	'Végétal' (scenography), a contemporary dance collaboration with Ballet Atlantique, La Rochelle, France
1996	'Clay floor installation', Glasgow Museum of Modern Art
	'Printemps de Cahors', Cahors, France
	'Northern Rock Art', DLI Museum & Durham Art Gallery
	'Sheepfolds', Tully House Museum and Art Gallery, Carlisle and Margaret Harvey Gallery, St Albans
	'Wood', Michael Hue-Williams Fine Art, London; Galerie Lelong, New York; Haines Gallery, San Francisco
1998–99	'transistors', Hashimoto Museum of Art, Morioka, Japan; Royal Museum of Scotland, Edinburgh

Commissions

1988	'Lambton Earthwork', County Durham
1990	'Enclosure', Royal Botanic Garden, Edinburgh
1991	'Steel Cone', Gateshead
1992	'Black Spring', Royal Botanic Gardens, Adelaide
1993	'Four Corner Stones', Nice
	'Stone Gathering', Northumberland
	'Rockfold', Northumberland
	'Fieldgate', Poundridge, New York
1994	Mallorca (private commission)
	Laumeier Sculpture Park
1995	'Cone', New York
	'Cone', Oxfordshire
1996	'Boulder Wall', Bedford Corners, New York

Bibliography

Rain Sun Snow Hail Mist Calm, The Henry Moore Centre for the Study of Sculpture, Leeds, 1985

Mountain and Coast, Autumn into Winter Japan 1987, exhibition catalogue, Gallery Takagi, Nagoya, Japan, 1987

Parkland, Yorkshire Sculpture Park, Wakefield, 1987

Leaves, Common Ground, London, 1989

Garden Mountain, Galerie Aline Vidal, Paris, 1989

Touching North, Fabian Carlsson/Graeme Murray, Edinburgh, 1989

Andy Goldsworthy, Viking, UK; Abrams Inc., US; Éditions Anthese, France; Zweitausendeins, Germany, 1989

Sand Leaves, The Arts Club of Chicago, Chicago, 1991

Hand to Earth, W. S. Maney, Leeds; Abrams Inc., US, 1991

Ice and Snow Drawings, exhibition catalogue, Fruitmarket Gallery, Edinburgh, 1992

Two Autumns, exhibition catalogue, Tochigi Prefectural Museum of Fine Arts, Japan, 1993

Stone, Viking, UK; Abrams Inc., US; Éditions Anthese, France; Zweitausendeins, 1994

Black Stones, Red Pools, The Pro Arte Foundation/Michael Hue-Williams Fine Art Ltd, London; Galerie Lelong, New York, 1995

Végétal, Ballet Atlantique–Régine Chopinot, France, 1996

Alaska Works, Andy Goldsworthy, exhibition catalogue, Anchorage Museum of History and Art and Alaska Design Forum, Anchorage, 1996

Sheepfolds, Michael Hue-Williams Fine Art Ltd, London, 1996

Wood, Viking, UK; Abrams Inc., US; Éditions Anthese, France; Zweitausendeins, Germany, 1996

transistors, exhibition catalogue, Hashimoto Museum of Art, Morioka, Japan; Royal Museum of Scotland, Edinburgh, 1998

Douglas Gordon

1966	Born Glasgow, Scotland
1984–88	Glasgow School of Art
1988–90	The Slade School of Art, London
1996	Awarded Turner Prize

1997 Awarded Premio 2000 at Venice Biennale
 Daad-Stipendium, Berlin
1998 Central Krankenversicherung Prize, Kölnischer Kunstverein, Cologne
 Lord Provost's Award, Glasgow City Council, Glasgow
 Awarded Guggenheim Museum SoHo Hugo Boss Prize, New York
Lives and works in Glasgow

Selected solo exhibitions
1993 '24 Hour Psycho', Tramway, Glasgow and Kunst-werke, Berlin
 'Migrateurs' (curated by Hans Ulrich Obrist), Musée d'Art Moderne de la
 Ville de Paris
1994–95 Lisson Gallery, London
1995 'Bad Faith', Kunstlerhaus, Stuttgart
 'The End', Jack Tilton Gallery, New York
 'Jukebox' (in collaboration with Graham Gussin), The Agency, London
 'Entr'Acte 3', Van Abbe Museum, Eindhoven
1995–96 Centre Georges Pompidou, Paris
 Rooseum Espresso, Malmö, Sweden
1996 'Douglas Gordon & Rirkrit Tiravanija', FRAC Languedoc-Roussillon,
 Montpellier
 '24 Hour Psycho', Akademie der Bildende Kunste, Vienna
 Galleria Bonomo, Rome (part of the British Art Festival)
 Canberra Contemporary Art Space, Canberra
 Museum für Gegenwartskunst, Zurich
 Galerie Walchenturm, Zurich
 'The Turner Prize 1996', Tate Gallery, London
1997 Galleri Nicolai Wallner, Copenhagen
 Bloom Gallery, Amsterdam
 Galerie Micheline Swajcer, Antwerp
 Münster Skulptur Projekt, Münster, Germany
 Galerie Mot & Van den Boogaard, Brussels
 Gandy Gallery, Prague
 'Douglas Gordon', Biennale de Lyons
 '5 Year Drive-By', Kunstverein Hannover
1998 'Leben nach dem Leben nach dem Leben …', Deutsches Museum, Bonn
 'Douglas Gordon', Dvir Gallery, Tel Aviv
 'Douglas Gordon', Kunstverein Hannover, Hannover, Germany

Selected group exhibitions
1989 'Smith Biennial', Stirling, Scotland
 'Windfall '89', Bremen, Germany
1990 'Sites/Positions', touring throughout Glasgow
 'Self Conscious State', Third Eye Centre, Glasgow
1991 'Barclays Young Artist Award', Serpentine Gallery, London
 'London Road …' (in collaboration with Roderick Buchanan), Orpheus
 Gallery, Belfast
 'The Bellgrove Station Billboard Project', Bellgrove, Glasgow
 'Windfall '91', Seaman's Mission, Glasgow
 'Walk On', Jack Tilton Gallery, New York and Fruitmarket Gallery, Edinburgh
1992 'Anomie', Patent House/Andrew Cross, London
 'Speaker Project', Institute of Contemporary Arts, London
 'Love at First Sight', The Showroom, London
 'And What Do You Represent?', Anthony Reynolds Gallery, London
 'Guilt By Association', Museum of Modern Art, Dublin
1992–93 'Instructions', Studio Marconi, Milan
1993 'Purpose Built …', Real Art Ways, Hartford, Connecticut
 'Before the Sound of the Beep' (artist's soundworks throughout Paris)
 'Left Luggage', Maison Hanru, Paris
 'Prospekt '93', Kunsthalle, Frankfurt
 'Wonderful Life', Lisson Gallery, London
1993–94 'High Fidelity' (with Tom Gidley), Kohji Ogura Gallery, Nagoya (tour to the
 Röntgen Kunst Institut, Tokyo)
1994 'Watt', Witte de With Center for Contemporary Art, Rotterdam and
 Kunsthal, Rotterdam
 'Stains in Reality' (Stan Douglas, Douglas Gordon, Joachim Koesterm),
 Galleri Nicolai Wallner, Copenhagen
 'Wall to Wall', Leeds City Art Gallery (South Bank Centre National Touring
 Exhibition)
 'Something between my mouth and your ear' (installation for 'The Reading

Room', a project initiated by Book Works, London), Dolphin Gallery, Oxford
'Modern Art', Transmission Gallery, Glasgow
'Gaze: l'Impossible transparence', Carré des Arts, Parc Florale de Paris, Paris
'The Institute of Cultural Anxiety: Works from the collection', Institute of
Contemporary Arts, London
'Points de vue: Images d'Europe', Centre Georges Pompidou, Paris
1995 'Eigen & Art at the Independent Art Space', Independent Art Space, London
 'Take me (I'm yours)', Serpentine Gallery, London and Kunsthalle, Nurnberg
 'General Release' (British Council selection of young British artists), Scuola
 di San Pasquale, Venice
 'Shift', De Appel Foundation, Amsterdam
 'Wild Walls', Stedelijk Museum, Amsterdam
 'Am Rande der Malerei', Kunsthalle, Bern
 'Shopping', CAPC Musée d'Art Contemporain, Bordeaux
1995–96 'Biennale de Lyons', Lyons
 'The British Art Show 4', South Bank Centre National Touring Exhibition,
 various venues in Manchester, Edinburgh and Cardiff
1996 'By Night', Fondation Cartier pour l'Art Contemporain, Paris
 'Hall of Mirrors: Art and Film' (touring exhibition), Museum of
 Contemporary Art, Los Angeles; The Wexner Center for the Arts,
 Columbos, Ohio; Palazzo delle Espozioni, Rome; Museum of
 Contemporary Art, Chicago
 'Traffic', CAPC Musée d'Art Contemporain, Bordeaux
 'Spellbound', Hayward Gallery, London
 'Sawn-Off', Uppsala Konstmusum, Uppsala
 'Manifesta 1', Rotterdam
 'Auto reverse 2', Le Magasin, Grenoble
 'Nach Weimar', Kunstammlungen Weimar
 'Scream and Scream Again', MOMA Oxford
 10th Sydney Biennale, Sydney
 'Girls High', The Mackintosh Gallery, Glasgow School of Art; Glasgow
 Fruitmarket, Glasgow
 'ID', Van Abbemuseum, Eindhoven
 'Life/Live', Musée d'Art Moderne de la Ville de Paris; Centro Cultural de
 Belem, Portugal
1997 Southampton City Art Gallery
 'Animal', Centre for Contemporary Arts, Glasgow
 'Wish you were here too', 83 Hill Street, Glasgow
 'Gothic', Institute of Contemporary Art, Boston
 'Past, Present, Future' (curated by Germano Celant), Venice Biennale
 'Material Culture: the object in British Art in the '80s and '90s', Hayward
 Gallery, London
 Hiroshima Art Document, Hiroshima, Japan
 'Quelques motifs de déclaration Amours', Fondation Cartier pour l'art
 Contemporain, Paris
 'Follow Me, Britische Kunst an der Unterelbe', billboards between
 Buxtehude and Cuxhaven
 'Scream and Scream Again: Film in Art', Museum of Contemporary Art,
 Helsinki
 'Künstlerinnen, 50 Positionen', Kunsthaus Bregenz, Vienna
 'Pictura Britannica: Art From Britain', Museum of Contemporary Art,
 Sydney (touring to Art Gallery of South Australia, Adelaide and City Gallery,
 Wellington, New Zealand)
 'Flexible', Museum für Gegenwartskunst, Zurich
 Goetz Collection Exhibition, Munich
 'Infra-slim Spaces', Soros Contemporary Art Gallery SCCA, Kiev, Ukraine
1998 'Art Calls' (curated by Jacob Fabricius), Denmark
 'New Art from Scotland', Museet for Samtidskunst, Oslo
 Mary Boone Gallery, New York (curated by Neville Wakefield)
 'Close Echoes', City Gallery, Prague and touring to Kunsthalle Krems
 'British Art', Tochigi Prefectural Museum of Fine Arts, Japan
 '7 Artists from Europe', Takasaki Museum of Art, Gunma
 'Tuning up No. 5', Kunstmuseum Wolfsburg
 'London Calling', British School at Rome, Rome
 'Projected Allegories', Contemporary Arts Museum, Houston, Texas
 'Then and Now', Lisson Gallery, London
 'Crossings', Kunsthalle Vienna

Guggenheim Museum Hugo Boss Prize, Guggenheim SoHo, New York
'New Works', Galerie Mot & Van den Boogaard, Brussels
'Time Zone', Kölnischer Kunstverein, Cologne
'Emotion: Young British and American Art from the Goetz Collection',
Deichtorhallen, Hamburg
'So Far Away, So Close', Encore, Brussels, MEC, Glasgow
'Exhibition of Contemporary Art from Private Collections in France', Tel Aviv
Museum of Art
'Happy Hours', Yvon Lambert, Paris
1998–99 'transistors', Hashimoto Museum of Art, Morioka, Japan; Royal Museum of
Scotland, Edinburgh
'Exhibition of Contemporary British Art: Japanese Museum Tour', Tochigi
Prefectural Museum travelling to Fukuoka City Art Museum, Hiroshima
City Museum of Contemporary Art, Tokyo Museum of Contemporary Art,
Ashiya City Museum of Art and History

Commissions
1994 Book Works, London
1997 Agnes B., publication curated by Hans-Ulrich Obrist
1998 'Empire', Visual Art Project for the Merchant City Civic Society, Glasgow

Bibliography
Books and catalogues
Windfall '89, exhibition catalogue, Bremen, Germany, 1989
Self Conscious State, exhibition catalogue, Third Eye Centre, Glasgow, 1990
Alan Dunn, Francis McKee, Nigel Rolfe, *The Bellgrove Station Billboard Project*,
exhibition catalogue, Bellgrove, Glasgow, 1991
Windfall '91, exhibition catalogue, Seaman's Mission, Glasgow, 1991
Murdo Macdonald, *Walk On*, exhibition catalogue, Jack Tilton Gallery, New York and
Fruitmarket Gallery, Edinburgh, 1991
Thomas Lawson, Ross Sinclair, *Guilt by Association*, exhibition catalogue, Museum of
Modern Art, Dublin, 1992
Instructions Received, exhibition catalogue, Gio' Marconi, Milan, 1992–93
Stuart Morgan, Ross Sinclair, *24 Hour Psycho*, exhibition catalogue, Tramway,
Glasgow, 1993
Douglas Gordon, *Migrateurs*, exhibition catalogue, Musée d'Art Moderne de la Ville de
Paris, 1993
Viennese Story, Vienna Secession, Vienna, 1993
High Fidelity, exhibition catalogue, Ogura Gallery, Nagoya, Japan, 1993
Simon Sheikh, Stan Douglas, Douglas Gordon, *Joachim Koester*, exhibition catalogue,
Galleri Nicolai Wallner, Copenhagen, 1994
Douglas Gordon, *Cahier #2*, Witte de With Center for Contemporary Art, Richter
Verlag, 1994
Wall to Wall, exhibition catalogue, South Bank Centre, London, 1994
Points de View: Images d'Europe, exhibition catalogue, Centre Georges Pompidou,
Paris, 1994
Douglas Gordon, exhibition catalogue, Van Abbemuseum, Eindhoven, 1995
Wild Walls, exhibition catalogue, Stedelijk Museum, Amsterdam, 1995
Am Rande der Malerei, exhibition catalogue, Kunsthalle, Bern, 1995
R. Cork, T. Lawson, R. Finn-Kekey, *The British Art Show 4*, exhibition catalogue,
South Bank Centre National Touring Exhibition, 1995
Traffic, exhibition catalogue, CAPC Musée d'Art Contemporain, Bordeaux, 1996
Spellbound, exhibition catalogue, Hayward Gallery, London, 1996
Art and Film Since 1945. Hall of Mirrors, exhibition catalogue, Moca/Monacelli, Los
Angeles, 1996
Nach Weimar, exhibition catalogue, Kunstammlungen Weimar, Cantz Verlag, 1996
Artisti Britannici a Roma, exhibition catalogue, Umberto Allemandi & C., Turin, 1996
Sawn-Off, exhibition catalogue, various venues, Sweden, 1996
Propositions, exhibition catalogue, Musée Départemental de Rochechouart, 1996
Manifesta 1, exhibition catalogue, Rotterdam, 1996
Scream and Scream Again, exhibition catalogue, MOMA Oxford, 1996
33⅓, exhibition catalogue, Canberra Contemporary Art Space, Canberra, 1996
The Turner Prize 1996, exhibition catalogue, Tate Gallery, London, 1996
Close Your Eyes, exhibition catalogue, Museum für Gegenwartskunst, Zurich, 1996
Quelques motifs de déclarations d'Amours, exhibition catalogue, Fondation Cartier
pour l'art Contemporain, Paris, 1997
Skulptur: Projekte in Münster, exhibition catalogue, Munster, 1997
Emotion: Young British and American Art from the Goetz Collection (edited by Zdenek
Felix), exhibition catalogue, Deichtorhallen, Hamburg, 1998

Kidnapping: Douglas Gordon, exhibition catalogue, Stedelijk Van Abbemuseum,
Eindhoven, 1998
Kunstverein Hannover, exhibition catalogue, Hannover, 1998
Real/Life: New British Art, exhibition catalogue, Tokyo, 1998
transistors, exhibition catalogue, Hashimoto Museum of Art, Morioka, Japan; Royal
Museum of Scotland, Edinburgh, 1998

Articles and reviews
Liam Gillick, 'Windfall', *Artscribe*, London, 1989
Euan McArthur, 'Windfall', *Variant*, London, 1989
Euan McArthur, 'Sites/Positions', *Artscribe*, London, Summer, 1990
Peter Suchin, 'The Missing Text', *Variant*, London, 1991
Matthew Slotover, 'Windfall', *Frieze*, London, 1991
Nicola White, 'Windfall', *Alba*, 1991
Ian Hunt, 'Guilt by Association', *Frieze*, London, 1992
Michael Archer, 'Anomie', *Art Monthly*, London, 1992
Thomas Lawson, 'Hello, it's me', *Frieze,* London, Issue No. 9, 1993
Ian Buchan, 'Day of the Psycho', *Evening Times*, March 11, 1993
Ross Sinclair, 'Douglas Gordon', *Art Monthly*, London, June, 1993
Laura Cottingham, 'Wonderful Life, Lisson Gallery', *Frieze*, London, Issue No. 12, 1993
Andrew Wilson, 'Wonderful Life, Lisson Gallery, London', *Forum International,*
Belgium, Issue No. 19, 1993
Andrew Renton, 'Douglas Gordon: *Tramway*', *Flash Art,* Issue No. 172, 1993
David Mellor, 'Wonderful Life', *Untitled*, Issue No. 3, 1993
Michael Archer, 'Collaborators', *Art Monthly*, Issue No. 178, 1994
'Douglas Gordon', *The Guardian*, December 10, 1994
Richard Cork, 'Douglas Gordon', *The Times*, London, December 31, 1994
Iwona Blazwick, 'Douglas Gordon', *Art Monthly*, London, Issue No. 183, 1995
Gregor Muir, 'Douglas Gordon — Lisson Gallery — Londres', *Block Notes*, Issue
No. 8, Paris, 1995
Hou Hanru, 'Une élégante menace', *Omnibus*, Issue No. 8, Paris, 1995
Angela Kingston, 'Douglas Gordon', *Frieze*, Issue No. 21, London, 1995
Margareta Persson, 'Take me (I'm yours)', *Material,* Issue No. 25, Stockholm, 1995
Martin Maloney, 'Douglas Gordon', *Flash Art International*, Issue No. 182, Milan, 1995
Judith Findlay, 'Trust. Tramway, Glasgow', *Untitled,* London, Summer, 1995
Robert Garnett, 'The British Art Show 4', *Art Monthly*, Issue No. 192, London,
1995–96
Jérôme Sans, 'Douglas Gordon, Centre Georges Pompidou', *Artforum,* New York,
April, 1996
Amanda Crabtree, 'Biennale de Lyons', *Untitled*, Issue No. 10, London, 1996
Yves Abrioux, 'Douglas Gordon, Pompidou Centre, Paris & Lyons Biennale', *Untitled*,
Issue No. 10, London, 1996
Katrina M. Brown, 'Sawn Off', *Art Monthly*, Issue No. 196, London, 1996
Liam Gillick, 'The Corruption of Time', *Flash Art,* Issue No. 188, Milan, 1996
'Turner Prizewise', *Art Monthly*, Issue No. 198, London, 1996
Bill Hare, 'Motion and Emotion: Walking a Tightrope', *Contemporary Art*, Issue No. 4,
London, 1996
Stuart Morgan, 'Manifesta', *Frieze*, Issue No. 30, London, 1996
Adrian Searle, 'Winning game of good and evil', *The Guardian*, London,
November 29, 1996
Jonathan Jones, 'Douglas Gordon Confessions of a justified sinner', *Untitled,* Issue
No. 12, London, 1996
Christine Van Assche, 'Six questions to Douglas Gordon', *Parachute*, Issue No. 84, 1996
Sotiris Kyriacou, 'The Rise and Rise of British Video', *Contemporary Visual Arts*, Issue
No. 14, 1997
Tobia Bezzola, 'De Spectaculis or Who Is Kim Novak Really Playing?', *Parkett,*
Issue No. 49, 1997
Russell Ferguson, 'Divided Self', *Parkett,* Issue No. 49, 1997
Richard Flood, '24 hour psycho', *Parkett,* Issue No. 49, 1997
Yvonne Volkart, 'Douglas Gordon at Museum für Gegenwartskunst, Galerie
Walcheturm', *Flash Art*, Summer, 1997
Iwona Blazwick, 'In Arcadia', *Art Monthly*, September, 1997
Daniel Birnbaum, 'Sweet Nothings', *Frieze*, Issue No. 36, September–October, 1997
Carol Vogel, 'Boss Prize to a Scot', *The New York Times*, July 31, 1998

Publications by the artist
'Colours for Identification …' (in collaboration with Simon Patterson), *Frieze*,
Issue No. 2, 1992
Quelques motifs de déclaration Amours, exhibition catalogue, Fondation Cartier pour

l'art Contemporain, Paris, 1997
'Sailing Alone Around the World — a correspondence between Douglas Gordon and
Liam Gillick', *Parkett,* Issue No. 49, 1997
'Signature, April 1997', *Parkett,* Issue No. 49, 1997
Kidnapping: Douglas Gordon, exhibition catalogue, Stedelijk van Abbemuseum,
Eindhoven, 1998

Jake Harvey

1948	Born Kelso, Scotland
1966–72	Studied Sculpture at Edinburgh College of Art
1975	Member of the Scottish Society of Artists
1977	Associate of the Royal Scottish Academy
1983	Lecturer at Scottish Sculpture Trust Symposium, Duncan of Jordanstone College, Dundee
	Erected sculpture at Landmark, Scottish Sculpture Trust
	Member of the Federation of Scottish Sculptors
1984–87	Trustee, Scottish Sculpture Trust
1989	Elected a member of the Royal Scottish Academy
	William Gillies Bursary to India (Tamil Nadu, Andhra Pradesh, Orissa, Madhya Pradesh, Maharashtra)
	Visited art school and carving centre at Mahabilapuram
1991	Sculpture convenor, Royal Scottish Academy
1992	Sculpture images commissioned by Runrig (*Amazing Things* album)
1994	Travelled to India (Kerala, Karnataka, Maharatsa, Rajasthan, Gujarat)
	Visited art schools in Jaipur and Baroda
	Travelled to Germany (Dusseldorf, Cologne and Berlin)
1996	Trustee of the Bo'ness International Arts Symposium
1998	Residency in Nambu Cast Iron Foundry, Morioka, Japan

Selected solo exhibitions
1985	'The Making of the Hugh MacDiarmid Memorial', Third Eye Centre, Glasgow
1991	'Sculpture and Drawings', Border Arts Festival Exhibition, Robson Gallery, Selkirk
1993	'North', Magnus Festival Exhibition, Pier Art Centre, Stromness and Peacock Printmakers, Aberdeen
	Scottish Gallery, Edinburgh
	'Jake Harvey Sculpture 1972–93', retrospective exhibition, Talbot Rice Gallery, Edinburgh
1994	Corrymella Scott Gallery, Jesmond, Newcastle
	'Recent Works', Old Gala House, Galashiels
1998	'Ground', The Crystal Gallery, Morioka, Japan

Selected group exhibitions
1978	'Objects and Constructions', Edinburgh College of Art (Scottish Arts Council)
1983	'Built in Scotland', Third Eye Centre, Glasgow; City Art Centre, Edinburgh; Camden Arts Centre, London
	'Maquettes for The Hugh MacDiarmid Memorial', Talbot Rice Art Centre, Edinburgh and Scott-Hay Gallery, Langholm
1984	'Putting Sculpture on the Map', Talbot Rice Art Centre, Edinburgh
1985	'Hands Off', Crawford Art Centre, St Andrews
	'Taking Form', Main Gallery, Glasgow; Fair Maids House, Perth; Talbot Rice Art Centre, Edinburgh
	'About Landscape', Talbot Rice Art Centre, Edinburgh
1986	'One Cubic Foot', Talbot Rice Art Centre, Edinburgh and touring
	'Scottish Artists', Leinster Gallery, London
1990	'Scottish Art in the 20th Century', Royal West of England Academy, Bristol
1991	'Scottish Sculpture Open 6', Scottish Sculpture Workshop Exhibition, Kildrummy Castle, Aberdeenshire
	'Virtue and Vision', National Galleries of Scotland Festival Exhibition, RSA Galleries, Edinburgh
1994	'The Art of the Garden', Scottish Gallery, Greywalls
1995	'Scandex', Scottish Sculpture Workshop Exhibition, Aberdeen Art Gallery; Kulturtorget, Stavanger, Norway; Lulea, Sweden; Kemi, Finland

	'Calanais', An Lanntair Gallery, Stornoway, Isle of Lewis; Celtic Arts Festival, Lorient, France; Aberdeen Art Gallery, Aberdeen; Seagate, Dundee; Talbot Rice Gallery, Edinburgh; Maclaurin, Ayr
	Art First, Cork Street, London
1996	'Will Maclean and Jake Harvey', Art First, London
1998	'Celtic Connections', Yorozu Tetsugoro Museum, Japan
	'The Early Imagist Works', Motherwell Heritage Centre, Scotland
1998–99	'transistors', Hashimoto Museum of Art, Morioka, Japan; Royal Museum of Scotland, Edinburgh

Commissions
1971	Dunn and Wilson, Grangemouth
1982–84	'The Hugh MacDiarmid Memorial', Langholm
1985	'Charles Rennie Mackintosh Sculpture', Glasgow
1987	'Newcraighall Mining Sculpture', Newcraighall, Edinburgh
1988	'Compaq Computers Symbol Stone', Bishopton, Glasgow
1991	'Poacher's Tree', Maclay, Murray and Spens, Edinburgh
1996	Motherwell Heritage Centre carving
1996–97	'Tools for the Shaman', Hunterian Museum, Glasgow

Collections
Aberdeen Art Gallery
Aberdeen Hospitals Collection
Borders Education Authority, St Andrews Art Centre, Galashiels
Contemporary Art Society, London
Edinburgh Museums and Galleries
Kelvingrove Museum
Kulturtoget Collection, Lulea, Sweden
Motherwell District Council
Scottish Arts Council
University of Edinburgh

Kevin Henderson

1963	Born Singapore
1981–86	Grays School of Art, Aberdeen
1982–83	Oregon State University, Oregon, US
1993	Artist-in-residence, Scottish Arts Council, Canberra and Tasmania, Australia
1996–	Member of the editorial panel of Transcript (a journal of visual culture), Duncan of Jordanstone College of Art
1997	Established the publishing imprint, Water Press
1997–	Lecturer in Faculty of Fine Art, Duncan of Jordanstone College of Art, Dundee

Lives and works in Dundee

Selected solo exhibitions
1993	'Incorporeal 3: The Insect Cage. Correct Sadist. Between the wish and the thing lies the World' (scenography by Edward Colless, K. H. and David McDowell), 237 Elizabeth Street, Hobart
	'Fascist Skins', Centre for the Arts, Hobart
	'Decor', Canberra House and Arcade, Canberra
	'Fragments for Solo Reader' (performance and installation with David Watt), Photospace Gallery, Canberra School of Art, Canberra
	'21,600 each 24 Hrs.' (performances curated by K. H. and Christopher Chapman), Canberra Travelodge Hotel, Canberra
	'The Operative: An 8Hr. Patrol along the Line' (eight-hour continuous performance), National Gallery of Australia, Canberra
1994	'Tone' (collaborative sound/installation with Christopher Chapman), The Basement Gallery, Melbourne
1995	'Weighing from Land' (installation/performance with K. H., Colin Mackechnie and Euan Patterson), Transmission Gallery, Glasgow
	'The Lane' (contemporary improvisational music performance with K. H., Colin Mackechnie and Euan Patterson), Fruitmarket Gallery, Edinburgh
	'All the old men paid rent but Rory' (contemporary improvisational music performance with Neil Bateman, K. H., Euan Patterson, Jas Sherry), part of 'Explosion: 13th Note' (Fotofeis '95 events programme), Glasgow
	'Ghost Dispenser' (24-hour continuous performance/installation), Catalyst Arts, Belfast
	'Keyring' (five-hour continuous performance), Duncan of Jordanstone

College of Art, Dundee

1996 'Ghost Dispenser' (24-hour continuous performance/installation), Cooper Gallery, Duncan of Jordanstone College of Art, Dundee
'ALOHA from Heathfield' (Super-8 'road movie' event), Heathfield studios, Duncan of Jordanstone College of Art, Dundee
'At a standstill, Smoking (revised)' (billboard installation), part of ARTSITE, Bedford Street, Belfast
'MachineGun' (performance), part of 'Fix '96', Catalyst Arts, Belfast
'MachineGun' (performance), part of 'Beyond Borders', "Plus"', Playhouse Theatre, Derry
'Pool' (seven-day continuous performance/installation), part of 'Beyond Borders', "Plus"', Context Gallery, Derry
'MachineGun' (performance with K. H., Nick Schad, Jas Sherry), Streetlevel Photoworks, Glasgow
'Voodoo State' (performance), part of 'Splatter', Crawfordsburn House, Bangor
'Flato d'artista (after Piero Manzoni)' (performance), Duncan of Jordanstone College of Art, Dundee

1997 'The Ornament of Zero' (continuous performance), Cooper Gallery, Duncan of Jordanstone College of Art, Dundee
'Old Snow for a Foreign Room' (performance), part of 'Elastic Frontiers', Sheffield Hallam University, Sheffield
'Old Snow For a Foreign Room' (performance), part of 'Curious Fix', Catalyst Arts, Belfast
'… sleep hitcher' (three-minute performance), part of 'On the Buses', The Globe Gallery, South Shields, England

Selected group exhibitions

1987 'Work on Paper', Eden Court Theatre, Inverness
1989 'Scatter: New Scottish Art', Third Eye Centre, Glasgow
1990 'The British Art Show', McLellan Galleries, Glasgow, Leeds City Art Centre and Hayward Gallery, London
'Self Conscious State' (with Christine Borland, Roderick Buchanan, Douglas Gordon and Craig Richardson), Third Eye Centre, Glasgow
1991 'Kunst Europa', Kunstverein Kirchzarten, Germany
'Walk On', Jack Tilton Gallery, New York and Fruitmarket Gallery, Edinburgh
1992 'Guilt By Association' (with Christine Borland, Roderick Buchanan, Douglas Gordon and Craig Richardson), Irish Museum of Modern Art, Dublin
'Contact: 552 4813', Transmission Gallery, Glasgow
1993 'Install x 4', Plimsoll Gallery, Centre for the Arts, Hobart, Tasmania
1995 Speaker in workshop/discussion group (with Rosy Martin), Fotofeis '95, conference for European photographers, Scotland
'Cluster' (curated by K. H. and Sarah Munro), Collective Gallery, Edinburgh
'Swarm', Scottish Arts Council Travelling Gallery
1996 'Open Plan' (annual members exhibition), Catalyst Arts, Belfast
1997 'The Last Minute' (a five-week programme of performance art, video screenings and seminars, curated by K. H.), Cooper Gallery, Duncan of Jordanstone College of Art, Dundee
1998–99 'transistors', Hashimoto Museum of Art, Morioka, Japan; Royal Museum of Scotland, Edinburgh

Bibliography

Marina Abramovic, *Transcript*, Issue No. 3, 1996
'For Research Purposes', *Circa*, 1996
'Mall (and Jude)', *Poetic Art* anthology, Arrival Press, Queensland, 1997
transistors, exhibition catalogue, Hashimoto Museum of Art, Morioka, Japan; Royal Museum of Scotland, Edinburgh, 1998

Ian Kane

1951 Born Inverness, Scotland
1975–80 Undergraduate and post-graduate studies in sculpture, Edinburgh College of Art
1986–87 Artist-in-residence, Scottish Arts Council, Amsterdam

Selected solo exhibitions

1987 Klove Gallery, Amsterdam
1988 'Discovering the Familiar', Moving Space Gallery, Ghent, Belgium
Koma Gallery, Mons, Belgium

1991 Moving Space Gallery, Ghent
1993 'Presence', Moving Space Gallery, Ghent
1996 'Pure', Moving Space Gallery, Ghent

Selected group exhibitions

1984 'Four-person Show', Transmission Gallery, Glasgow
'Scottish Young Contemporaries' (prizewinner), Third Eye Centre, Glasgow and touring Scotland
1985 'Federation of Scottish Sculptors Group Show', Talbot Rice Art Centre, Edinburgh
1986 'Signs of the Times. Art and Industry', Talbot Rice Art Centre, Edinburgh
1987 'A Different View on Sculpture', Moving Space Gallery, Ghent
'Four-person Show', Edinburgh College of Art
1988 'Artists Invitations', Moving Space Gallery, Ghent
'Outdoor Sculpture', Crawford Art Centre, St Andrews University
1989 '3x(2x1) Propositions', Moving Space Gallery, Ghent
1990 'Field' (with Matthew Inglis and Gordon Brennan), Talbot Rice Gallery, Edinburgh
1991 'Del'Artiste a l'Enfant', Gallery-Edition du Faisan, Strasbourg, France and touring
'Themaobject', Moving Space Gallery, Ghent
1992 'Matthew Inglis, Ian Kane, Linda Taylor', Fruitmarket Gallery, Edinburgh
1993 'A for ALPHABET', Moving Space Gallery, Ghent
'Revival', Moving Space Gallery, Ghent
1994 'Michel Dejean, Ian Kane, Jacques + Kindt', Espace Bateau Lavoir, Paris
'New Art in Scotland', Centre for Contemporary Arts, Glasgow
1995 '9', Talbot Rice Gallery, Edinburgh
1996 'The Skin of the White Lady', Eindhoven, The Netherlands
1997 '"E"motion', Moving Space Gallery, Ghent
1998–99 'transistors', Hashimoto Museum of Art, Morioka, Japan; Royal Museum of Scotland, Edinburgh

Bibliography

Murdo Macdonald, 'Young Contemporaries and Ancient Cultures', *Edinburgh Review*, Issue No. 67, 1984
Meeting Points, exhibition catalogue, Klove Gallery, Amsterdam, 1987 (reprinted as *A Different View on Sculpture*, Moving Space Gallery, Ghent, Belgium, 1987)
Bill Hare, *Field*, exhibition catalogue, Talbot Rice Gallery, Edinburgh, 1990
Hugo de Boom, *Stream*, exhibition catalogue, Moving Space Gallery, Ghent, Belgium, 1991
Piet Vanrobaeys, 'Stream of Consciousness/But what is Nature?', *Arte Factum*, Issue No. 39, 1991
Hugo de Boom, 'About Presence', *Presence*, exhibition catalogue, Moving Space Gallery, Ghent, Belgium, 1993
Statement for *New Art in Scotland*, exhibition catalogue, Centre for Contemporary Arts, Glasgow, 1994
Discerning the Familiar, exhibition catalogue, Moving Space Gallery, Ghent, Belgium, 1998
transistors, exhibition catalogue, Hashimoto Museum of Art, Morioka, Japan; Royal Museum of Scotland, Edinburgh, 1998

Aileen Keith

1953 Born Johnstone, Renfrewshire, Scotland
1972–75 Edinburgh College of Art
1975–77 Lived and worked in Italy
1978–80 Sculpture and Drawing, Edinburgh College of Art
1981– Part-time lecturer in Sculpture and Drawing, Edinburgh College of Art
1984 Member of Federation of Scottish Sculptors

Selected solo exhibitions

1990 'Informal Works on Paper', Edinburgh College of Art
1993 'Fragments of Memory, Figments of Imagination' (sculpture and drawings), Collective Gallery, Edinburgh and Robson Gallery, Halliwell's House, Selkirk

Selected group exhibitions

1984 'Putting Sculpture on the Map', Talbot Rice Art Centre, Edinburgh
1985 Dublin/Edinburgh Exhibition, Edinburgh College of Art
RSA Summer Exhibition, Edinburgh
'Sculpture Now', Cramond Sculpture Park, Edinburgh

1985–86 'Scottish Sculpture Open 3', Kildrummy Castle, Aberdeenshire and
Cramond Sculpture Park, Edinburgh
'One Cubic Foot', Artspace, Aberdeen and Talbot Rice Art Centre,
Edinburgh
'Taking Form', Main Fine Art, Glasgow; Fair Maid's House Gallery, Perth;
Talbot Rice Art Centre, Edinburgh
1986 'Through Other Eyes II', Crawford Centre for the Arts, St Andrews
SSA Annual Exhibition, Edinburgh
1988 'Sculpture from Scotland', Economist Plaza, London; Lyth Art Centre,
Caithness; Waverley Station, Edinburgh
'Vintage 88', Queen's Hall, Edinburgh
1989 'Borders Biennial' (touring exhibition)
1990 'Laing Exhibition', Talbot Rice Gallery, Edinburgh
'Vintage 90', Queen's Hall, Edinburgh
1991 Paisley Art Institute (drawing competition)
'Totems' (outdoor sculpture exhibition), MacRobert Art Centre, Stirling
1992 'CD Show', Collective Gallery, Edinburgh
1993 Paisley Art Institute (drawing competition)
'CD 2', Collective Gallery, Edinburgh
Demarco Foundation Christmas Exhibition, St Mary's School, Edinburgh
1994 'River Tweed Project', Corner Gallery, Kailzie, Peebles and Harestanes
Visitors Centre, Jedburgh
Royal Scottish Academy Annual Exhibition
'Nine Sculptors in Scotland', Edinburgh College of Art
'CD 3', Collective Gallery, Edinburgh
1995 Paisley Art Institute (drawing competition)
'The City is a Work of Art' (artist–architect collaborative project), Traverse
Theatre, Edinburgh
1997 Paisley Art Institute (drawing competition)
1998–99 'transistors', Hashimoto Museum of Art, Morioka, Japan; Royal Museum of
Scotland, Edinburgh

David Mach

1956 Born Methil, Fife, Scotland
1974–79 Duncan of Jordanstone College of Art, Dundee
1979–82 Royal College of Art, London
1988 Nominated for Turner Prize, Tate Gallery
1992 Awarded Lord Provost's Prize, Royal Glasgow Institute, Glasgow
Selected solo exhibitions
1981 Richard Booth Bookshop, Hay-on-Wye, Wales
1982 Lisson Gallery, London
New 57 Gallery, Edinburgh
Galerie t'Venster, Rotterdam
1983 Mock Shop, Kingston Polytechnic, Knights Park
'Castaways', Galerie Andata/Ritorno, Geneva
Ateliers Contemporains d'Arts Plastiques, St Brieuc
1985 'Towards a Landscape', Museum of Modern Art, Oxford
Galerie Foksal, Warsaw
Stoke City Museum, Stoke-on-Trent
1986 Cleveland Art Gallery, Middlesborough
'David Mach Roadshow', Barbara Toll Fine Art, New York
Mercer Union Gallery, Toronto
Herning Kunstmuseum, Herning, Denmark
'Fuel for the Fire', Riverside Studios, London
Seagate Gallery, Dundee
'If you go down to the woods', Corner House, Manchester
'Chimney Sweep', Town Hall, Manchester
Sherratt & Hughes Bookshop, Leadenhall Market, London
Hacienda Club, Manchester
National Museum of Photography, Film and Television, Bradford
1987 Musée des Arts Decoratifs, Centre du Verre, Paris
'Si avui t'endinses en els boscos', Fundaçio Joan Miró, Barcelona
'Adding Fuel to the Fire', Metronom Gallery, Barcelona
'Mosaic', permanently sited in Cattle Market Car Park, Kingston

'Natural Causes', Wiener Secession, Vienna
One of two British representatives at XIX Bienal, São Paulo, Brazil
'Chinese Whispers', Nicola Jacobs Gallery, London
1988 'A Hundred and One Dalmatians', Tate Gallery, London
Dunlop Art Gallery, Regina, Saskatchewan
'A Million Miles Away', Barbara Toll Fine Art, New York
'Signs of Life', Provinciaal Museum, Hasselt, Belgium
'Multi-Story, Car Park', BBC-TV Centre, London
'A Nice Location', Kawasaki City Museum, Tokyo
'The Art that Came Apart', Musée d'Art Contemporain, Montréal
'David Mach', Galerie ek'ymose 1, Bordeaux, France
'Parvis 2', Tarbes, France
Galerie Andata/Ritorno, Geneva
1989 'Stream of Consciousness', Artspace, San Francisco
'David Mach', FGG Gallery, Frankfurt
'Tamed, Trained & Framed', Maurice Keitelman Gallery, Brussels
'Liberté, Egalité, Fraternité — A new Utopia', Galerie Nikki Diana
Marquardt, Paris
'Ploughman's Lunch', Middleton Hall, Milton Keynes
'Kissin' Cousins', Hamburg Messe, Hamburg
'Along Classical Lines', Spoleto Festival, National Gallery of Victoria,
Melbourne
'Home Cookin' ', Galerie 175, Brussels
'Wet and Dry', Centro Cultural de la Villa, Madrid
'Five Easy Pieces', Barbara Toll Fine Art, New York
'A Hair's Breadth', Brooklyn Museum, New York
1990 'Here to Stay', Tramway, Glasgow
'Chicago Trophies', Chicago Art Fair, Chicago
'Over to the Right a Bit', House of Ukrainian Artists, Kiev
'Creature Comforts', Pittsburgh Center for the Arts
1991 'David Mach: Sculpture', Ace Contemporary Art, Los Angeles
'David Mach: Sculpture', Maurice Keitelman Gallery, Brussels
Gallery 400, University of Illinois, Chicago
1992 Orpheus Gallery, Belfast
Barbara Toll Fine Art, New York
'Welcome to Euromach', Galerie Nikki Diana Marquardt, Paris
Illustrated ABSA Annual Report
1993 'David Mach: Sculpture', Ujazdowski Castle Centre for Contemporary Art,
Warsaw
'Between the Lines', Hakone Open-Air Museum, Hakone-machi, Japan
'David Mach: New Work', Viafarini, Milan and Studio Casoli, Milan
Installed sculpture in new headquarters building of Union des Banques
Suisses, Geneva
'Square Town/Town Square', Seagate Gallery, Dundee
'Matchheads', Essex University, Colchester, England
'Flayed, Stretched & Tanned', Walsall Art Gallery, England
1994 'Fully Furnished', Museum of Contemporary Art, San Diego
'Freeze', Musée Leon Dierx, Reunion Island
'Drawings', CASK, Kitakyushu, Japan
'Hako', Glasgow Print Studio, Glasgow
'Likeness Guaranteed', Newlyn Art Gallery, Penzance, England
'Headcase', Aberdeen Art Gallery, Aberdeen
Sculpture installation, Sun Pavilion, Harrogate
'Temple at Tyre', Leith Docks, Edinburgh
'David Mach', Mercer Gallery, Harrogate
1995 'Whirl', Summerlee Museum, Coatbridge, Scotland
'David Mach: Sculpture', Sunderland City Art Gallery
'Matchheads', Ace Contemporary Exhibitions, Los Angeles
'Drawings', Jill George Gallery, London
'David Mach', Galerie Andata/Ritorno, Geneva
1996 Installed 'Garden Urn' at Hat Hill Sculpture Park
'Naked', Jason&Rhodes Gallery, London
Ferens Art Gallery, Kingston-upon-Hull
Installed 'Some of the People', to celebrate Glasgow Underground's
Centenary, Patrick Station, Glasgow
Building work began on 'Train', Darlington
1997 Installed 'It Takes Two' (temporarily), at Circular Quay, Sydney (part of

the Festival of Sydney)
Gallery Ha Moomche, Tel Aviv
'The Last Detail', Galerie Jerome de Noirmont, Paris
'New Drawings', Jill George Gallery, London
'Train' sculpture unveiled in Darlington
'The Revels', International Arts Festival, Melbourne
1998 'Columns', CRDC, Nantes
'Drawings', École des Beaux Arts, Nantes

Selected group exhibitions
1982 'Sculpture at the Open Air Theatre', Regent's Park, London
1983 'Truc et Troc, Leçons des Choses', Musée d'Art Moderne de la Ville de Paris
'British Sculpture '83', Hayward Gallery, London
'Sculpture Symposium', Yorkshire Sculpture Park
1984 International Garden Festival, Liverpool
1986 'Painting and Sculpture Today: 1986', Indianapolis Museum of Art, Indiana
'The British Edge', Institute of Contemporary Art, Boston
1987 'The Vigorous Imagination', Scottish National Gallery of Modern Art, Edinburgh
'The Vessel', Serpentine Gallery, London
1988 'New Directions: New Attitudes in Scottish Art', touring in Yugoslavia
'New British Art', Tate Gallery, Liverpool
1989 'Scottish Art Since 1990', Scottish National Gallery of Modern Art, Edinburgh
Summer exhibition, Royal Academy of Art, London
1990 'Scottish Art Since 1900', Barbican Centre, London
National Garden Festival, Gateshead
'Three Scottish Sculptors', Venice Biennale
'British Art Now: A Subjective View' (touring exhibition), Setagaya Museum, Tokyo; Fukuoka Art Museum; Nagoya City Art Museum; Tochigi Prefectural Museum of Fine Arts; Hyogo Prefectural Museum of Modern Art; Hiroshima City Museum of Contemporary Art
1991 'Kunst Europa', Karlsruhe, Germany
'Virtue and Vision: Sculpture and Scotland 1540–1990', Royal Scottish Academy, Edinburgh
1994 'A Changing World: 50 Years of Sculpture from the British Council Collection', State Russian Museum, St Petersburg
1996 Stedelijk Museum, Schiedam
1997 'David Mach and Zadok Ben-David', Chelouche Gallery, Tel Aviv
1998–99 'transistors', Hashimoto Museum of Art, Morioka, Japan; Royal Museum of Scotland, Edinburgh

Commissions
1989 'Out of Order', Royal Borough of Kingston-upon-Thames
1991 'It Takes Two', Camden Arts and British Rail, Euston Square Gardens, London
1994 Second sculpture for headquarters of Union des Banques Suisses, Geneva
1996 Sculpture for McMaster Museum of Art, Hamilton, Ontario

Bibliography
Tom Bendhem, *David Mach: Master Builder*, exhibition catalogue, Galerie t'Venster, Rotterdam, 1982
Marco Livingstone, *David Mach: Towards a Landscape*, exhibition catalogue, Museum of Modern Art, Oxford, 1985
Mel Gooding, *David Mach: Fuel for the Fire*, exhibition catalogue, Riverside Studios, London, 1986
David Mach: Natural Causes, exhibition catalogue, Weiner Secession, Vienna, 1987
A Hundred and One Dalmations, exhibition catalogue, Tate Gallery, London, 1988
Secco y Mojado: Wet and Dry, Centro Cultural de la Villa and the British Council, Madrid, 1989
Marco Livingstone (ed.), *ArT RANDOM: David Mach*, Kyoto Shoin International Co. Ltd, Kyoto, Japan, 1990 (reprinted 1991)
David Mach Magazine Installation: Between the Lines, Hakone Open-air Museum, Hakone-machi, Japan, 1993
David Mach: Temple at Tyre, Edinburgh District Council, Edinburgh, 1995
David Cassidy, *David Mach at the Zamak Ujazdowski*, Lampoon House Nasanori Omai, Toyko, 1995
Meir Agassi, *David Mach/Zadok Ben-David*, exhibition catalogue, Chelouche Gallery, Tel Aviv, 1997
transistors, exhibition catalogue, Hashimoto Museum of Art, Morioka, Japan; Royal Museum of Scotland, Edinburgh, 1998

Tracy Mackenna

1963 Born in Scotland
1981–86 Glasgow School of Art, Glasgow
1986–87 Lived and worked in Hungary
1996 Leverhume Special Research Fellowship, Duncan of Jordanstone College of Art, Dundee
1997– Has worked collaboratively with Edwin Janssen

Selected solo exhibitions
1990 'Anti Routes', Graeme Murray Gallery, Edinburgh
1991 'Intervals' (consecutive installations, three artists), Mayfest, Glasgow
1992 'Dispersion', 4 Rue du Pont St Jaime, Grenoble, France
1993 'Tracy Mackenna', Centre for Contemporary Arts, Glasgow
1993–94 'Purposeful Invisibility', Arnolfini, Bristol
1994 'Invasions Naturelles', @Art Connexion, Lille, France
'Slipped In', Lending Library, Glasgow School of Art, Glasgow
1995 'Not a Shred of Evidence', Mead Gallery, University of Warwick, Coventry
'Big Fears and General Anxieties', Galerie du Triangle, Bordeaux, France
1996 'Blips', Lotta Hammer, London
'… lips', Cleveland, London
'Chitchat', Galerie du Triangle, Bordeaux
1997 'Cell 6', Barbican Centre, London

Selected group exhibitions
1994 'Ubergänge', Galeria Médium, Bratislava, Slovakia
'Art(s) d'Europe?', Galérie de l'Esplanade, Paris
'Les Diagonales', Centre de la Voix, Royaumont, France
'Ms.(cellaneous)', Newlyn Orion, Penzance
'Stimulants', Francis Cooper Gallery, DJCA, Dundee
1995 'Tracy Mackenna, Douglas Gordon, Julie Roberts', Ludwig Museum, Budapest, Hungary
'Fairytale in the Supermarket', The Scotland Street Museum, Glasgow
'D&AD Festival of Excellence', Saatchi Gallery, London
'Freedom', Kelvingrove Art Gallery & Museum, Glasgow and touring Britain and Northern Ireland
'Revue Ligne Oblique No 0', 65 Cours Pierre Puget, Marseille, France
'Taking Form', Fruitmarket Gallery, Edinburgh
'Swarm', Scottish Arts Council Travelling Gallery
'Sad Songs', Centre for Contemporary Arts, Glasgow
1996 Casa Gallery, Tokyo, Japan
'City Limits', Staffordshire University, England
'A Few Works', Lotta Hammer, London
'Manifesta I', Rotterdam, The Netherlands
'Kilt ou Double', La Vigie, Nîmes, France
'Art for People', Transmission Gallery, Glasgow
'Itinerant Texts', Tramway, Glasgow, Camden Arts Centre, London, Dartington College of Arts
'Duel' (with Karla Sachse), Henry Moore Institute for the Study of Sculpture, Leeds
'Take It From Here', City Library and Arts Centre, Sunderland
1997 'Of All Places' (with Edwin Janssen), MK Gallery, Rotterdam, The Netherlands
'Ed and Ellis in Finland' (with Edwin Janssen), Gallery Just, Turku, Finland
'The Hidden City', de Vleeshal, Middelburg, The Netherlands
1998–99 'transistors' (with Edwin Janssen), Hashimoto Museum of Art, Morioka, Japan; Royal Museum of Scotland, Edinburgh

Collections
Arts Council of England
Contemporary Art Society, London
Danube Sculpture Park, Hungary
Henry Moore Institute Library, Leeds
Limerick City Art Gallery, Ireland
Limerick City Corporation, Ireland
Scottish Arts Council
Scottish National Gallery of Modern Art
Szatmar Museum, Hungary

Bibliography

New Sculpture in Scotland, exhibition catalogue, Cramond Sculpture Centre, Edinburgh, 1988

Art in the Garden — Installations, exhibition catalogue, Graeme Murray Gallery, Edinburgh, 1988

Shape and Form. Six Sculptors from Scotland, exhibition catalogue, Collins Gallery, Glasgow, 1989

Scottish Connection, exhibition catalogue, Feeringbury Manor, Essex and Cramond Sculpture Centre, Edinburgh, 1989

Tracy Mackenna: Sculpture, exhibition catalogue, Glasgow Print Studio, Glasgow, 1989

Keith Hartley, *Scottish Art Since 1900*, exhibition catalogue, National Galleries of Scotland, Edinburgh, in association with Lund Humphries, London, 1989

New Directions in Scottish Sculpture, exhibition catalogue, Barbican Centre, London, 1990

Sommeratelier, Deutsche Messe AG, Germany, 1990

Europe Unknown, Ministry of Culture, Polish Section of AICA, Poland, 1991

Kunst, Europa, exhibition catalogue, Arbeitsgemeinschaft Deutscher Kunstvereine, Germany, 1991

Notes for the exhibition 'Génériques, le Visuel et l'Écrit', Hôtel des Arts, Fondation Nationale des Arts, Paris, 1992

Tracy Mackenna, exhibition catalogue, Centre for Contemporary Arts, Glasgow, 1993

More Than Zero, exhibition catalogue, Centre National d'Art Contemporain de Grenoble, 1993

Tracy Mackenna, *Purposeful Invisibility*, exhibition catalogue, Arnolfini, Bristol, 1993

art(s) d'Europe?, exhibition catalogue, Pépinières européennes pour jeunes artistes, Paris, 1994

Revue Ligne Oblique No. 0 (video), Marseille, France, 1995

Taking Form, exhibition catalogue, Fruitmarket Gallery, Edinburgh, 1995

Swarm, exhibition catalogue, Scottish Arts Council, Edinburgh, 1995

Scottish Autumn, exhibition catalogue, British Council, Hungary, 1995

Freedom, exhibition catalogue, Amnesty International Glasgow Groups, Art Gallery and Museum, Glasgow, 1995

Duel, Tracy Mackenna and Karla Sachse, exhibition catalogue, The Centre for the Study of Sculpture, The Henry Moore Institute, Leeds, 1996

Manifesta 1, exhibition catalogue, Manifesta, Rotterdam, 1996

Not a Shred of Evidence, Tracy Mackenna, exhibition catalogue, Mead Gallery, Warwick Arts Centre, University of Warwick, 1997

Tracy Mackenna, *Bulk*, exhibition catalogue, Barbican Centre, London, 1997

transistors, exhibition catalogue, Hashimoto Museum of Art, Morioka, Japan; Royal Museum of Scotland, Edinburgh, 1998

Reviews

Paula Garcia-Stone, 'Outside the Gallery', *Alba*, Winter, 1988

'Almanah', *Panoramic Britanic*, 1989–90

Cordelia Oliver, 'Tracy Mackenna: Following an Inner Voice', *The Green Book*, Vol. iii, 1990

Claudia Peres, 'Ritratto di Città Glasgow', *Casa Vogue*, July–August, 1990

Clare Henry, 'Kunst Europa', *Arts Review*, July, 1991

Fiona Byrne Sutton, 'Intervals', *Variant*, Issue No. 9, 1991

Zwickl Andras, 'Beszamolo a hannoveri "Sommeratelier"-rol', *Uj Muveszet*, Issue No. 2, 1991

Clare Henry, 'Kunst Europa', *Portfolio*, Issue No. 13, 1991–92

Anne Barclay Morgan, 'Dossier: Glasgow, Scotland', *Sculpture*, Issue No. 3, 1993

'More Than Zero', *La Lettre Grenoble Culture*, Issue No. 29, 1993

C. G., 'Expositions', *Les Affiches de Grenoble*, October 15, 1993

Bernadette Bost, 'Le Mystère et l'Usage', *Le Monde Rhone-Alps*, October 23, 1993

Ross Sinclair, 'Tracy Mackenna', *Art Monthly*, Issue No. 166, 1993

Lynne Green, 'Exposure', *Contemporary Art*, Winter, 1993–94

Philippa Goodall, 'Encounter and Reverie', *Women's Art*, Issue No. 56, 1994

Andrew Cross, 'Tracy Mackenna', *Untitled*, Issue No. 4, 1994

Kerstin Mey, 'A Mason's Play on Words', *Women's Art*, Issue No. 64, 1995

Clare Henry, 'Catalogue of Confusion', *The Herald*, July 20, 1995

Robert Clark, 'Cry Freedom', *Artists Newsletter*, November, 1995

Jenny Mayhew, 'Cry Freedom', *Artwork '77*, 1995–96

Duncan Macmillan, 'Civil Disservice', *The Scotsman*, January 8, 1996

Stephanie Brown, 'Commissions, Scottish Office', *CRAFTS*, Issue No. 139, 1996

Judith Findlay, 'Glaswegian Goods', *Flash Art*, Issue No. 188, 1996

Brigid Grauman, 'A Collective "Manifesta" on Art', *The European*, July 5, 1996

Michael Gibbs, 'Manifesta 1', *Art Monthly*, July–August, 1996

'Vox Pop', *Circa*, special Scottish edition to accompany *Circa 77*, 1996

Johnny Davis, *The Face*, Issue No. 99, 1996

Richard Reynolds, 'Tracy Mackenna', *Flash Art*, Issue No. 193, 1997

Publications by the artist

'Artists Page', *Alba*, Issue No. 6, 1991–92

'Génériques, le Visuel et l'Écrit', *Variant*, Issue No. 13, 1993

Television and radio

'Third Ear', BBC Radio 3, 1990

'Talking Pictures' (producer Erina Rayner), Scottish Television, 1991

'Out There' (producer Donny O'Rourke), Scottish Television, 1993

Will Maclean

1941	Born Inverness, Scotland
1961–65	Grays School of Art, Aberdeen
1968	Ring-net fisherman, Skye
1974	Worked on 'Ring-Net' project
1981	Lecturer, Fine Art, Duncan of Jordanstone College of Art, Dundee
1994–	Professor of Fine Art, Duncan of Jordanstone College of Art

Selected solo exhibitions

1967	British School, Rome
1968	New 57 Gallery, Edinburgh
1970	Richard Demarco Gallery, Edinburgh
1971–73	Loomshop Gallery, Lower Largo, Fife, Scotland
1978	'Ring-Net', Third Eye Centre, Glasgow, touring to Richard Demarco Gallery, Edinburgh, Leeds Art Gallery, Inverness Art Gallery, Campbeltown Museum and Tarbet Museum
1979	Compass Gallery, Glasgow
	Gilbert Parr Gallery, London
1983	Richard Demarco Gallery, Edinburgh
	Landmark Centre, Carrbridge, Scotland
1984	Kirkcaldy Museum and Art Gallery, Retrospective Loan Exhibition
	Downing College, University of Cambridge
1986	'Ring-Net', Scottish National Gallery of Modern Art
1987	Claus Runkel Fine Art, London
1990	Runkel-Hue-Williams, London
1991	Runkel-Hue-Williams, London
	Cyril Gerber Fine Art, Glasgow
1992	'Retrospective Exhibition', Edinburgh Festival
	Talbot Rice Gallery, Edinburgh and Art Space, Aberdeen
1993	Glasgow Art Gallery, Kelvingrove
	Tour to Wick, Thurso, Kingussie, Inverness
1994	New Hall, St Andrews University
	Comnairle Nan Eilean, Harris Festival
1995	'Voyages', Art First, London
	Gallery Gilbert, Dorchester
	Eise Carlow International Arts Festival (invited artist), Eire
	An Lanntair Gallery, Stornoway, Isle of Lewis
	Professorial Exhibition, Duncan of Jordanstone College of Art, Dundee
	'Scottish Festival' (invited artist, with John Bellany), State University of New York at Binghampton

Selected group exhibitions

1977	'Inscape', SAC Exhibition (selected by Paul Overy), Fruitmarket Gallery, Edinburgh, Warehouse, Covent Garden and Ulster Museum, Belfast
1981	'Art and the Sea', Third Eye Centre, Glasgow and touring to England and Wales
1986	'As An Fhearann (From the Land)', An Lanntair Gallery, Stornoway, Isle of Lewis and Royal Scottish Museum, Edinburgh and touring to Canada
1987	'The Scottish Show' (touring exhibition)
1988	'Scottish Art Since 1900', Scottish National Gallery of Modern Art and Barbican Centre, London
1990	'Scotland's Pictures — The National Collection', RSA, Edinburgh
	'Scotland Creates — 5000 Years of Scottish Art and Design', McLellan Galleries, Glasgow

1991	'Virtue and Vision, Sculpture and Scotland', National Gallery of Scotland in the Royal Scottish Academy
1994	'Worlds in a Box', South Bank Centre National Touring Exhibition, London; City Art Centre, Edinburgh; Graves Art Gallery, Sheffield; Sainsbury's Centre for the Visual Arts, University of East Anglia
1995	'Contemporary British Art in Print', Scottish National Gallery of Modern Art
	'Prints from Paragon', Talbot Rice Gallery, Edinburgh
	'Calanais/The Atlantic Stones', An Lanntair Gallery, Stornoway, Isle of Lewis
1998–99	'transistors', Hashimoto Museum of Art, Morioka, Japan; Royal Museum of Scotland, Edinburgh

Installations

1994	Cuimhneachain Nan Gaisgeach Memorial Cairn, Balallan, Isle of Lewis
1996	Memorial Sculpture at Aignish
	Cuimhneachain Nan Gaisgeach Memorial Sculpture at Gress River

Collections

Aberdeen Art Gallery
Aberdeen City Libraries
Argyllshire Education Trust
Arts Council of Great Britain
BBC Scotland
British Museum, London
Broadford Hospital, Skye
Carlow Town Collection, Ireland
Clare College, Cambridge
Comhairie Nan Eilean, Isle of Lewis
Contemporary Art Society, London
Dumbarton Education Trust
Dundee District Council
Edinburgh City Art Gallery
Fanim Hall Collection, Vancouver
Ferens Art Gallery, Hull
Fife Education Authority
Fitzwilliam Museum, Cambridge
Glasgow Art Gallery, Kelvingrove
Government Art Collection, London
Highland Regional Council, Inverness
Inverness Education Authority
Inverness Museum and Art Gallery
Isle of Man Arts Council
King's College, Cambridge
Kirkcaldy Museum and Art Gallery
Lille Art Gallery, Milngavie, Scotland
McLaurin Art Gallery and Museum, Ayr
McManus Art Gallery, Dundee
McMaster University, Ontario, Canada
Mitchell Library, Glasgow
Motherwell District Council
National Library of Scotland
National Trust for Scotland
Oldham Museum and Art Gallery, England
Perth Museum and Art Gallery
Peterhead Museum and Art Gallery, Scotland
Royal Scottish Academy Collection
St Andrews University Collection, St Andrews
Scottish Arts Council
Scottish Craft Collection, Edinburgh
Scottish Life Collection, London
Scottish National Gallery of Modern Art
Scottish Office Collection, Edinburgh
Scunthorpe Art Gallery, England
Stoke-on-Trent Art Gallery
Westfield State Collection, Massachusetts, US
Yale Centre for British Art, New Haven, US

Bibliography

Tom McGrath and Will Maclean, *Ring-Net Herring Fishing on the West of Scotland*, Third Eye Centre, Glasgow, 1978
Tim Neat and Will Maclean, *Constructions and Small Sculptures*, exhibition catalogue, Richard Demarco Gallery, Edinburgh, 1983
Cordelia Oliver and Will Maclean, *Constructions and Drawings*, exhibition catalogue, Kirkcaldy Museum and Art Gallery, 1984
Edward Lucie-Smith, 'Will Maclean and Barbara Rae', *Scottish Contemporary Art in Washington and London*, exhibition catalogue, Leinster Fine Art, 1984
Alan Woods and Claus Runkel, 'Will Maclean: With a Catalogue Raisonne', *Sculptures and Box Constructions*, 1974–1987, exhibition catalogue, Claus Runkel Fine Art Ltd, London, 1987
Duncan Macmillan, *Will Maclean, New Work*, exhibition catalogue, Runkel-Hue-Williams, London, 1990
Tom Normand, *A Night of Islands*, exhibition catalogue, Crawford Art Centre, St Andrews, 1990
Iain Gale, *Voyages*, exhibition catalogue, Art First, London, 1990
Valerie Gillies, 'The Ringing Rock', 1990
Valerie Gillies, *The Chanter's Tune*, Edinburgh, 1990
Alan Woods, 'The Artist as Voyager: Will Maclean and Richard Demarco', exhibition catalogue, Peacock Printmakers, Aberdeen, 1991
Cuimhneachain Nan Gaisgeach/The Parc Cairn publication by National Gaelic Arts Project, 1991
'A Semblance of Steerage with Ian Stephen', Morning Star publications, 1991
Murdo Macdonald, 'The Social Space in Scottish Art', a study of David Wilkie, William McTaggart, Will Maclean and George Wyllie, *Edinburgh Review*, 1991
Duncan Macmillan, 'Symbols of Survival: The Art of Will Maclean', *Mainstream*, Edinburgh, 1992
Selected Affinities, University of Dundee, 1995
transistors, exhibition catalogue, Hashimoto Museum of Art, Morioka, Japan; Royal Museum of Scotland, Edinburgh, 1998

Articles and reviews

Edward Gage, 'Painting by Will Maclean at the New 57 Gallery', *The Scotsman*, 1968
Juliet Clough, 'Elegy for Fish', *The Times* educational supplement, 1974
Marina Vaizey, 'Scottish Contemporary Art in Washington and London', Arts *Review*, 1984
Clare Henry, 'Will Maclean' (The Ring-Net at the Scottish National Gallery of Modern Art), *Glasgow Herald*, 1986
Sylvia Stevenson, 'Will Maclean at Claus Runkel Fine Art', *Galleries*, Issue No. 4, 1987
Alan Woods, 'Interview with Will Maclean', *Alba*, Issue No. 9, 1988
Victoria Keller, 'The Work of Will Maclean', *Scottish Life*, Issue No. 1, 1989
Sylvia Stevenson, 'Will Maclean', *Apollo*, 1990
Valerie Gillies, 'Will Maclean: Symbols of Survival', *The Green Book*, Issue No. 9, 1991
William Packer, 'Modern in Their Time: Christopher Wood and Will Maclean', *Financial Times*, 1995
Iain Gale, 'Will Maclean — Critics Choice', *Independent*, 1995
Andrew Patrizio, 'Will Maclean', *Galleries*, 1995
John Russell Taylor, 'Voyages, Will Maclean', *The Times Arts*, 1995
Hayden Murphy, 'Allegories of a Dramatic Imagination', *The Times* educational supplement, 1995
Duncan Macmillan, 'Monumental Struggle — The Lewis Cairns', *The Scotsman*, 1996
'The Artist's Eye — Will Maclean', *Art Review*, 1996

Eduardo Paolozzi

1924	Born Leith, Scotland
1943	Part-time study at Edinburgh College of Art
1943–47	Full-time study at Edinburgh College of Art and, from 1944, at Slade School of Fine Art in Oxford and London
1947–49	Two-year stay in Paris
1949–55	Instructor, Central School of Art and Design, London
1955–58	Lecturer, St Martin's School of Art, London
1960–62	Visiting professor at Staatlich Hochschule für Bildende Kunste, Hamburg
1968–69	Tutor in Ceramics, Royal College of Art, London
1977–81	Professor of Ceramics at Fachhochschule, Cologne
1981–91	Professor of Sculpture, Akademie der Bildenden Kunste, Munich
1986	Her Majesty's Sculptor in Ordinary for Scotland
1989	Visiting professor, Royal College of Art, London
	Knighted
1996–	Visiting professor, Edinburgh College of Art

Selected solo exhibitions

1947 Drawings and sculptures, Mayor Gallery, London
1948 Recent drawings, Mayor Gallery, London
1949 Drawings and bas reliefs, Mayor Gallery, London
1958 Sculpture, Hanover Gallery, London
1960 Manchester City Art Gallery
 30th Venice Biennale (retrospective in British Pavilion, then touring)
 Betty Parsons Gallery, New York
1962 Betty Parsons Gallery, New York
1963 Waddington Galleries, London
1964 Sculpture, Museum of Modern Art, New York
 Recent sculpture and collage, Robert Fraser Gallery, London
1965 Hatton Gallery, University of Newcastle-upon-Tyne
 Sculpture, collage and graphics, Chelsea School of Art, London
 'As Is When', Editions Alecto, London
1966 Sculpture and prints, Scottish National Gallery of Art, Edinburgh
 Robert Fraser Gallery, London
 Recent sculptures, Pace Gallery, New York
1967 Pace Gallery, New York
 'Universal Electronic Vacuum', Alecto Gallery, London
 Rijksmuseum Kröller-Müller, Otterlo, Holland
 Sculpture and graphics, Hanover Gallery, London
1968 Worth Ryder Art Gallery, University of California
 Galerie Neuendorf, Hamburg
 Silkscreens, Stedelijk Museum, Amsterdam
1969 Stadtische Kunsthalle, Dusseldorf
 Wurttembergischer Kunstverein, Stuttgart
 Galerie Mikro, Berlin
 Goeteborgs Konstmuseum, Sweden
1970 Pollock Gallery, Toronto
1971 Tate Gallery (retrospective), London
1972 'The Conditional Probability Machine', St Katherine's Gallery, London
1973 Victoria & Albert Museum, London and touring
1974 Galerie Wentzel, Hamburg
 Kestner Gesellschaft, Hanover
1975 Nationalgalerie (retrospective), Berlin
 Kunstverein Karlsruhe, Germany
 Ausstellung Kunsthalle, Bremen
 Arts Council of Great Britain (the same exhibition toured in 1976)
 Fruitmarket Gallery, Edinburgh (Scottish Arts Council–sponsored)
 Marlborough Fine Art Gallery, London
1977 Victoria & Albert Museum (print retrospective), London
 Galerie Renate Fassbender, Munich
 Collages and drawings, Anthony d'Offay Gallery, London
1978 Kasseler Kunstverein, Kassel, Germany
1979 Talbot Rice Art Centre, Edinburgh
 'Work in Progress', Kolnishcher Kunstverein, Cologne
 'The Development of an Idea', Glasgow League of Artists, Glasgow and touring
1980 Westfalisher Kunstverein (touring print exhibition)
1982 Museum für Kunste und Gewerbe, Hamburg
1983 Aedes Gallery, Berlin
 Cleveland 6th International Drawing Biennale
1984 Royal Scottish Academy, Edinburgh
 Architectural Association, London
 Stadtische Galerie im Lenbachhaus, Munich
1985 Museum Ludwig, Cologne
 Moderna Galerija, Ljubliana, Yugoslavia
 Centre for Contemporary Art, Breda, The Netherlands
 Ivan Dougherty Gallery, Sydney
 Espace Lyonnais d'Art Contemporain, Lyons, France
 Crawford Municipal Art Gallery, Cork, Ireland
 Museum of Mankind, London
1986 'Kopfe', Skulpturenmuseum Glaskasten, Germany
 Royal Academy of Art, London
 Glaskasten, Marl, West Germany
1987 Serpentine Gallery, London
1988 'Lost Magic Kingdoms and Six Paper Moons from Nahuatl', British Museum, London and National Touring Exhibition
 'The Artist as Hephaestus', National Portrait Gallery, London
 'Krazy Kat Archive', Victoria & Albert Museum, London
1989 Talbot Rice Art Centre, Edinburgh
 Stadtmuseum, Munich
1994 Yorkshire Sculpture Park, Wakefield, Yorkshire

Selected group exhibitions

1948 Galerie Maeght, Paris
1952 26th Biennale, Venice
1953 Institute of Contemporary Arts Gallery, London
1954 Institute of Contemporary Arts Gallery, London
1956 Whitechapel Art Gallery, London
1957 'Ten Young Sculptors', 4th São Paulo Bienal
 Arts Council Gallery, Cambridge
1958 Carnegie Institute, Pittsburgh
1959 'Documenta 2', Kassel, Germany
 'New Images of Man', Museum of Modern Art, New York
1960 '2nd International Biennial of Prints', Museum of Modern Art, New York
 Biennale, Venice
1961 Musée Rodin, Paris
1963 7th São Paulo Bienal
1964 'Documenta 3', Kassel, Germany
1967 'Sculpture from Twenty Nations' (touring exhibition), Guggenheim Museum, New York
1968 'Documenta 4', Kassel, Germany
1969 'Pop Art Redefined', Hayward Gallery, London
1976 'Arte Inglese Oggi', Palazzo Reale, Milan
1977 Hayward Annual, Hayward Gallery, London
1980 'Kelpra Studio Gift', Tate Gallery, London
 'Dovecot Studios 1912–1980' (exhibition of tapestries), National Gallery of Scotland
1981 '20th-Century British Sculpture', Whitechapel Art Gallery, London
1984 'The Automobile and Culture', Museum of Contemporary Art, Los Angeles
1988 'Sculptures from a Garden' (touring exhibition)
1998–99 'transistors', Hashimoto Museum of Art, Morioka, Japan; Royal Museum of Scotland, Edinburgh

Commissions

1951 Fountain for Festival of Britain
1968 Tapestry for Whitworth Art Gallery, Manchester
1973 Sculpture playground for Sir Terence Conran at Wallingford
1981 'Piscator' at Euston Square for British Railways Board
1984 Tapestry for the Chartered Accountants Hall, London
 Glass mosaic murals for Tottenham Court Road Station, London
 Cast-metal panelled door for The Hunterian Gallery, University of Glasgow
 Mosaic panels for Milward Square, Kingfisher Shopping Centre, Redditch
 Cooling Tower for Bessborough Street, London
 Films sets for Percy Adlon's Herschel and the Music of the Stars Fountain for Garden Exhibition, West Berlin
1986 Constructed wood relief in Queen Elizabeth II Conference Centre, London
 Twenty-six bronze elements for Rhinegarten, Cologne
1987 Bronze self-portrait for 34–36 High Holborn, London
1988 Bronze sculpture for Kowloon Park, Hong Kong
1990 Bronze head for Design Museum, London
1991 Giant bronze hand and foot with stone for Edinburgh
1994 'Isaac Newton' for British Library, London

Collections

United Kingdom

Arts Council of Great Britain
British Council
Contemporary Art Society, London
Dundee Corporation, Scotland
Ferens Art Gallery, Kingston-upon-Hull
National Gallery of Scotland
Tate Gallery, London
Temple Newsam, Leeds
Ulster Museum, Belfast

Victoria & Albert Museum, London
Whitworth Art Gallery, Manchester
United States
Museum of Modern Art, New York
Solomon R. Guggenheim Museum, New York
Albright-Knox Art Gallery, Buffalo
Institute of Fine Arts, Minneapolis
Dallas Museum of Contemporary Art, Texas
Museum of Art, Baltimore
University Art Museum, Berkeley, California
Museum of Art, Baltimore
Princeton University, New Jersey
Rockefeller Collection, New York
Carnegie Institute, Pittsburgh
Hirshhorn Collection, Washington
Europe
Nationalgalerie, Berlin
Rijksmuseum Kröller-Müller, Otterlo, Holland
Stedelijk Museum, Amsterdam
Museo d'Arte Moderna, Rome
Musée de Peinture et Sculpture, Grenoble
Palazzo Reale, Milan
Peggy Guggenheim Collection, Venice
Kunsthalle, Hamburg
Other
Museo de Bellas Artes, Caracas
National Gallery of Ontario, Toronto

Bibliography
Lawrence Alloway (in collaboration with Eduardo Paolozzi), *Metallization of a Dream*, Lion and Unicorn Press, London, 1963
Michael Middleton, *Eduardo Paolozzi* (edited by Jasia Reichardt), Art in Progress series, Methuen, London, 1963
U. M. Schneede, *Paolozzi*, Abrams, New York and Verlag Gerd Hatje, Stuttgart, 1970
Diane Kirkpatrick, *Eduardo Paolozzi*, Studio Vista, London, 1970
Wieland Schmied, et al, *Eduardo Paolozzi: Sculpture, Drawings, Collages and Graphics*, Arts Council, London, 1976
Rosemary Miles, *The Complete Prints of Eduardo Paolozzi*, Victoria & Albert Museum, London, 1977
Eduardo Paolozzi — Recurring Themes, exhibition catalogue, Royal Scottish Academy, Edinburgh, 1984
Winfried Konnertz, *Eduardo Paolozzi*, Du Mont, Cologne, 1984
Richard Cork (ed.), *Eduardo Paolozzi: Underground*, exhibition catalogue, Royal Academy/Wiedenfeld, London, 1986
Frank Whitford, *Paolozzi: Sculptures from a Garden*, exhibition catalogue, Serpentine Gallery, London, 1987
transistors, exhibition catalogue, Hashimoto Museum of Art, Morioka, Japan; Royal Museum of Scotland, Edinburgh, 1998

Publications by the artist
Metafisikal Translations, Kelpra Studios Ltd and Eduardo Paolozzi, London, 1962
Kex (edited by Richard Hamilton), printed by Lund Humphries for the William and Norma Copley Foundation, London, 1966
Abba Zaba, edited and printed by Hansjorg Mayer and the students of Watford School of Art, 1970

Films by the artist
The History of Nothing (with Denis Postle), 1960–62
Kakafon Kakkoon, 1965
Mr Machine (animated by Peter Lake and Keith Griffiths), 1971
Music for Modern Americans (through RCA, with music by Stuart Jones), 1983

ARTIST BIOGRAPHY COLLATED BY SABRINA GRINLING

Bill Scott

1935	Born Moniaive, Dunfriesshire, Scotland
1958	DA (Edin.), Edinburgh College of Art
1958–59	Post-graduate scholarship

1959–60	École des Beaux Arts, Paris
1970–73	Council member, Society of Scottish Artists
1984	Elected RSA
1990–97	Head, School of Sculpture, Edinburgh College of Art
1994	Appointed Professor, Faculty of Art and Design, Heriot-Watt University, Edinburgh

Selected solo exhibitions

1971	Whibley Gallery, Cork Street, London
1972	Compass Gallery, Glasgow
1974	Stirling Gallery
1979	'Sculpture and Drawings', New 57 Gallery, Edinburgh
1980	Lamp of Lothian, Collegiate Centre, Haddington
	Artspace Gallery, Aberdeen
1985	Kirkcaldy Museum and Art Gallery
1994	Talbot Rice Gallery, Edinburgh

Selected group exhibitions

1975	'11 Scottish Sculptors', Fruitmarket Gallery, Edinburgh
1978	'Objects & Constructions', SAC Festival Exhibition
	'Brotherston, Kempsell, Scott', Fruitmarket Gallery, Edinburgh
1979–80	'British Art Show', Mappin Gallery, Sheffield; Hatton Gallery, Newcastle; Arnolfini Gallery, Bristol
1981	'Scottish Sculpture Open', Kildrummy Castle, Aberdeenshire
1982–83	'Built in Scotland', Third Eye Centre, Glasgow; City Arts Centre, Edinburgh; Camden Arts Centre, London
1986	'One Cubic Foot', Talbot Rice Gallery, Edinburgh, touring to Aberdeen and Glasgow
1991	'Virtue and Vision', National Galleries of Scotland
	'Scottish Artists Exhibition', Royal West of England Academy, Bristol
1993	Chelsea Harbour Show
1994–95	'Scandex Exhibition', Aberdeen, Norway, Sweden, Finland
1995	'Nine Scottish Sculptors', Edinburgh College of Art, Edinburgh Festival
1996	'Joseph Beuys in Scotland', Demarco European Art Foundation
1997	British Art Medals, London, York, New York and Colorado
1998–99	'transistors', Hashimoto Museum of Art, Morioka, Japan; Royal Museum of Scotland, Edinburgh

Commissions

1969	Sculpture for new Byre Theatre, St Andrews
1980	Sculpture for Cumbernauld Shopping Centre
1985	Sculpture for Kentigern House, Glasgow
1994	Sculpture for Gyle, Edinburgh
1998	Memorial Sculpture for Sir Alec Douglas-Home

Collections
Aberdeen Art Gallery
Argyll County Council
Edinburgh City Art Centre
Kirkcaldy Museum and Art Gallery
Lanarkshire County Council
Leeds City
National Library of Scotland
Royal Scottish Academy
Scottish Arts Council

William Turnbull

1922	Born Dundee, Scotland
1946–48	Slade School of Fine Art, London
1948–50	Lived in Paris
1952–61	Visiting artist, Central School of Arts and Crafts, London
1964–72	Taught sculpture at the Central School of Arts and Crafts, London

Lives and works in London

Selected solo exhibitions

1950	Sculpture, Hanover Gallery, London
1952	Sculpture and paintings, Hanover Gallery, London
1957	Sculpture and paintings, Institute of Contemporary Arts, London
1960	Sculpture, Molton Gallery, London

Selected group exhibitions

Collections

Bibliography
William Turnbull (with an introduction by David Sylvester), exhibition catalogue,
Hanover Gallery, London, 1950
Reyner Banham, 'The Next Step', *Art News and Review*, January 26, 1952
Lawrence Alloway, 'Britain's New Iron Age', *ARTnews*, June, 1953
William Turnbull (introduction by Lawrence Alloway), exhibition catalogue, Institute of
Contemporary Arts, London, 1957
William Turnbull (introduction by Lawrence Alloway), exhibition catalogue, Molton
Gallery, London, 1960
Lawrence Alloway, 'The Sculpture and Painting of William Turnbull', *Art International*,
Issue No. 1, February 1, 1961
Theo Crosby, 'International Union of Architects Congress Building, South Bank',
Architectural Design, November, 1961
Jasia Reichardt, 'Bill Turnbull', *Art News and Review*, April 22, 1961
Turnbull, exhibition catalogue, Marlborough-Gerson Gallery, New York, 1963
William Turnbull (introduction by Gene Baro), exhibition catalogue, Benjamin College,
Vermont, 1965
Jasia Reichardt, 'William Turnbull', *Architectural Design*, May, 1967
Frank Whitford, 'The Paintings of William Turnbull', *Studio*, April, 1967
Alan Bowness, 'William Turnbull', *IX Bienal São Paulo*, exhibition catalogue, British
Council, 1967
Richard Morphet, *William Turnbull*, exhibition catalogue, Alistair McAlpine Gift, Tate
Gallery, London, 1971
Bernard Cohen, 'William Turnbull — Painter and Sculptor', *Studio International*,
July–August, 1973
William Turnbull, Sculpture and Painting (introduction by Richard Morphet), exhibition
catalogue, Tate Gallery, London, 1973
William Feaver, 'William Turnbull', *Art International*, Issue No. 7, 1974

Recent Paintings, Sculptures and Prints by William Turnbull (introduction by Richard Morphet), exhibition catalogue, Scottish Arts Council Gallery, Edinburgh, 1974
Hilton Kramer, 'William Turnbull', *New York Times*, January 8, 1982
Kim Lim and William Turnbull (introduction by Roger Bevan), exhibition catalogue, National Museum of Singapore, 1984
William Turnbull, exhibition catalogue, Waddington Galleries, London, 1985
Mel Gooding, 'William Turnbull, Jock McFayden, Julian Trevelyan', *Art Monthly*, Issue No. 93, 1986
Eleanor Heartney, 'William Turnbull at Dintenfass', *Art in America*, May, 1986
H. S., 'William Turnbull', *ARTnews*, New York, 1986
Anne Massey, 'The Independent Group: Towards a Redefinition', *Burlington* (UK), Issue No. 1009, 1987
John Russell, 'William Turnbull', *New York Times*, November 17, 1987
William Turnbull (introduction by Roger Bevan), exhibition catalogue, Waddington Galleries, London, 1987
Penelope Curtis, *Patronage & Practice: Sculpture on Merseyside*, Tate Gallery, Liverpool, 1989
Colin Renfrew, 'The Sculptures of William Turnbull', *Sculpture in the Close*, exhibition catalogue, Jesus College, Cambridge, 1990
David Robbins, *The Independent Group: Postwar Britain and the Aesthetics of Plenty*, MIT Press, Cambridge, Massachusetts and London, 1990
William Turnbull, exhibition catalogue, Waddington Galleries, London, 1991
Adrian Searle, 'William Turnbull: Waddington's', *Time Out*, October 9–16, 1991
Marco Livingstone, *Pop Art*, exhibition catalogue, Royal Academy of Arts, London, 1991
Ready, Steady, Go: Painting of the Sixties from the Arts Council Collection, exhibition catalogue, Arts Council and South Bank Centre, 1992
Sculpture, exhibition catalogue, Waddington Galleries, London, 1992
New Beginnings: Postwar British Art from the Collection of Ken Powell, exhibition catalogue, Scottish National Gallery of Modern Art, Edinburgh, 1992
William Packer, 'Totemic Images', *The Financial Times*, November 21, 1995
Sarah Kent, 'Matter in mind', *Time Out*, November 22, 1995
Toni del Renzio, 'William Turnbull: Serpentine Gallery', *Art Monthly*, Issue No. 192, 1995
British Abstract Art Part 2: Sculpture (introduction by Bryan Robertson), exhibition catalogue, Flowers East, London, 1995
William Turnbull: Sculpture and Paintings (introduction by David Sylvester), exhibition catalogue, Merrell Holberton Publishers and Serpentine Gallery, London, 1995
Of the Human Form, exhibition catalogue, Waddington Galleries, London, 1995
transistors, exhibition catalogue, Hashimoto Museum of Art, Morioka, Japan; Royal Museum of Scotland, Edinburgh, 1998

Craig Wood

1960	Born Edinburgh, Scotland
1985–86	Dyfed College of Art, Carmarthen, Dyfed, Wales
1986–89	BA, Goldsmiths College, University of London
1993–94	Kunsthalle Nurnberg/Faber-Castell
	University of Warwick in Venice (art history department)
1996	DAAD Berlin
1997	Gregory Fellow in Sculpture, University of Leeds
1998	Visiting lecturer with Goldsmiths College, London

Selected solo exhibitions

1989	The Crypt, Bloomsbury, London
1990	Laure Genillard Gallery, London
	Galerie des Archives, Paris
	Galerie Etienne Ficheroulle, Brussels (with Absalon)
1991	Third Eye Centre, Glasgow (with Perry Roberts)
	Chisenhale Gallery, London (with Perry Roberts)
	Galerie des Archives, Paris
1992	Galleria Franz Paludetto, Turin
	Laure Genillard Gallery, London
	Stadtisches Museum Abteiberg, Monchengladbach, Germany
1993	Kunsthalle, Nurnberg, Germany
1994	Castello di Rivara, Italy
	Chapelle Jeanne d'Arc, Thouars, France
	Galerie des Archives, Paris

1995	Querini Stampalia Library, Venice and 152c Brick Lane, London
	Warwick University (in collaboration with Alessandra Rossi), England
	Laure Genillard Gallery, London
1996	DAAD Gallery, Berlin
	Kunstverein Elsterpark, Leipzig

Selected group exhibitions

1988	'Death', Kettle's Yard Gallery, Cambridge
1990	'Modern Medicine', Building 1, Tower Bridge Business Square, London
	'Exposition 1 — 1990', Centre International d'Art Contemporain de Montréal, Canada
1991	Graeme Murray Gallery, Edinburgh
	Interim Art, London
	'Images of an Organisational Landscape', IKOS, Florence
1992	'A Marked Difference', Arti et Amicitiae, Amsterdam
	'London', Karsten Schubert, London
	'États Specifiques', Musée des Beaux Arts André Malraux, Le Havre, France
1993	'In Site — New British Sculpture', National Museum of Contemporary Art, Oslo
	'Made Strange — New British Sculpture', Ludwig Museum, Budapest
	'Fast Surface', Chisenhale Gallery, London
1994	'Clean', Ikon Gallery, Birmingham
	'Wall to Wall', Leeds City Art Gallery, National Touring Exhibitions
	'Visione Britannica', Valentina Moncada Galleria, Rome
1995	'Art Unlimited: Multiples of the 1960s and 1990s from the Arts Council Collection', South Bank Centre National Touring Exhibition, Centre for Contemporary Arts, Glasgow and UK tour
	'Institute of Cultural Anxiety', Institute of Contemporary Arts, London
	'Contemporary British Art in Print', Scottish National Gallery of Modern Art, Edinburgh
	'Wild Roses Grow by the Roadside', 152c Brick Lane, London
	'Elemental', Newlyn Art Gallery, Penzance, England
1996	'Mirades (sobre el Museu)', Museum d'Art, Barcelona
	'Summer Show', Kunsthaus Muthaseus, Drewen, Germany
1997	'Plastic', Richard Salmon Gallery, London and Arnolfini Gallery, Bristol
	'Mystral', Laure Genillard Gallery, London
	'Une Sélection et une Collection', Ville de Châtellerault, France
1998–99	'transistors', Hashimoto Museum of Art, Morioka, Japan; Royal Museum of Scotland, Edinburgh

Bibliography

Monumental Works, exhibition catalogue, The Crypt, St Georges Church, London, 1988
Mark Currah, 'The Gold Rush', *City Limits*, November 22–30, 1989
Doris Drateln, 'Craig Wood', *Kunstforum*, April–May, 1990
James Roberts, 'Gladstone Thompson, Craig Wood', *Artefactum*, April–May, 1990
Jonathan Watkins, 'Metamorphic Strategies', *Art International*, Summer, 1990
Olivier Zahm, 'Craig Wood', *Art Press*, September, and Flash Art, October, 1990
Eric Troncy, 'Craig Wood', *Artscribe*, November–December, 1990
Hilary Robinson, 'Less is more', *Forum*, March–April, 1991
Liam Gillick, 'Roberts/Wood', *Art Monthly*, June, 1991
James Robert, 'Perry Roberts, Craig Wood', *Flash Art*, Summer, 1991
Michael Archer, 'Perry Roberts/Craig Wood', *Artforum*, September, 1991
Liam Gillick and Andrew Renton (eds), *Technique Anglaise: Current Trends in British Art*, Thames & Hudson, London and One Off Press, London, 1991
Perry Roberts and Craig Wood (essay by James Roberts), exhibition catalogue, Third Eye Centre, Glasgow and Chisenhale Gallery, London, 1991
'Mapping the Future', *Frieze*, Issue No. 3, 1992
'A Marked Difference', *Arti* (bulletin of Arti et Amicitiae, Amsterdam), Issue No. 13, June, 1992
Craig Wood (text by Hannelore Kersting), exhibition catalogue, Stadtisches Museum Abteiberg, Monchengladbach, 1992
Jonathan Watkins, 'Invitations to Look Elsewhere', *Threshold* (bulletin of the National Museum of Contemporary Art, Oslo), Issue No. 9, January, 1993
Craig Wood (essay by Christine Hopfengart), exhibition catalogue, Kunsthalle Nurnberg and Castello di Rivara, Italy, 1993
Simon Grant, 'Drawings', *Art Monthly*, Issue No. 177, 1994
Installation Art (de Oliveira ed.), Thames & Hudson, London, 1994
Hygiene: Writers and Artists Come Clean and Talk Dirty (text by Angela Kingston), exhibition catalogue, Ikon Gallery, Birmingham, 1994

Wall to Wall (text by Liam Gillick), exhibition catalogue, South Bank Centre National Touring Exhibition, Leeds, 1994

Craig Wood — Untitled Leisure x 24 (text by Yves Chuillet), Chapelle Jean d'Arc, Thouars, 1994

The Institute of Cultural Anxiety. Works from the Collection (text by Jeremy Millar), exhibition catalogue, Institute of Contemporary Arts, London, 1994

Richard Dorment, 'Science friction', *The Daily Telegraph*, January 11, 1995

Adrian Searle, 'Craig Wood', *Time Out*, January 17–24, 1996

William Jeffett, 'Craig Wood, *Untitled*, Issue No. 10, 1996

Melissa Feldman, 'Craig Wood', *Art in America*, June, 1996

Martin Coomer, 'Craig Wood', *Flash Art,* March–April, 1996

Jonathan Jones, 'Plastic', *Untitled*, Issue No. 12, 1996

Plastic (text by Neil Cummings), exhibition catalogue, Edwardes Square Studios and Arnolfini, Bristol, 1996

Permanent Food, Association des Temps Liberes, 1996

Mats Bigert, 'Craig Wood', *Material*, Winter, 1997

'Ireland and Europe', Sculptors Society of Ireland, 1997

transistors, exhibition catalogue, Hashimoto Museum of Art, Morioka, Japan; Royal Museum of Scotland, Edinburgh, 1998

George Wyllie

1921	Born Glasgow, Scotland
1968	Irvine Arts Centre
1977	Scottish Arts Council Award (travelled to Greece and the United States)
1984	British Council Award (travelled to the United States)
1986–89	Past and honorary president Society of Scottish Artists
1989	Associate Royal Scottish Academy
1990	Lord Provost's Gold Medal, Glasgow
	Hon. D.Litt., Strathclyde University
1992	Royal Glasgow Institute
1993	British Council Award (travelled to and lectured in India and Singapore)

Selected solo exhibitions

1976	Collins Exhibition Hall, Strathclyde University
1977	MacRobert Art Centre, Stirling
1979	Talbot Rice Art Centre, Edinburgh
1981	Serpentine Gallery, London
	Collins Exhibition Hall, Strathclyde University
1982	Third Eye Centre, Glasgow
1984	Worcester Arts Museum, Massachusetts
1987	An Lanntair, Stornoway
1988	An Lanntair, Stornoway
1989	Richard Demarco Gallery, Edinburgh
1990	World Financial Center, New York
1991	Third Eye Centre, Glasgow
1992	Whitworth Art Gallery, Manchester
1994	'Blake's Bike', Rebecca Hossack Gallery, London
1996	'The Bosun's Pipe', Square Tower, Portsmouth
1998	Cottier Theatre, Glasgow

Selected events

1982–83	Installations in the United States
1985	'A Day Down a Goldmine' (theatre), Edinburgh Festival
1986	'A Day Down a Goldmine' (theatre), Institute of Contemporary Arts, London
1990	'A Day Down a Goldmine' (theatre), Tramway Theatre, Glasgow
	'The Why?s Man' (film)
1994	'A Temple for a Scots Pine', Edinburgh Festival
1995	'32-Spires for Hibernia', Republic of Ireland and Edinburgh Festival
1996	'Just in Case' (21ft stainless-steel safety pin), Mayfest, Glasgow
	The MacGillivray Walk, Fochabers-Harris, Highland Festival
	'This is the Captain Speaking', Edinburgh Festival
1997	'Just in Case' (21ft stainless-steel safety pin), Portsmouth
	'A Voyage Round a Safety-Pin' (theatre), Citizens Studio Theatre, Glasgow
	'The MacMillan Bikes', Finlaystone, Langbank
1998	'Just in Case', Edinburgh

Commissions and collections

British Council, Bombay
British Rail
The Caged Peacock, Princes Square, Glasgow
Clydesdale Bank (three branches)
County Hall, Cheshire
Deansgate, City of Manchester, Whitworth Art Gallery, Manchester
Fluxus Archive, Getty Foundation
General Accident Insurance World Headquarters, Perth
Glasgow Cathedral
Mayfest '96, Glasgow
Mitchell Swire, Aberdeen
Museum of Transport and Kelvingrove Art Gallery, Glasgow
St Johns Kirk, Perth
Smith Museum and Art Gallery, Stirling
Ufa-Fabrik, Berlin

General References

William Packer, *Scottish Sculpture '75*, Fruitmarket Gallery, Edinburgh, 1975

Small Sculpture from the Collection of the Scottish Arts Council, Scottish Arts Council, Edinburgh, 1978

Objects and Constructions. Selected Contemporary Scottish Sculpture, Edinburgh College of Art/Scottish Arts Council, Edinburgh, 1978

Rosalind Krauss, *Passages in Modern Sculpture*, MIT Press, Cambridge, Massachusetts, 1981

The Sculpture Show, Arts Council of Great Britain, London, 1983

Built in Scotland. Work by Ten Sculptors, Camden Arts Centre, London/Third Eye Centre, Glasgow, 1983

Figures and Objects. Recent Developments in British Sculpture, John Hansard Gallery, Southampton, 1983

Michael Compton, Douglas Hall, Martin Kunz, *Edinburgh International. Reason and Emotion in Contemporary Art*, Royal Scottish Academy, Edinburgh, 1987

Modern British Sculpture from the Collection, Tate Gallery, Liverpool, 1988

Starlit Waters. British Sculpture. An International Art 1968–1988, Tate Gallery, Liverpool, 1988

Fiona Byrne Sutton, *New Sculpture in Scotland*, Cramond Sculpture Park, Edinburgh, 1988

Shape and Form. Six Sculptors from Scotland, Collins Gallery, Glasgow/City Art Centre, Edinburgh, 1988

Keith Hartley, *Scottish Art since 1900*, Scottish National Gallery of Modern Art, Edinburgh, 1989

Duncan Macmillan, *Scottish Art 1460–1990*, Mainstream, Edinburgh, 1990

Jane Allison, *New Directions in Scottish Sculpture*, Barbican Art Gallery, London, 1990

Fiona Pearson (ed.), *Virtue and Vision. Sculpture and Scotland 1540–1990*, National Galleries of Scotland, Edinburgh, 1991

Fiona Byrne Sutton, 'Momentary monuments: site specific work in Glasgow 1990', *Alba*, January–February, 1991

Murdo Macdonald, *Walk On. Six artists from Scotland*, Jack Tilton Gallery, New York, 1991

Thomas Lawson, *Guilt by Association*, Irish Museum of Modern Art, Dublin, 1992

Gravity and Grace. The Changing Condition of Sculpture 1965–1975, Hayward Gallery, London, 1993

Isabel Vasseur, Duncan Macmillan, et al, *Lux Europae*, Edinburgh, 1993

15th Anniversary Scandex '94, Scottish Sculpture Workshop, Lumsden, 1994

Andrew Guest and Helena Smith (eds), *The City is a Work of Art. 1: Glasgow. Artists and Architects in Dialogue and Collaboration*, Scottish Sculpture Trust, Stirling, 1994

Murdo Macdonald, 'A Tradition in Scottish Sculpture', *Nine Sculptors in Scotland*, Edinburgh College of Art, Edinburgh, 1994

A Changing World. Fifty Years of Sculpture from the British Council Collection, The British Council, London, 1995

Maria Lind, *Sawn Off*, Stockholm, 1996

The City is a Work of Art. 2: Edinburgh, Scottish Sculpture Trust, Edinburgh, 1996

Keith Hartley and Ursula Prinz, *Correspondences. Scotland/Berlin*, Berlinische Galerie, Berlin/Scottish National Gallery of Modern Art, Edinburgh, 1997